Carole Solvay

Carole Solvay

To Move Without Noise

2000–2019

Richard O. Prum,
Roger Pierre Turine,
Adrien Grimmeau

Edited by

Alain Chang

Mercatorfonds

Distributed outside Belgium,
Luxembourg and the Netherlands by

Yale University Press

Everything that's alive stirs and
moves noiselessly, even the reeds,
even the stunted trees.

Jean Giono

The feather is a natural theme with infinite variations

Feathers are branched structures that grow from the skin of birds. Like hair, scales, nails and horns, feathers are skin appendages. Unlike these, however, feathers have parts within parts within parts. It is this unique, hierarchical structure that is key to the extraordinary diversity of feather form and function.

Feathers have branches within branches within branches. The tubular calamus, or quill, at the base of the feather extends into the rachis, or shaft. Extending from either side of the rachis and forming the planar vane of the feather are numerous branches called barbs. Extending to the sides of each barb are a myriad tiny, filamentous branches called barbules.

The feather is like a nested set of miracles, one within the other. Perhaps we shouldn't be surprised that the biggest miracles of all are the smallest ones. The tiny barbules have microscopic hooklets and grooves that interlock among the overlapping barbules, zippering together neighbouring barbs to create a new, emergent surface – the feather vane. It would be no more surprising if the hairs on your head wove themselves together to create a tapestry.

Feathers first evolved over 150 million years ago in the meat-eating theropod dinosaurs. Today, feathers are produced by the more than 15,000 species of lovely, living dinosaurs we know as birds. Feathers started as simple tubes, then evolved into tufts, and then into vaned feathers. For the dinosaurs, the evolution of the first feathers with a coherent planar feather vane was an evolutionary provocation: what can you do with this? The answer, of course, was flight. Ultimately, the dinosaurs evolved to use the new planes of their feathers to transport themselves out of the earth's terrestrial plane. Bringing together new feather technologies on the most microscopic scale available to animal cells, birds liberated themselves to explore the widest possible span of the biosphere. From over 30,000 metres above the earth's surface to more than 500 metres deep into its ocean, birds use their wing feathers to explore the greatest diversity of the earth's ecology.

What contributions can an ornithologist provide in a study of Carole Solvay's work? Would one ask a geologist for commentary on Michelangelo's *Pietà* or Auguste Rodin's *The Kiss*? In all honesty, that might not be one's first thought. The history of feathers, however, is really the history of evolutionary innovations: innovations nested one within one another; innovations that have created new opportunities for further innovations; unexpected transformations that lead to new dimensions, new structures and new potentials. From this perspective, ornithology is an excellent vantage point from which to appreciate Solvay's explorations.

Solvay's feather art is not *un hommage* to bird feathers. Rather, like the dinosaurs themselves, Solvay asks, 'What can I do with this?' Her creative answers constitute a transformative exploration of the materiality of feathers.

In Solvay's hands, feathers are crimped and crumpled, cut and buckled, woven and wired into new forms, new inventions, new conceptions, which attract our senses and challenge our imaginations. There are works that conjure images of other natural forms, like corals and flowers. There are diaphanous fabrics and spiky balls. There are jewellery boxes filled with fuzzy wires, and abstract, geometric mobiles. Each piece is a new achievement in artistic expression.

For tens of millions of years, birds have exploited feathers to create their own artistic effects. Avian seduction, affiliation and social competition have impelled the evolution of birds towards marvellous aesthetic achievements. Wisely, however, Solvay never tries to compete with the birds, or exploit their great diversity of tricks. Rather, she invents her own expressions, again and again, learning from the feathers but going where the birds cannot. Solvay shows the deepest respect for feathers by showing no regard for what the birds do with them.

In much of my science, I have explored how the physical properties of feathers – their colours, their textures, the sounds they make, etc. – emerge from their materiality, the physical feather. Every piece in *To Move Without Noise* exhibits Solvay's deep knowledge and relentless curiosity about feather materiality. I have spent a great deal of my life exploring the materiality of feathers as a scientist: with my fingers, under microscopes, even using some of the world's most advanced scientific instruments. Yet Solvay knows many things about feathers of which I have never dreamed. The feather is a natural

theme with infinite variations, but Solvay weaves, conjures and invents many new dimensions about these variations.

Feathers are premier examples of evolutionary innovation in nature; they are entirely novel, biotic inventions that have no precursors in evolutionary history. Unravelling the complex history of the origin of feathers has long presented a major challenge to evolutionary biology. In my own research, I approached this question by exploring the unique, hierarchical structure of feathers. I investigated how feathers grow in order to explore how feathers evolved.

Feather growth poses a fascinating riddle: feathers are branched like a tree but they grow from the base like a hair. This means that, unlike a tree, a feather grows in such a way that the tips of its 'twigs' and 'branches' are older than the 'trunk'. Understanding this developmental conundrum involved the study of numerous details, which provided the insights necessary to understand that feathers started as tubes, becoming tufts, and then planar vanes, and only then coherent vanes that allowed birds to fly.

Through her art, Solvay's crimping, crunching and unfurling presents a parallel exploration of feather hierarchy. The surfaces, interfaces, angles and cavities she creates expose the feather's structure – the same hierarchy that science explores, but seen in a new way. She beguiles both the scientist and the artist within us.

Perhaps the biggest challenge in feather evolution is: whence the feather vane? The first planar vane would not have been useful in flight, and would have been hardly more insulating or water-repellant than down. What evolutionary advantage could the first vane have provided? Recently, in my book *The Evolution of Beauty* (2017), I proposed that the feather vane may have been an aesthetic innovation.[1] The vane provided a two-dimensional canvas upon which birds might create complex new feather pigmentation patterns: spots, dots, chevrons and stripes. The feather vane may have evolved because of its contributions to aesthetic expression and appreciation by the birds themselves. This radical idea is supported by recent discoveries that show some of the earliest vaned feathers in the theropod dinosaurs already had complex pigmentation patterns.

Beauty can be its own innovation. This is an important scientific discovery, because the aesthetic innovation of vaned feathers both preceded, and was essential for, the

subsequent evolution of avian flight. Were it not for the beauty of feathers, birds may never have evolved to fly at all. It does not trivialise Solvay's art to call it beautiful, ravishing, inviting and sensuous. It is all of these. But feathers teach us that seduction of the senses is a great path towards further innovations and other novel functions. Likewise, Solvay's seductive book opens up new pathways in the possibilities of feathers.

Richard O. Prum, 2019

Richard O. Prum is the William Robertson Coe Professor of Ornithology at Yale University, and the Curator of Ornithology in the Yale Peabody Museum of Natural History. Prum is an evolutionary ornithologist with broad interests in avian biology. A life-long birdwatcher, he has researched many topics including feather development and evolution, plumage coloration, sexual selection, bird phylogeny, and the dinosaur origin of birds. He has conducted fieldwork on bird on all continents, and has studied fossil theropod dinosaurs in China. In 2017, he published *The Evolution of Beauty*, which was named one of the Top Ten Books of the Year by the *New York Times*, and was a finalist for the 2018 Pulitzer Prize in General Nonfiction. His popular writing has appeared in the *New York Times*, *New Yorker*, *Scientific American* and *Natural History Magazine*. He has been awarded MacArthur, Guggenheim and Fulbright Fellowships.

1. Richard O. Prum, *The Evolution of Beauty: How Darwin's Forgotten Theory of Mate Choice Shapes the Animal World and Us* (New York: Doubleday, 2017).

Feathers of Time

All is silence – evoking fragility. Everything whispers, almost transparent. Delicate fragments domed beneath peacock plumes.

Here, one finds feathers, *pennae*, barbs ... singing for you. A gentle song, woven with a winged hand. Luminous. The meticulous work of a forager bee, a seamstress, a poet of dancing fibres, dissuaded by neither time nor space.

Carole Solvay's work speaks to the infinitely small – the surprising flight of wild birds – as well as the grand scale: this majestic intoxication of flighty feathers conjures up an unexpectedly open room, exposed to the winds that transform your universe.

Solvay's world is neither placid nor tragic. It is, perhaps more aptly put, volatile. Scintillating and tranquil. Quiescent and whimsical. Nevertheless, it takes root in you. Rends the air, stormy as well as becalmed, flaunts its gladness. And witnesses. Resides between sky, earth and fathomless depths. Twenty thousand leagues under the sea. A hundred thousand in the air.

Her universe: an inexpressible sympathy with deities adorned with birds, and web-footed creatures – large and small – amplified by their fulsome plumage. But what else?

Everything is balance, harmony, composed without pretence or words. The medium and its inception are a unique language. Singular. Fragile, obdurate, absorbing, disarming, beguiling.

In the space they occupy, what remains of these feathers after distillation returns to breath, tremor, spark, outburst ... An airiness that reigns ... without raising its voice.

Solvay's art is complex, while remaining weightless – like wind-blown feathers – and yet freighted with meaning. A plethora of plumes which, under her hands, become not merely incantatory feathers, but also pennae, barbs (peacock feathers) that rustle or resound with swords drawn, evoking the unexpected image.

A creator of unclassifiable objects that enkindle explorers of unknown lands, Solvay induces you to see stars, because there is magic or mystery in the wind. Her artwork is often aquatic and yet also air-bound. Pagan mystery and rite.

For a moment – through journeying and dreaming (because it is at once a dream universe and a dreamed-up universe), we also see starfish, jellyfish, sea-foam and the great taking to flight of cormorants. In any case, an enigma without end. An enchantment without a name.

Roger Pierre Turine, 2017

Before devoting himself to art criticism, Roger Pierre Turine studied law and worked for Belgian television. For three decades, he has been a regular contributor to the Belgian daily newspaper *La Libre Belgique*, and is a member of the International Association of Art Critics (IAAC). Turine has written numerous prefaces for exhibition catalogues, and his books include works on Soviet art and on the arts of the Congo, as well as a series of conversations with such artists as Pierre Soulages, Jedd Novatt and Ernest Pignon-Ernest. He has also led workshops on art criticism in Africa, and over the last decade he has been actively involved with the Biennale of African Art in Dakar. He has curated exhibitions at Belgium's Yambi Festival (2007); the Henri-Victor Wolvens exhibition at the *Musée d'Ixelles* (Belgium, 2015); and the Ernest Pignon-Ernest retrospective at *Le Botanique*, Brussels (2018–19).

The Sting of Sweetness

Discussions of Carole Solvay's work often start by noting it is made out of feathers. But isn't it misleading to start there, giving away her secrets? This is not what is essential. Rather, what is at stake for Solvay is to lead the viewer to forget her materials.

In Solvay's work there are no feathers. Or no longer any. Undone, dissected, dissolved — one no longer finds feathers but rachises, calami, barbs, vanes. Manifold fragments whose origin can no longer be deciphered. What, then, are we witnessing? Theatre, a shadow play, where things are what they don't seem to be? Or, where they are no longer what they seem to be? Because everything endeavours to return to feathers. The theatre that unfolds recounts a narrative of lightness, balance and softness.

Feathery qualities — this is where the metaphor resides.

The analogy with theatre arises out of Solvay's installations, where light is used for dramatic effect, and where mysteries of the indecipherable world unfold in silence and beyond time. Here we no longer find feathers; rather, immobile actors, aware that equilibrium is rare. It's no longer a question of flying, but of landing in air.

For a decade, Solvay worked to eliminate feathers — to retain only fragments, so carefully removed they can no longer be recognised. The first artworks that emerged from this unexpected material took on a living form, something seemingly animate, appearing organic. But then she transcended this reference. Her work has grown in scope, becoming ever less figurative, progressively ethereal.

Beyond this point we enter a territory of air. The artist only retains the material's barest essentials, discovering its riches where they lie most hidden. With these meticulously chosen, sculpted elements she enrobes the void. At times, a fragment's discreet beauty seems to caress a current of wind. This masterful economy of means stimulates the imagination.

Our time is empty. One has to pare down, talk less. Solvay is silent. But for me, she brings to mind the owl in children's stories that — disturbed while reading magic spells — stares down at us over its glasses, without lifting its head. Solvay applies herself to the task; her

work is slow and repetitive. It encourages meditation. We believe we can detect movement, but in fact the work is motionless. It is frozen in the instant of breath, but will never stop falling like rain or rising like smoke rings. Fugitive, like embers fixed in a starry sky. All leading to the zero point of suspended time.

By dint of elimination, undoing, one day nothing will be left. The still point will be reached. 'Finally at home, in the pure, having reached the sting of sweetness', as Henri Michaux has it.[1]

Adrien Grimmeau, 2012

Adrien Grimmeau is an art historian. He has curated exhibitions on modern Belgian artists, such as 'Ferdinand Schirren en ses jardins imaginaires' (*Musées royaux des Beaux-Arts de Belgique*, 2012) and 'Dialogue with Light. Walter Leblanc – Jef Verheyen' (*Musée d'Ixelles*, 2016). His interests also encompass art in the public space, to which he has devoted several exhibitions, including 'YO: Brussels Hip Hop Generations' (BOZAR, 2017), and publications such as *Dehors ! Le Graffiti à Bruxelles* and *Being Urban. Pour l'art dans la ville / Bruxelles* (CFC-Editions, 2011 and 2016). He teaches at various art academies, and coordinates the Brussels Art Film Festival. Since 2018, he has been the director of the contemporary art centre ISELP in Brussels.

1. Henri Michaux, *Plume précédé par Lointain intérieur* (Paris: NRF, 1938, 1963). Own translation.

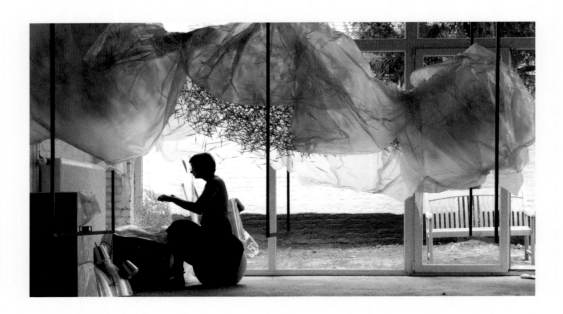

About the artist

Carole Solvay (b.1954) grew up in the countryside where life was still dictated by the seasons. As a child, she spent hours following the flight of swallows and the motion of the wind sweeping the grass, and listening to the leaves rustling in the trees… 'For me, trees are also an entire universe', she observed.

At 17, Solvay enrolled at art school, but realised after a few weeks that being confined by academic assignments did not suit her. She's always worked instinctively, preferring to discover things at her own pace and in her own fashion. 'I have a great need for silence and solitude, and my work is intrinsically linked to my inner growth. My pieces take time to build; the interrelationship of space and time is particularly important to me. The work that goes into creating my pieces is extremely repetitive – a long, painstaking and daily affair, but it suits me perfectly. While I create, I listen to music or radio interviews. I have multiple pieces in process at the same time, and the one I choose to focus on at any given moment is determined by my state of mind. Some of them require a great deal of accuracy and concentration; conversely, seeking out points of tension and

balance actually feels like play. It can happen that I'll spend weeks on a project only to completely change course and to eventually go in a completely different direction. In fact, the final result invariably differs from the initial idea.'

– But why feathers?

'My pieces are inspired by nature, and my life is filled with stories about birds. I spent hours watching them, and I came to know them very well. I never made a conscious decision to work with feathers. It just happened, but each new exploration leads to the next, and the story is not over. A feather's specific qualities allow for different things to be expressed, so I choose the structure and properties of my materials carefully and then adapt them to my needs. I prefer ordinary feathers, particularly sturdy ones like wing or tail feathers. Wire complements the process – I can simply bend it instead of tying a knot. And just like with a pencil stroke, I can use it to draw a line between feathers and create a shape for the whole.'

Reserved by nature, Carole rarely discusses her art works. Perhaps she does not want to influence the spectator's gaze… However, there is one key to broaching her work without spoiling emotion. Imbued with the writings of great poets, Carole does not so much seek inspiration from these words but rather she tries to envision the world through the eyes and ears of others. The following pages are scattered with phrases excerpted from readings that influenced her, like so many grains laid as watermarks between wire and feathers.

Alain Chang, 2019

Alain Chang is an independent designer whose work encompasses various fields of design, visual communication and the visual arts. He has taught in the Industrial Design Department at *La Cambre*, Brussels. He and Carole Solvay created an installation entitled *Whispers* (2010).

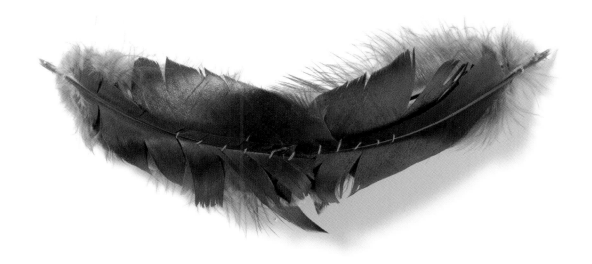

Even a worm
an inch long
has a soul
half-an-inch long.

Anonymous, Japanese

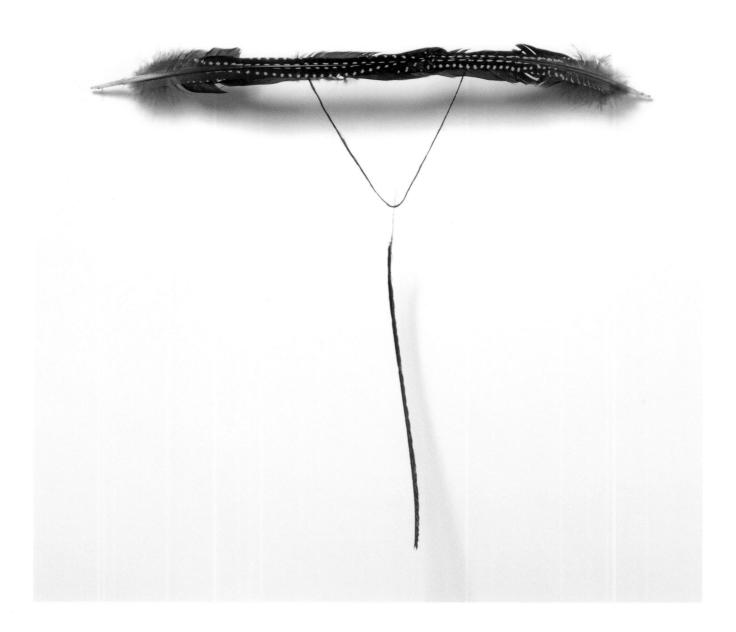

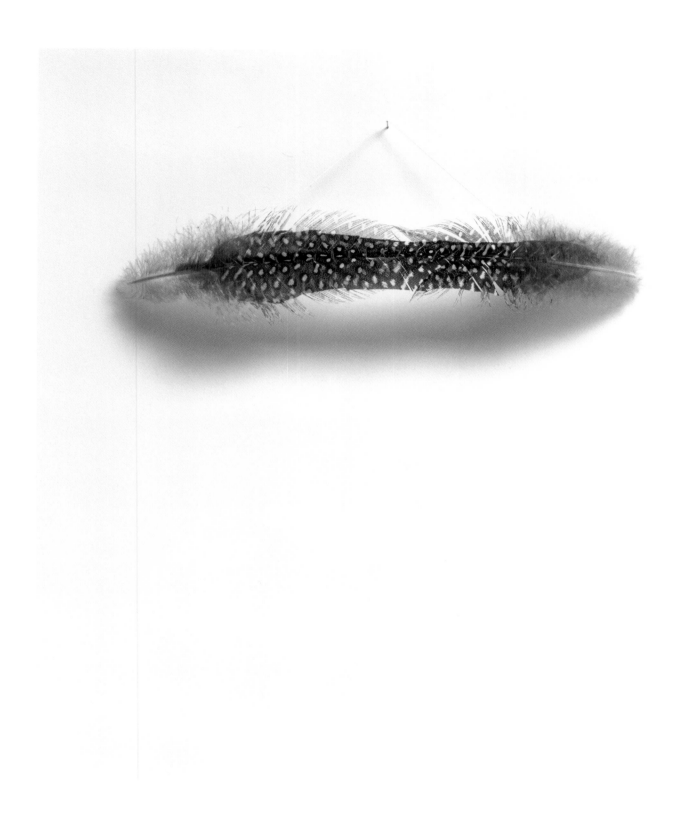

Tread softly because you tread on my dreams.

William Butler Yeats

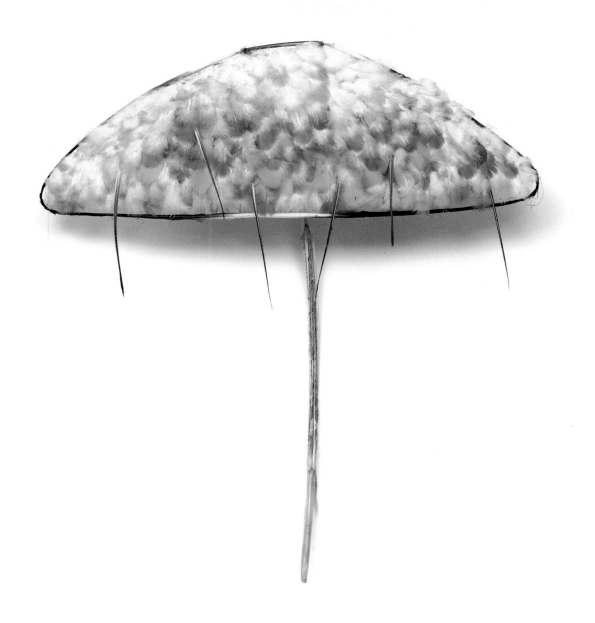

Tonight
my regret
will be like
a howl
lost
in the desert.

Giuseppe Ungaretti

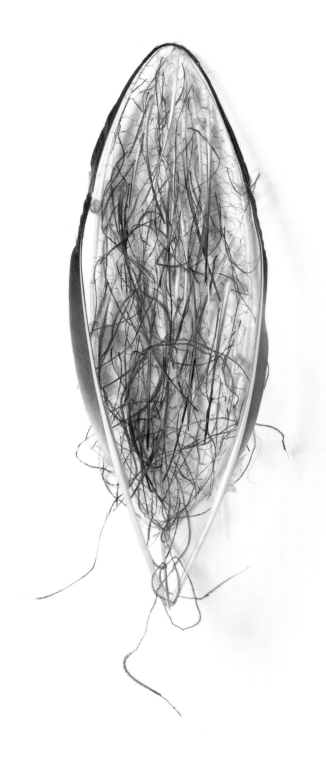

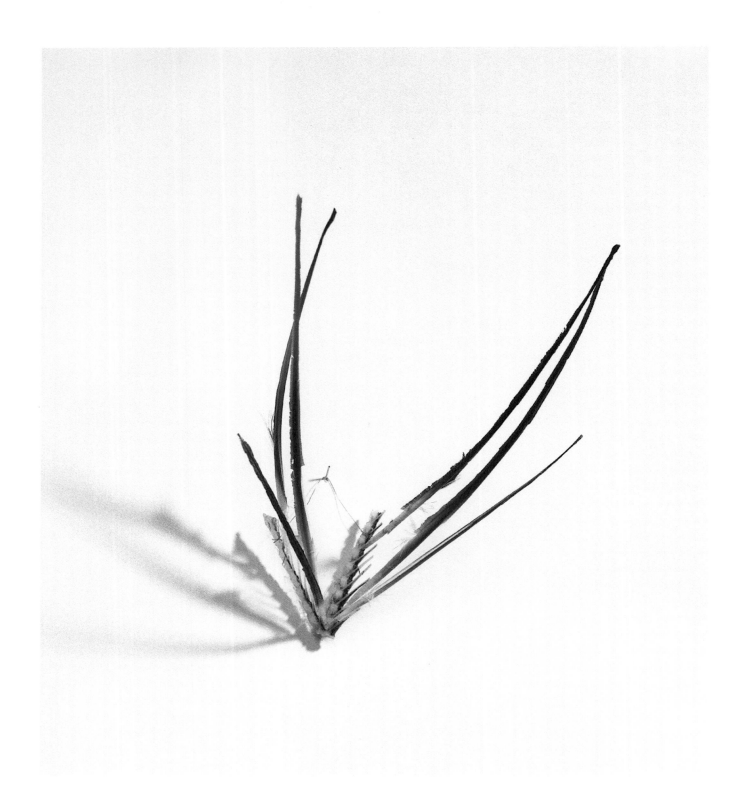

There will be time, there will be time

To prepare a face to meet the faces that you meet.

T. S. Eliot

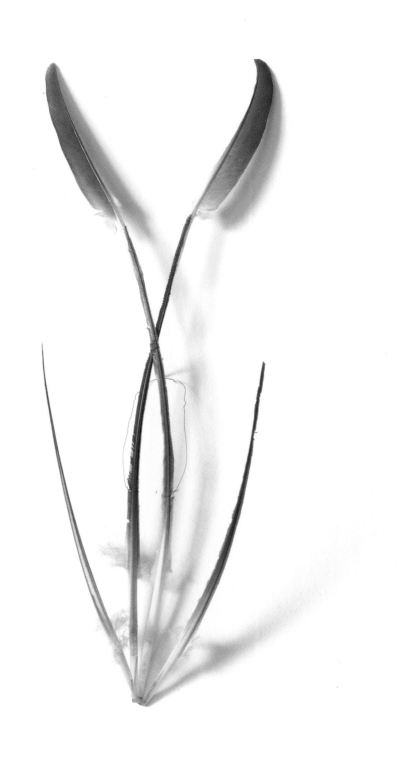

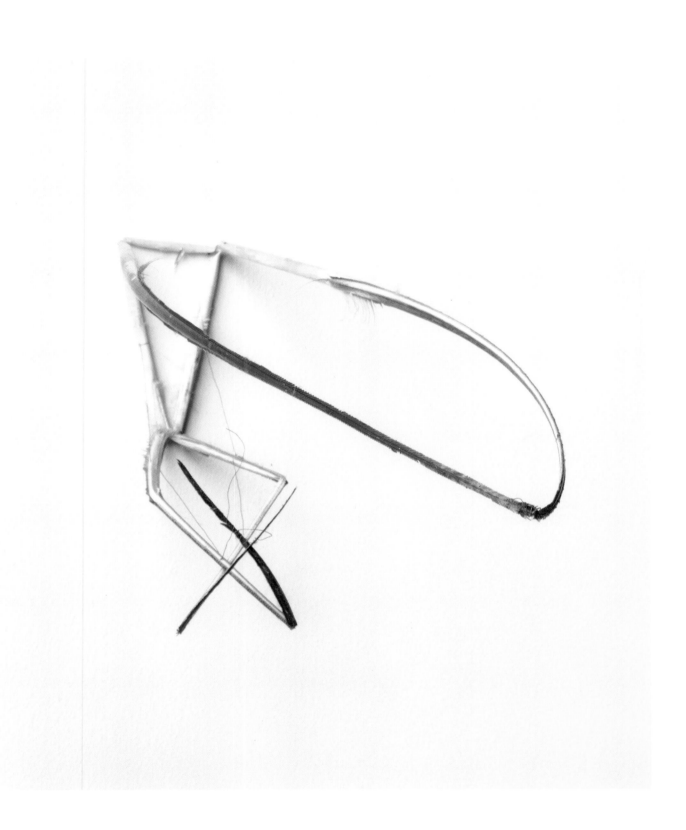

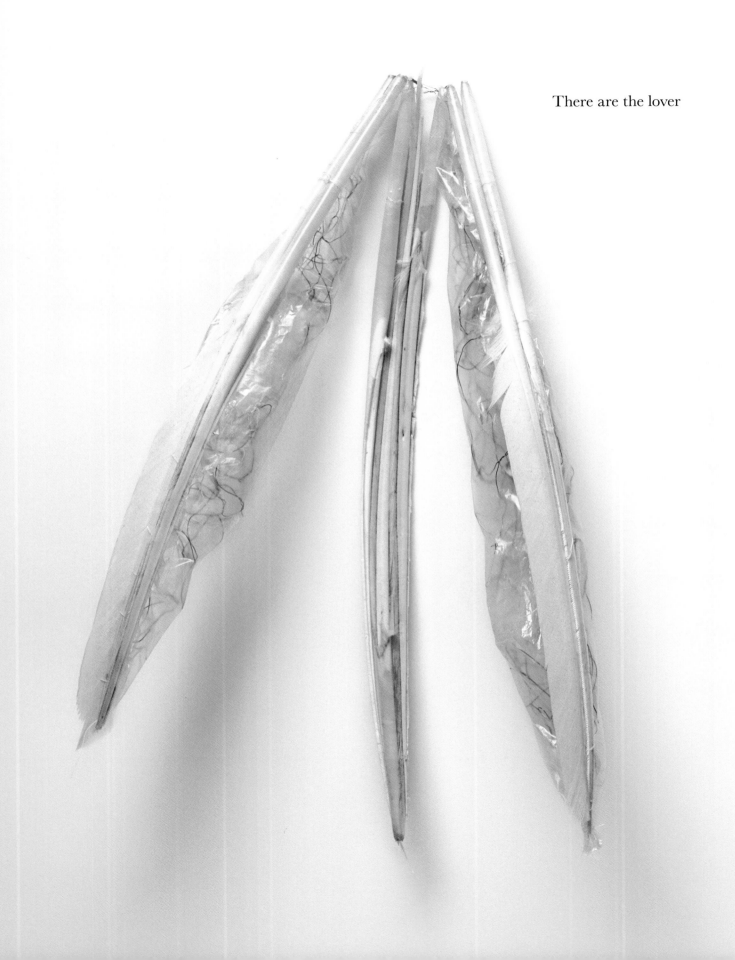

There are the lover

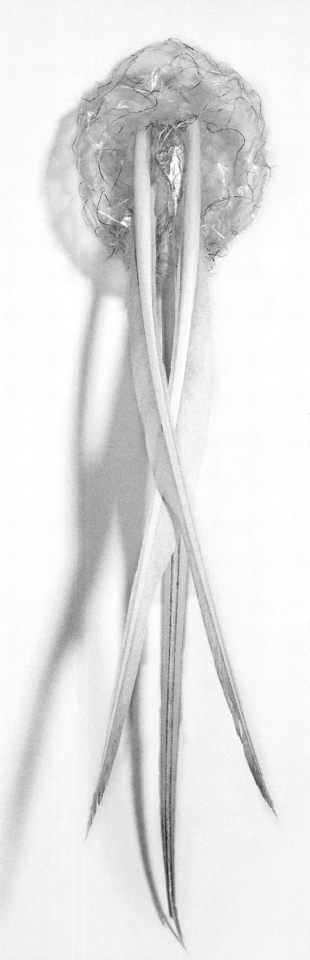

... and the beloved,
but these two come from
different countries.

Carson McCullers

A woman every night
Journeys secretly.

Paul Eluard

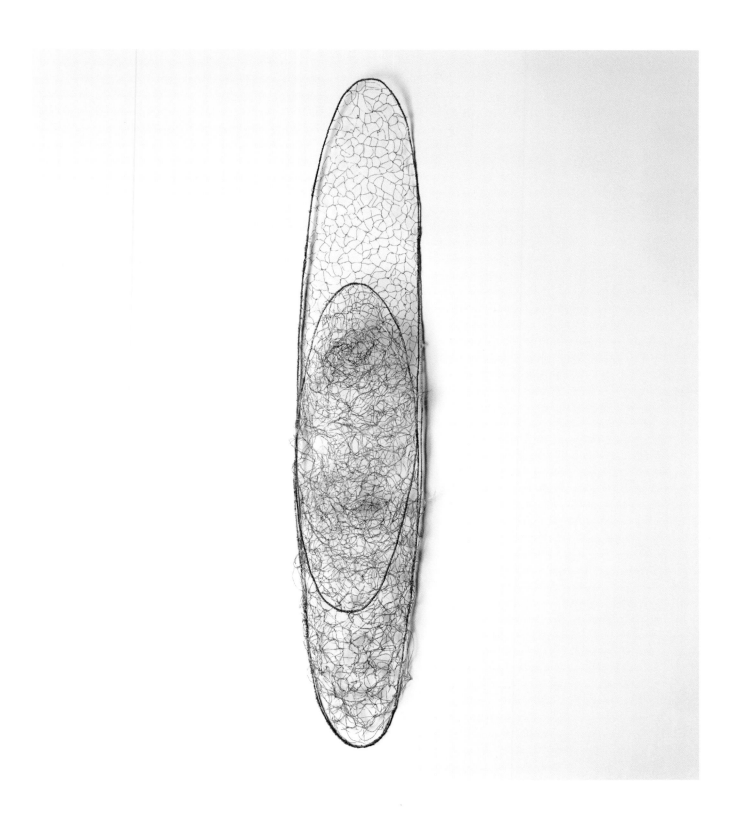

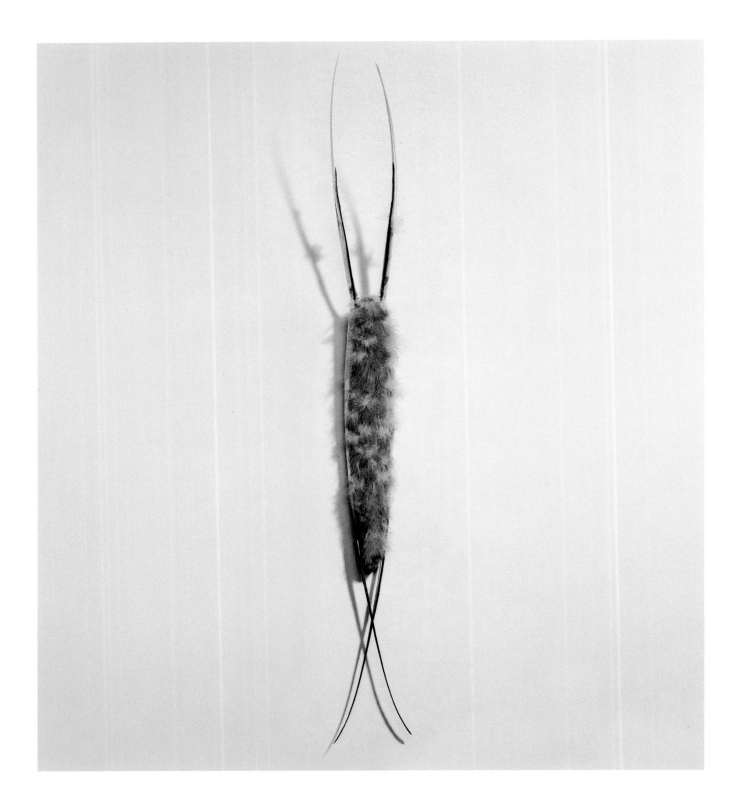

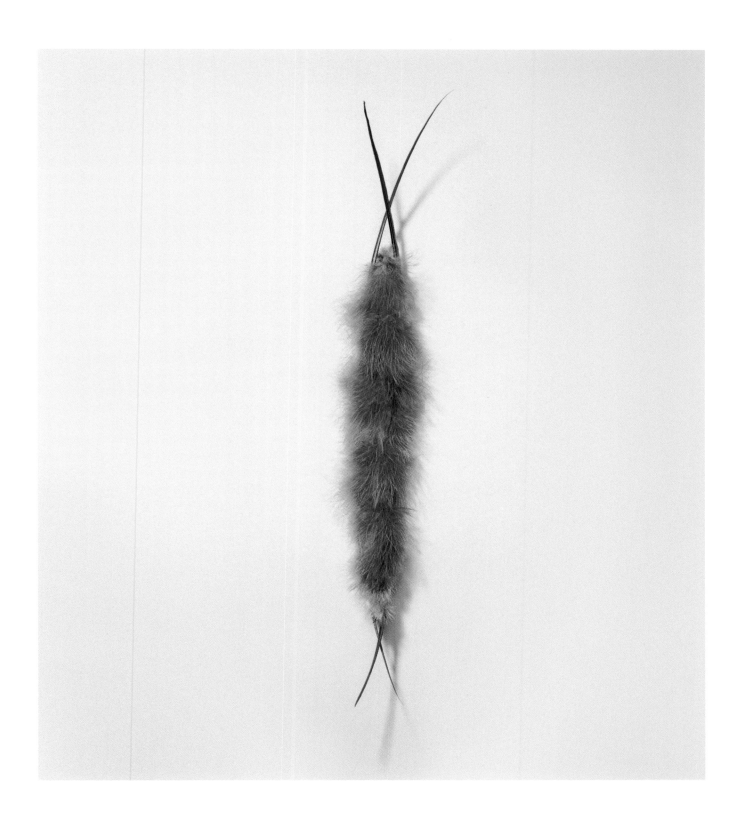

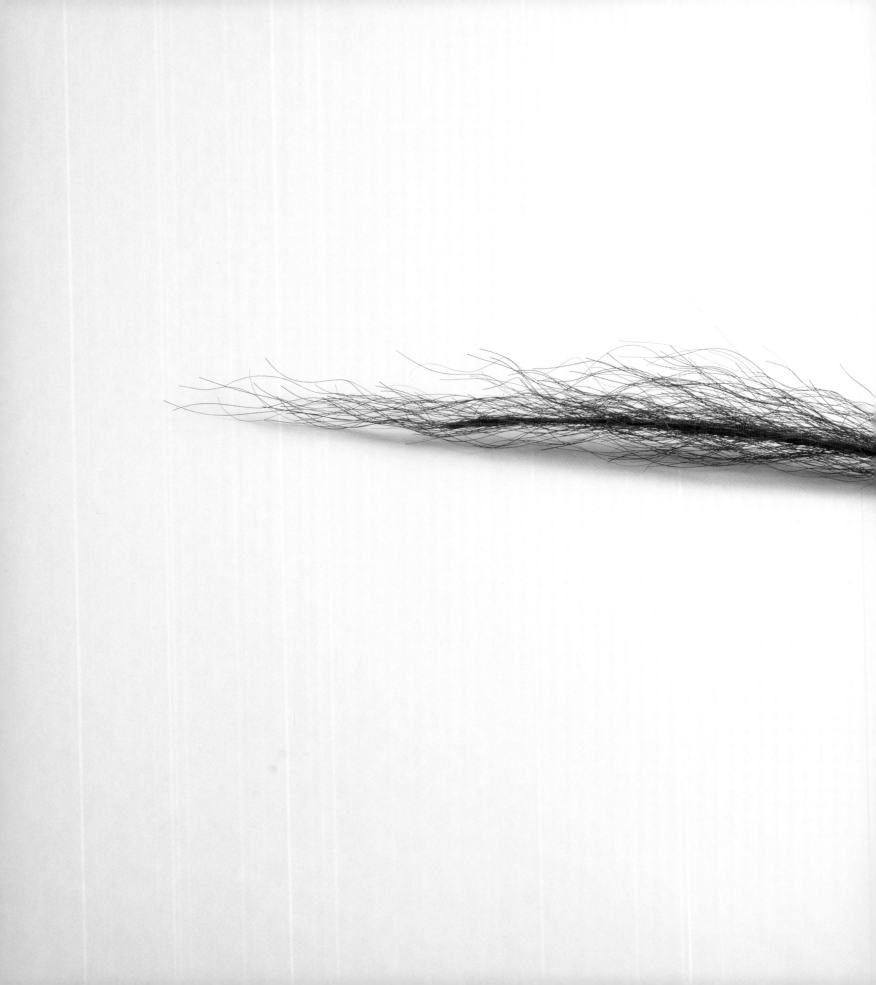

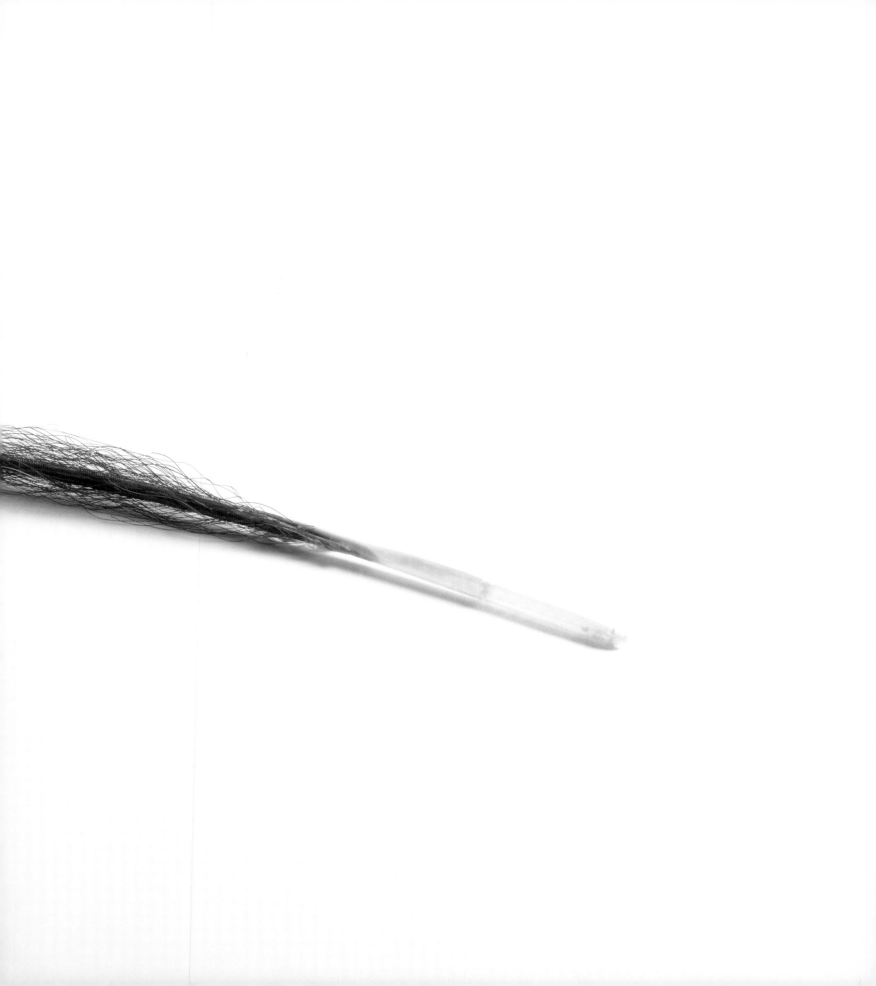

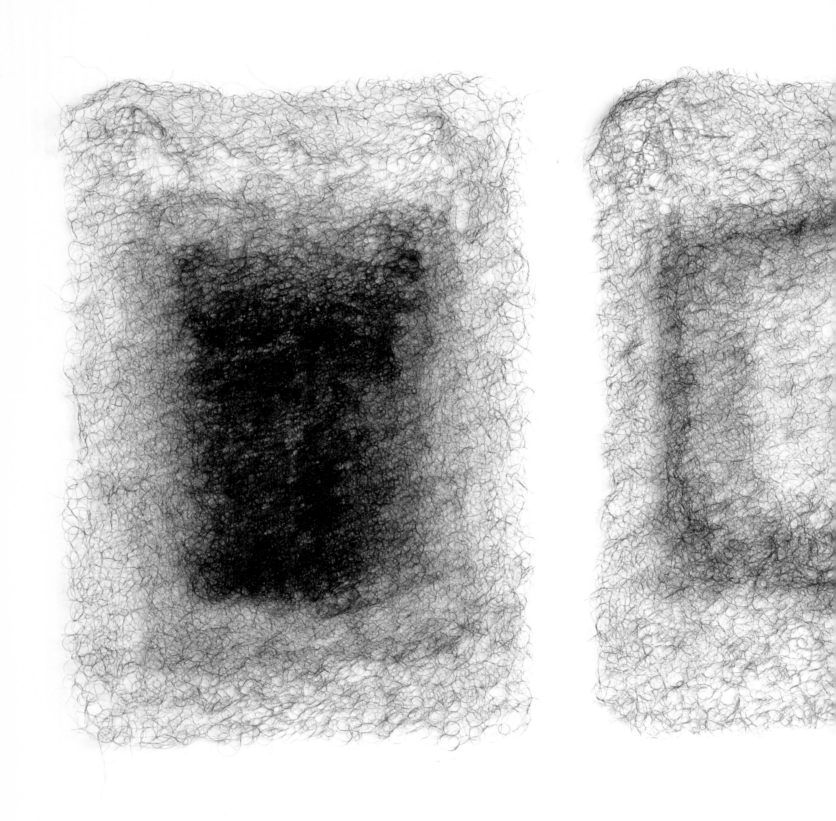

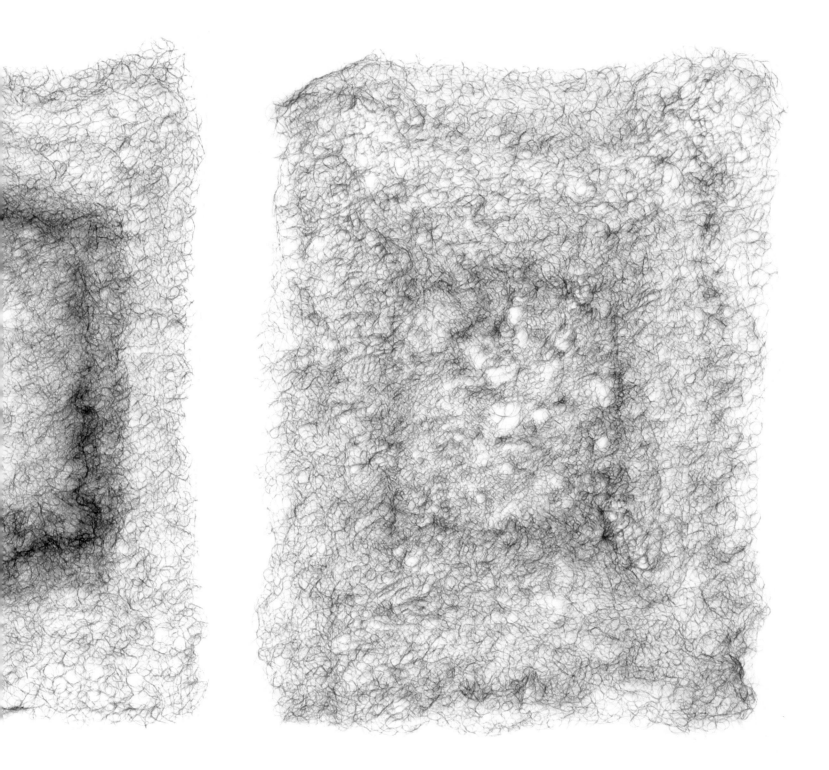

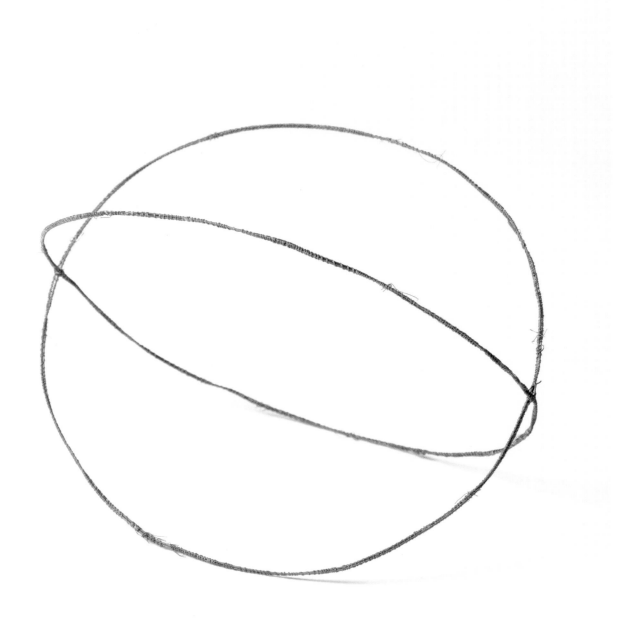

Like water, the world ripples across you and for a while you take on its colours. Then it recedes, and leaves you face to face with the void you carry inside yourself, confronting that central inadequacy of soul which you must learn to rub shoulders with and to combat, and which, paradoxically, may be your surest impetus.

Nicolas Bouvier

To yield is to be preserved whole.

To be bent is to become straight.

To be hollow is to be filled.

To be tattered is to be renewed.

To be in want is to possess.

To have plenty is to be confused.

Lao-Tzu

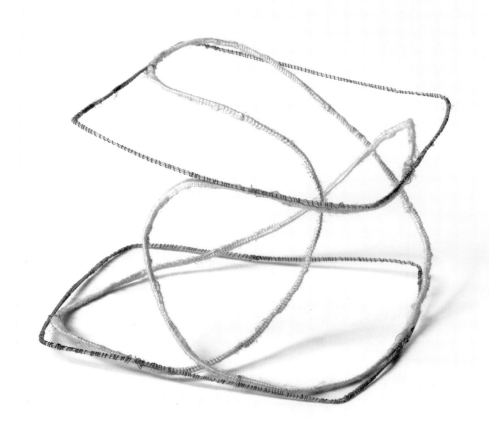

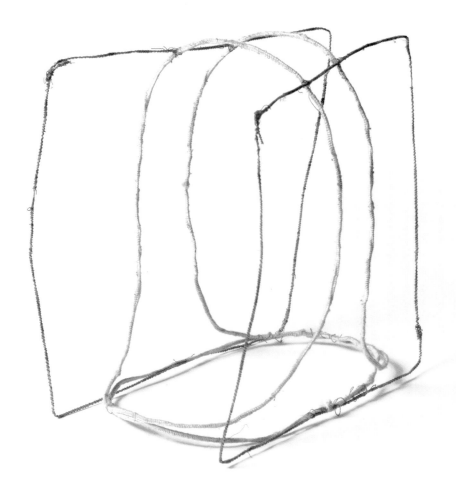

Beauty is the sum of those things that pass through us, unaware of us, and suddenly intensifying the lightness of being.

Christian Bobin

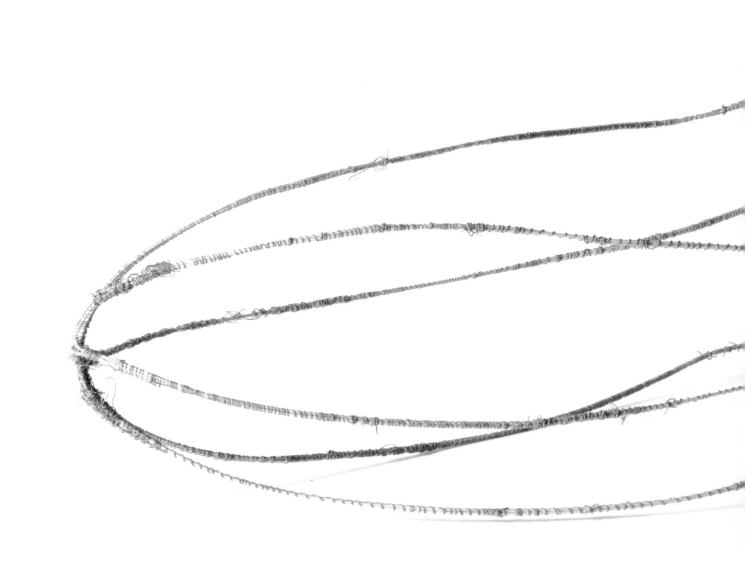

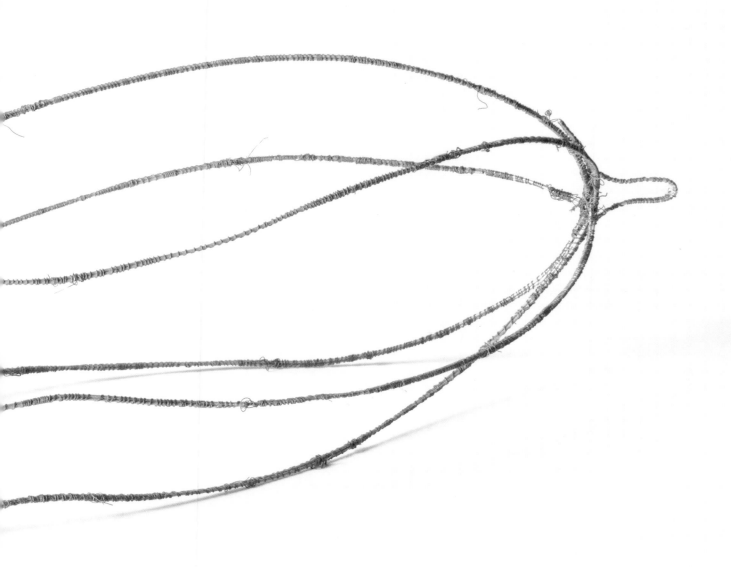

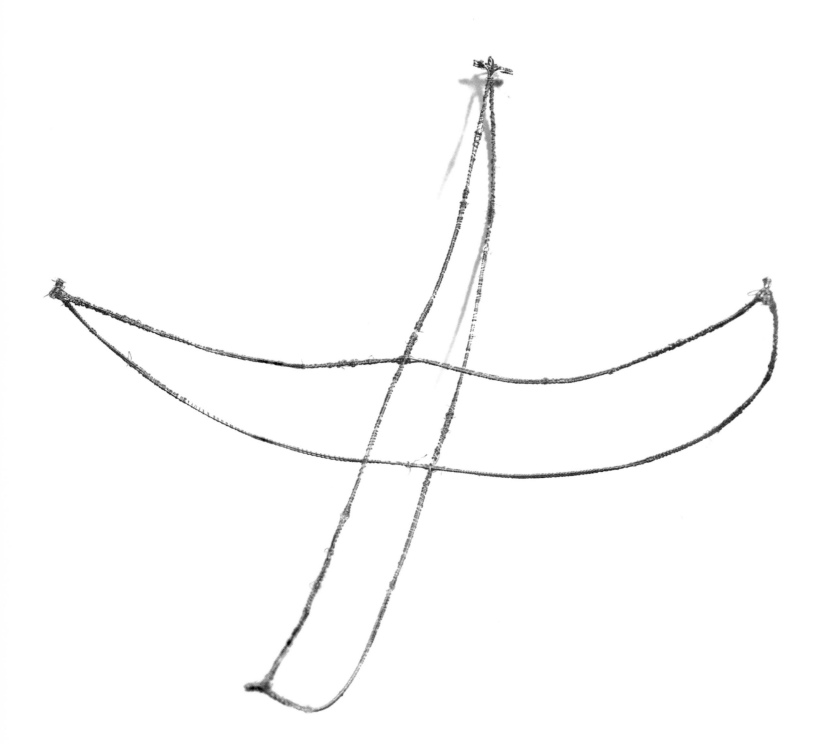

and I turn into a soft string, oscillating
between the visible and the invisible.

Jón Kalman Stefánsson

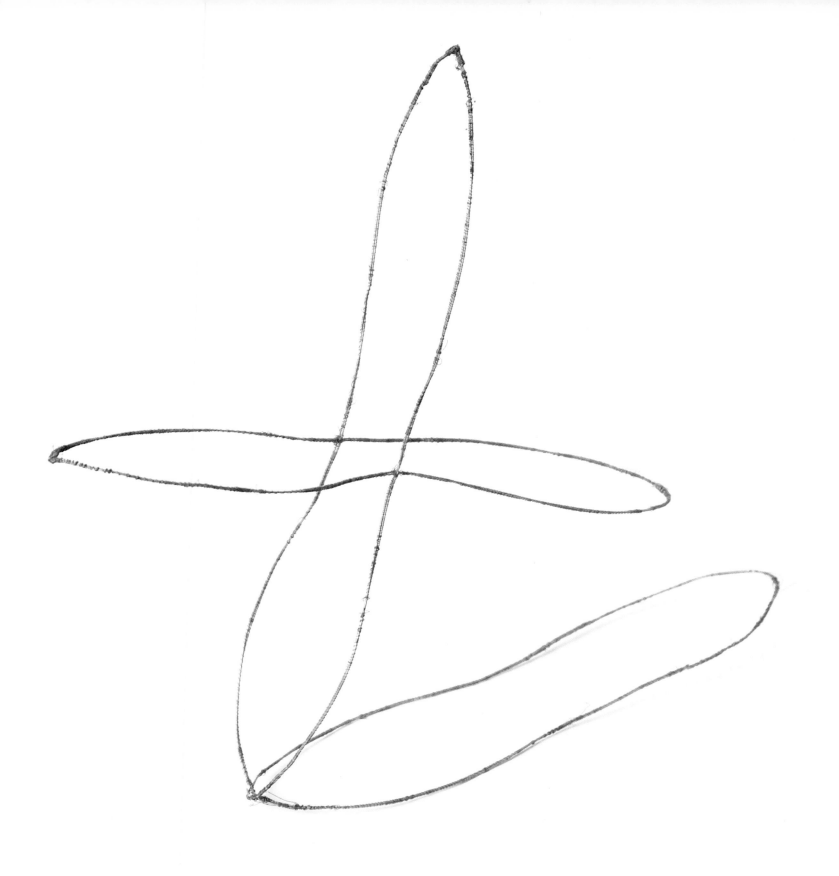

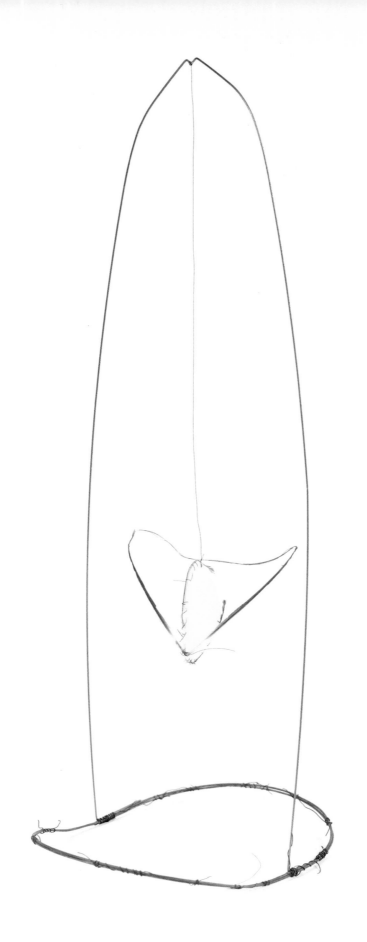

An excess of skill leads to vulgarity, nor should one have too much coarseness, as this is off-putting; but coarseness discovered through skill is wonderful.

Zhiqi Tang

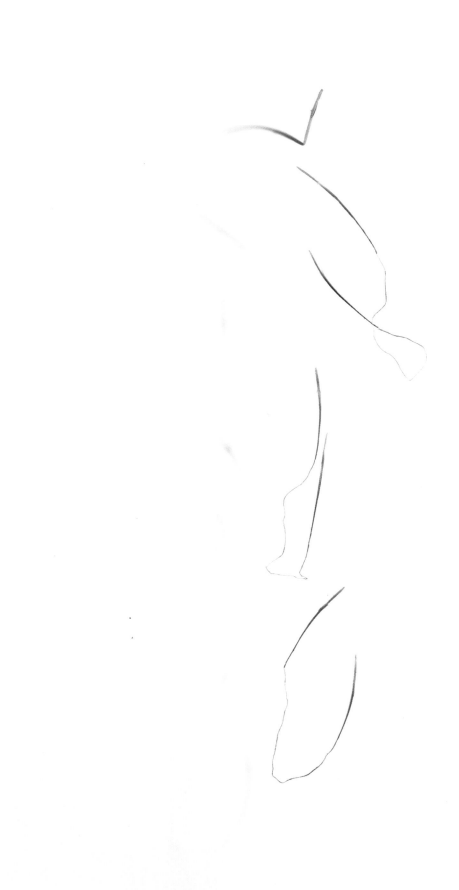

Calligraphy also evokes space by its absence.

It must be discreet and allow the eye to see the invisible.

Hassan Massoudy

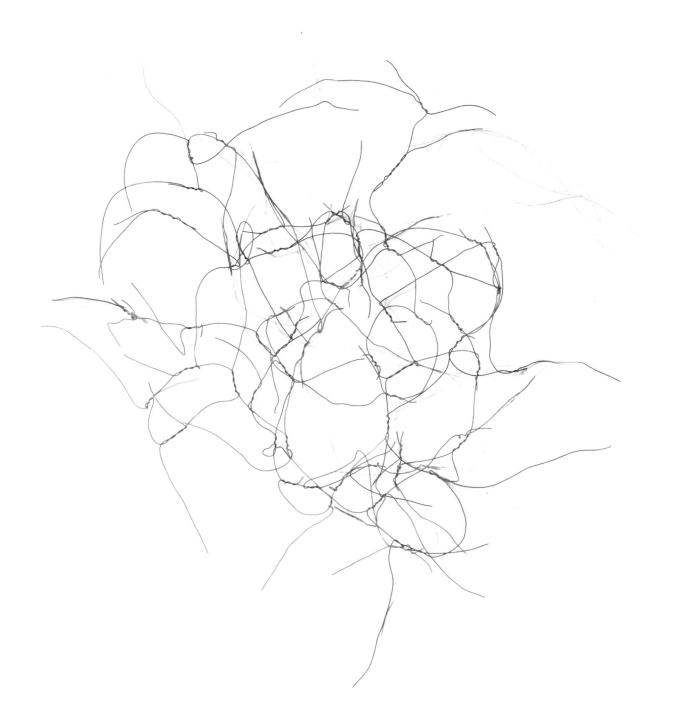

I have tried to remove weight, sometimes from people, sometimes from heavenly bodies, sometimes from cities; above all I have tried to remove weight from the structure of stories and from language.

Italo Calvino

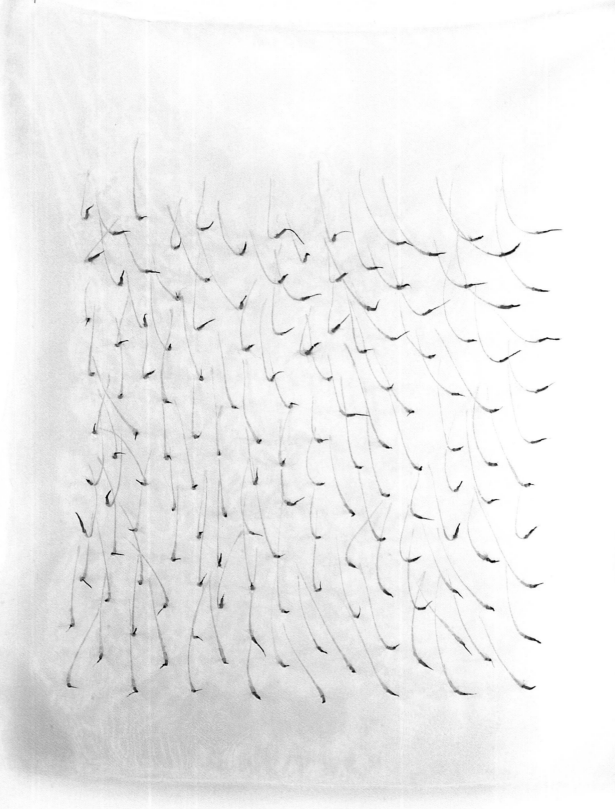

I think one does not write by hand. Talent lies in one's bottom. You have to know how to sit. If you don't know how to sit, you don't write. Discipline is called for.

Mahmoud Darwish

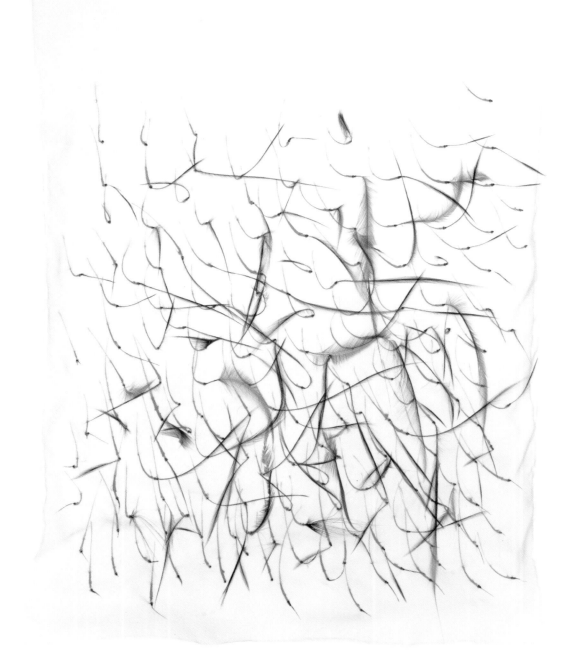

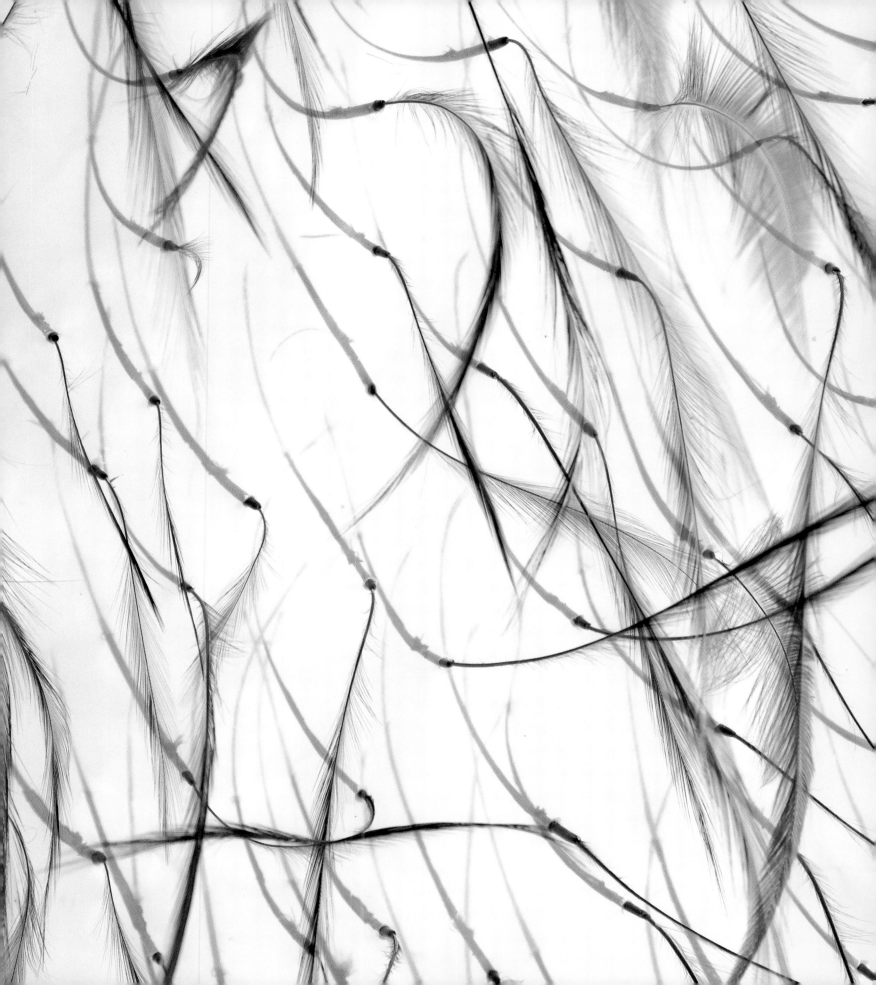

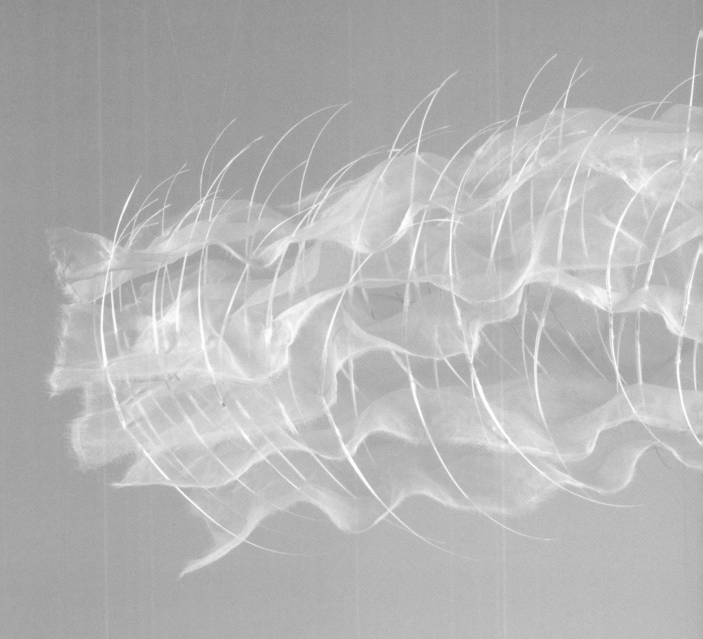

I think they ride the calm mid-heaven, as these,

In wise majestic melancholy train,

And watch the moon, and the still-raging seas,

And men, coming and going on the earth.

Rupert Brooke

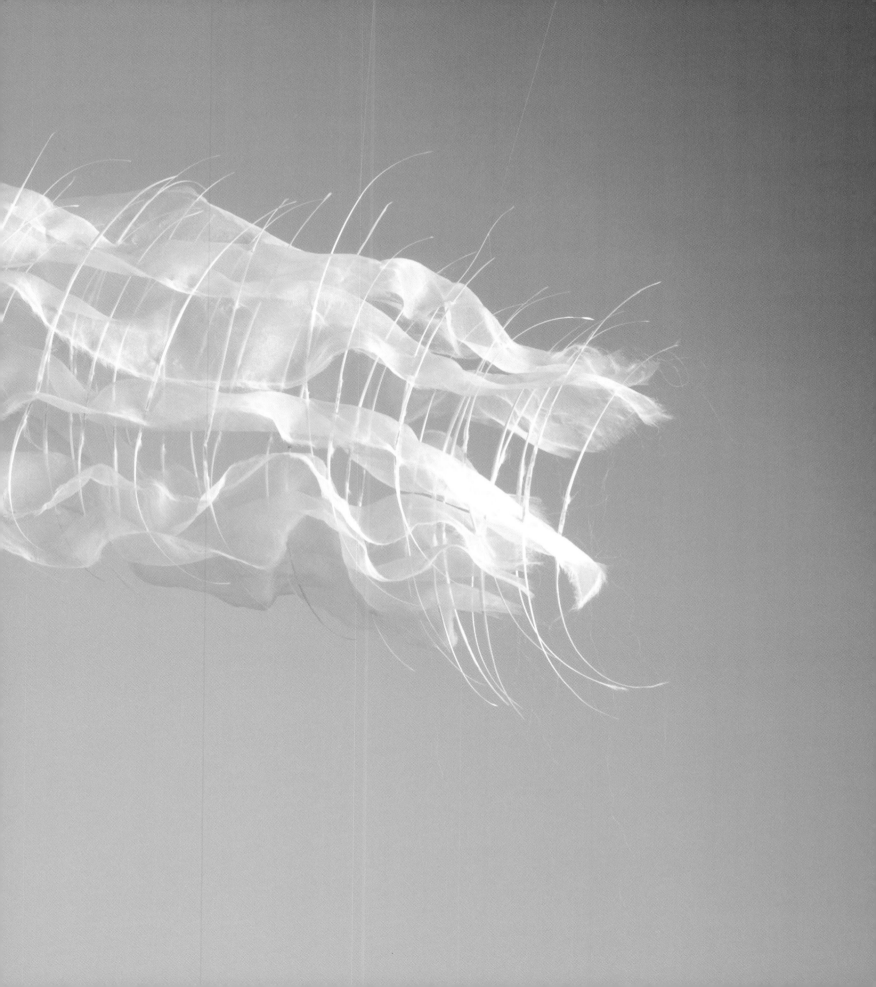

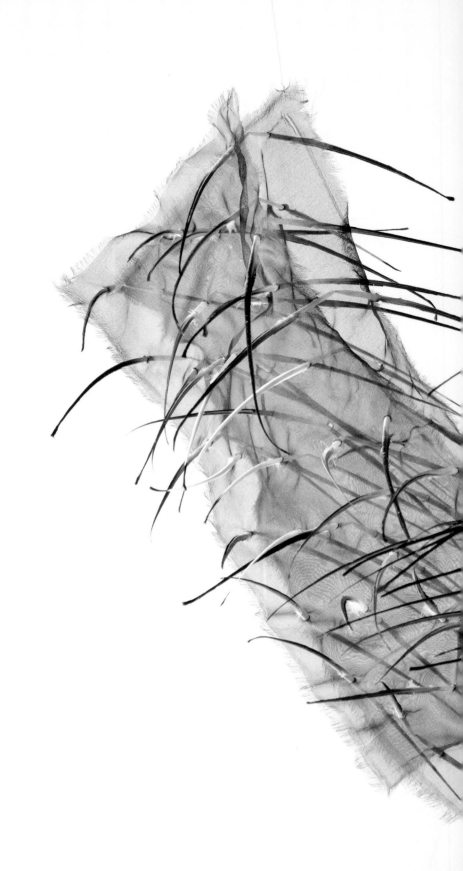

As for me, I will enter the berry tree
where the silkworm will turn me into a thread,
then I will enter the needle of a woman
from the myths,
and fly like a shawl
in the wind.

Mahmoud Darwish

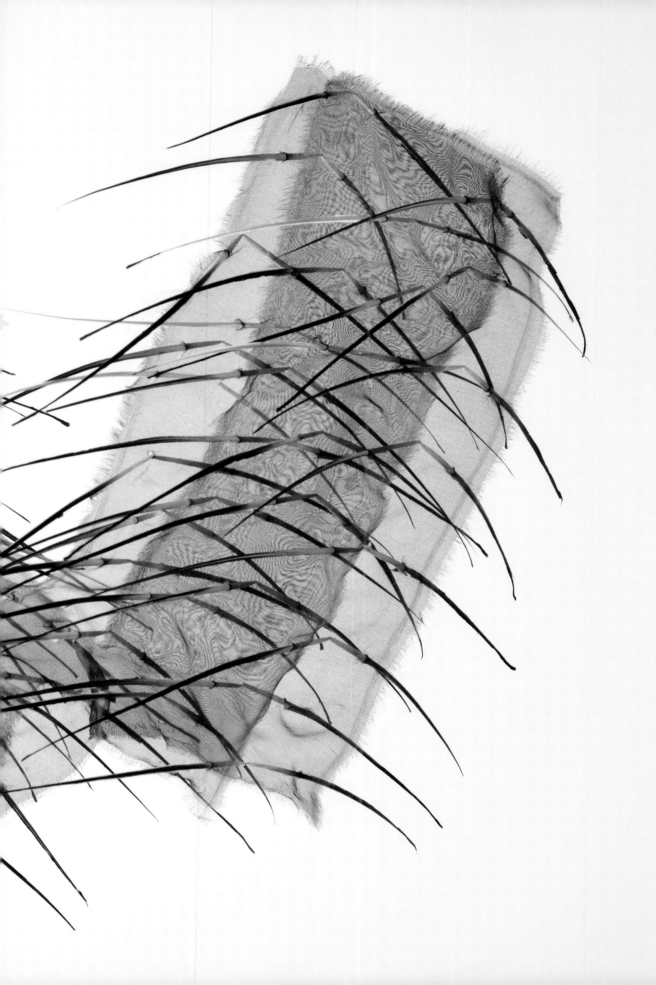

A tree grows inside me –
I brought it as a seedling from the sun.
Its leaves quiver like fish, like flames,
and its fruits sing like birds.

Nâzım Hikmet

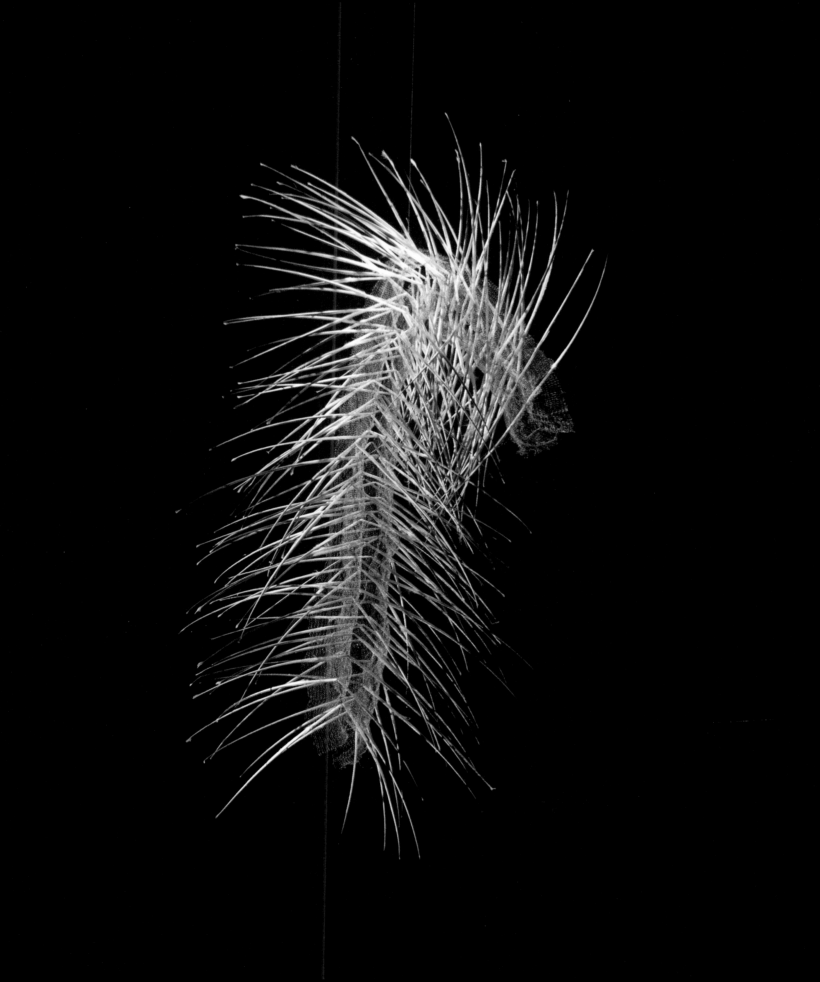

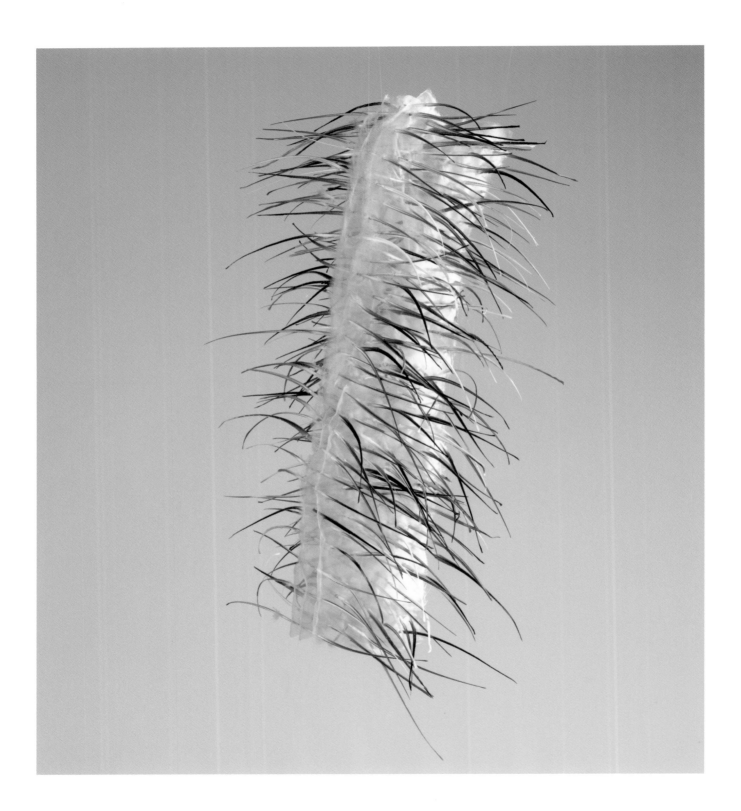

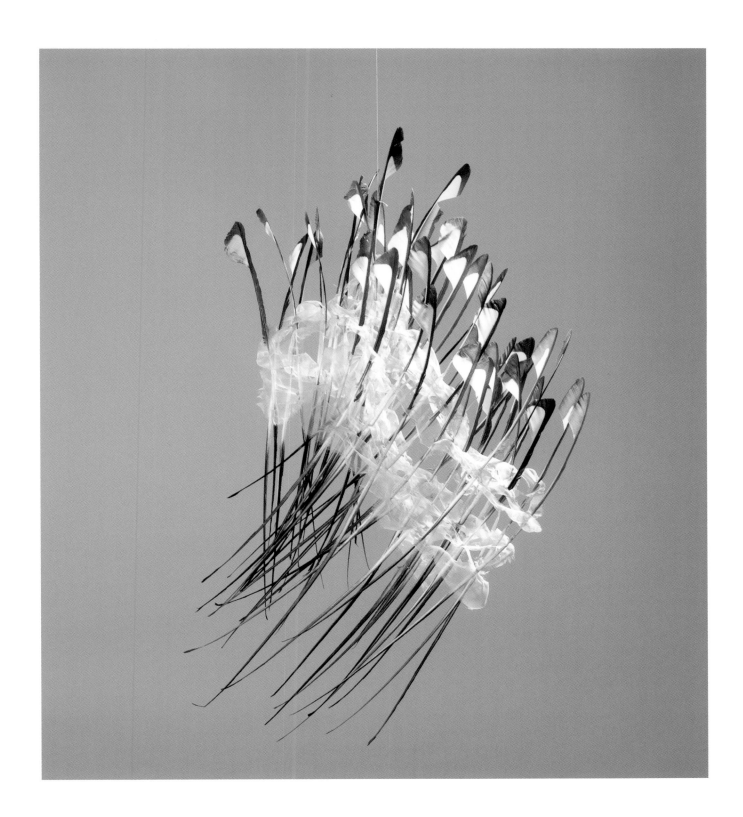

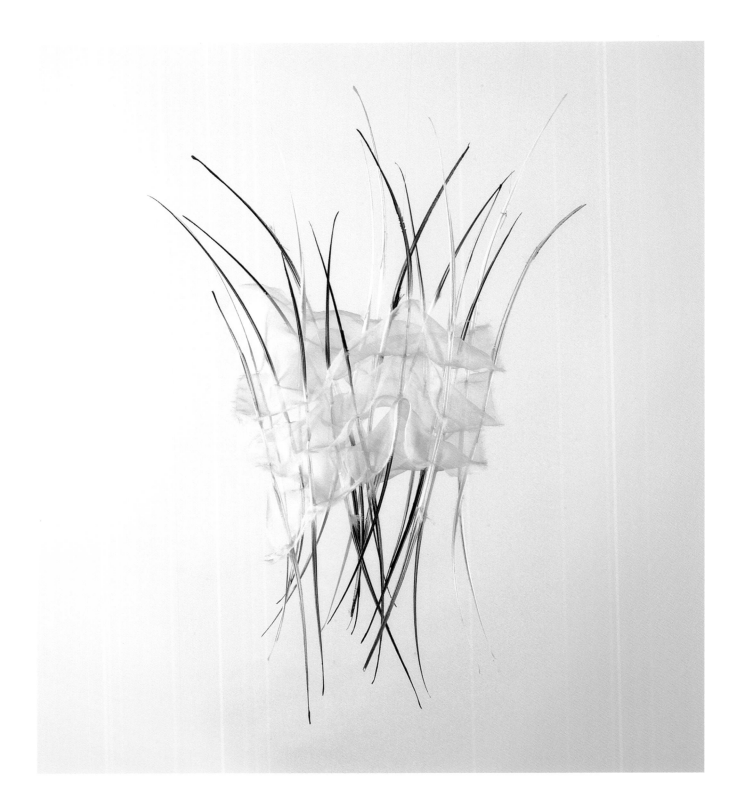

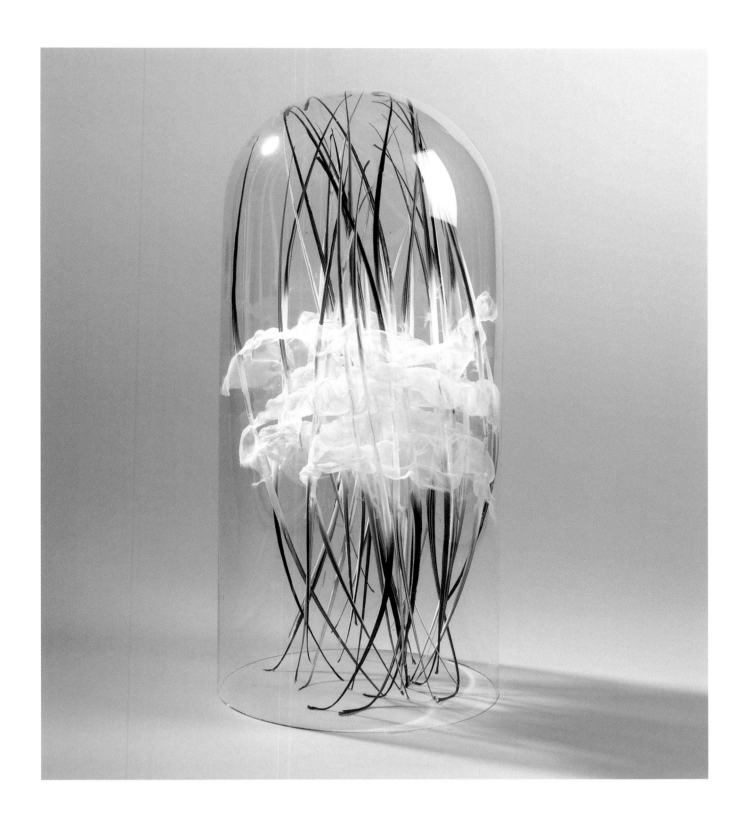

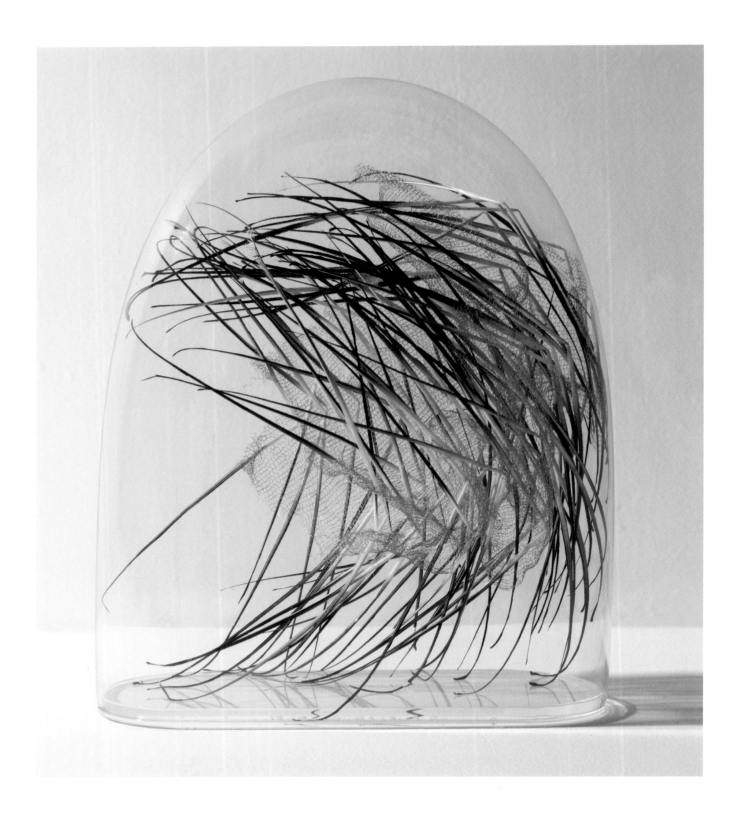

I remember only the emotion of things.

Antonio Machado

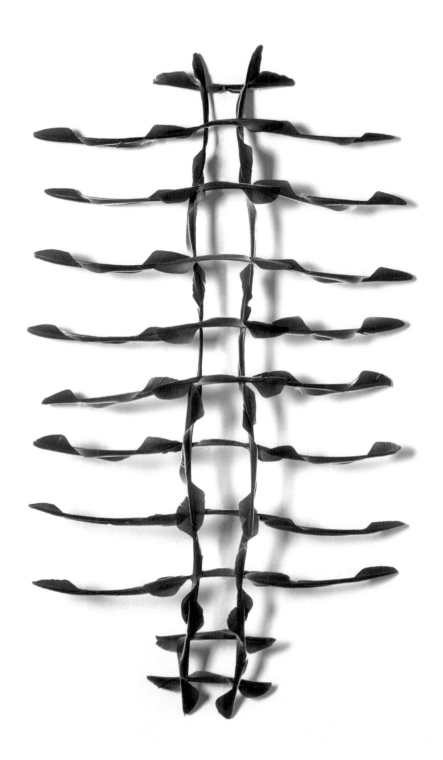

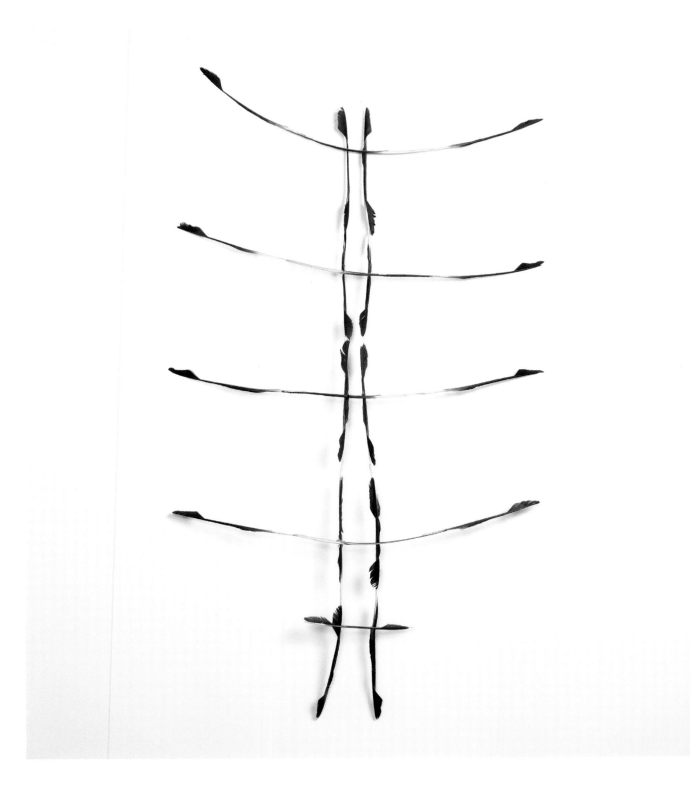

Thus the Superior man himself
Brightens his bright virtue.
Perseverance brings good fortune.

Yi Jing, hexagram 35

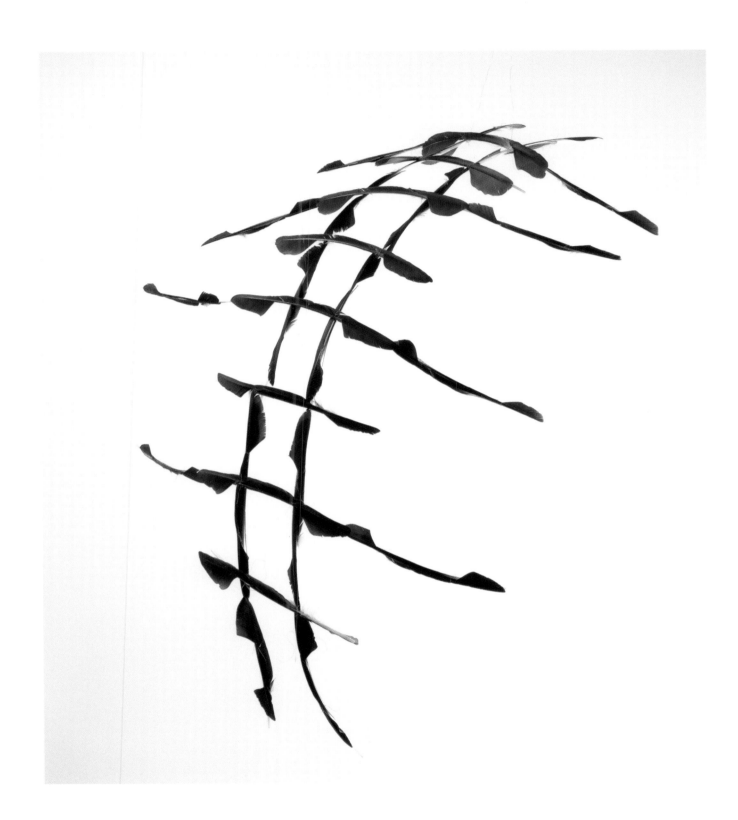

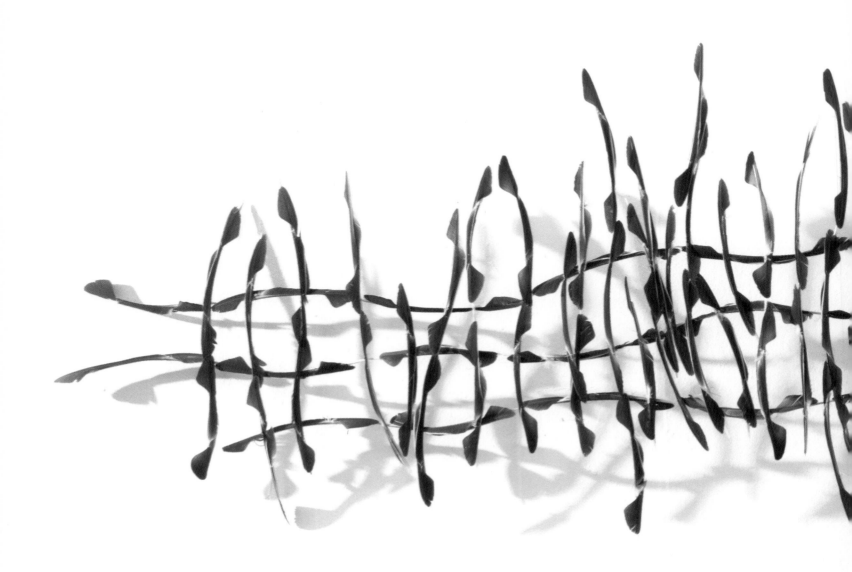

Music makes me feel very kind, it makes me feel like a child, it changes my whole being. I seem to have consoled and improved myself though different kinds of music, and now from this very long piece of music, I am gaining my rebirth.

Shen Congwen

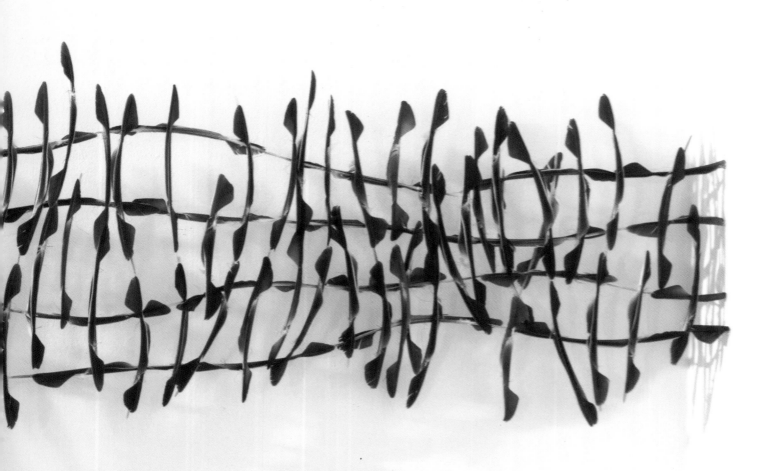

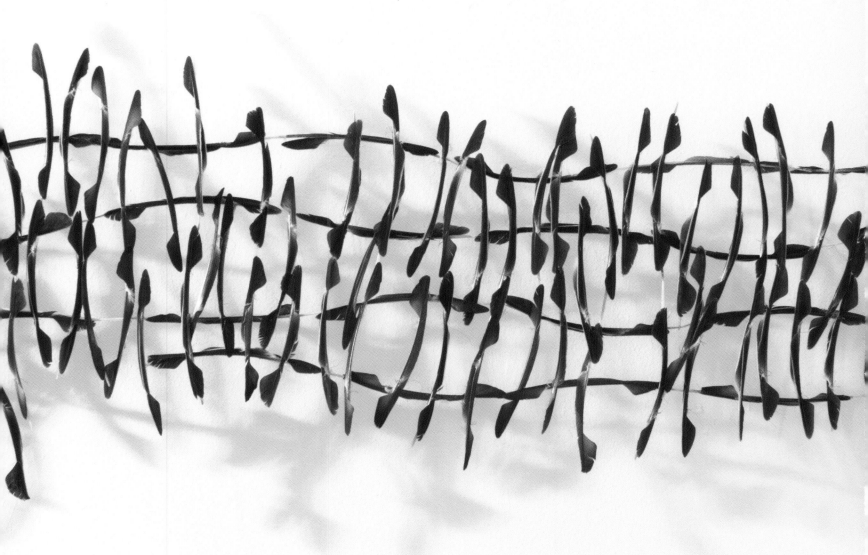

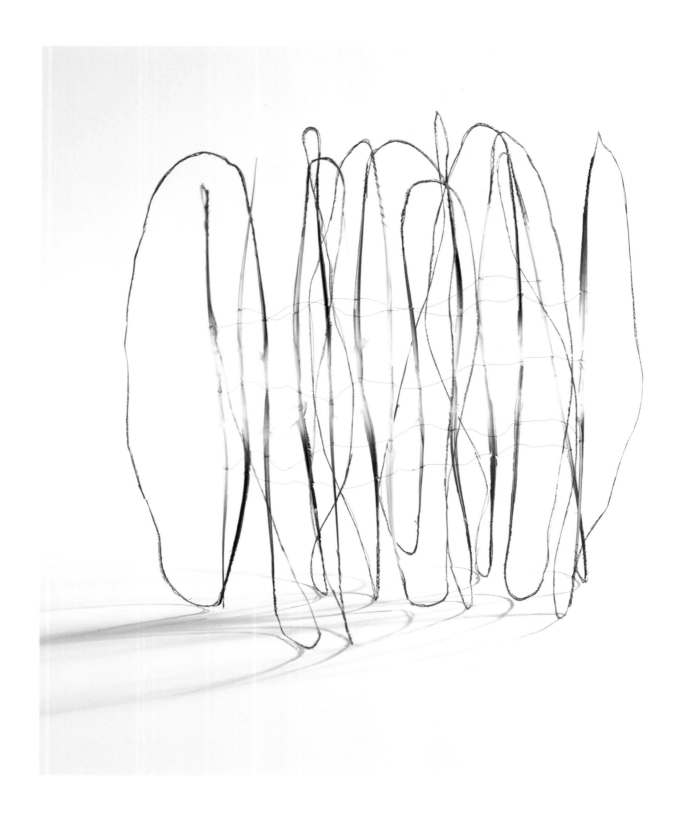

Poetry is what gets lost in translation.

Robert Frost

a poet ...
I am a clot of dreams

I am the fruit
of countless counter grafts
ripened in a greenhouse.

Giuseppe Ungaretti

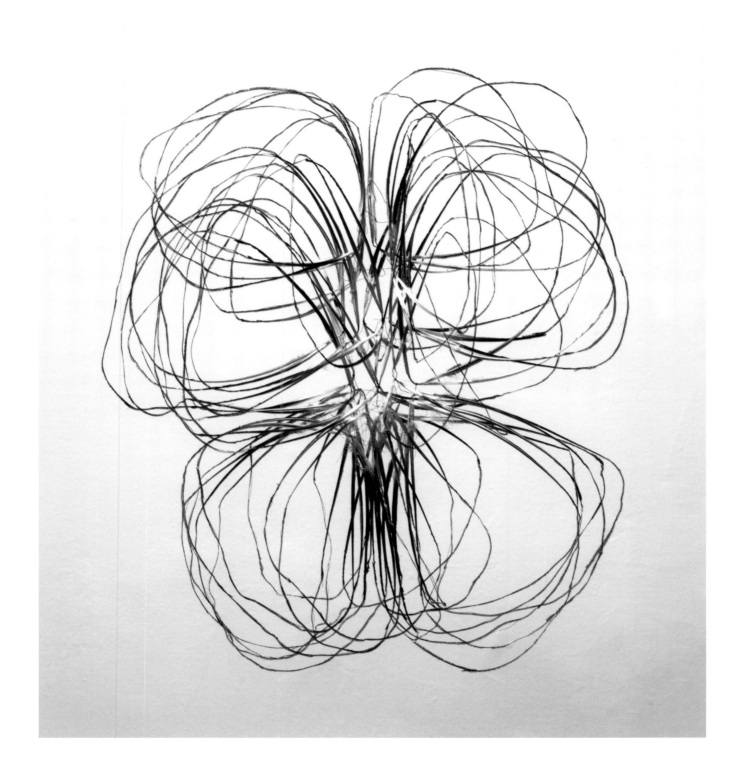

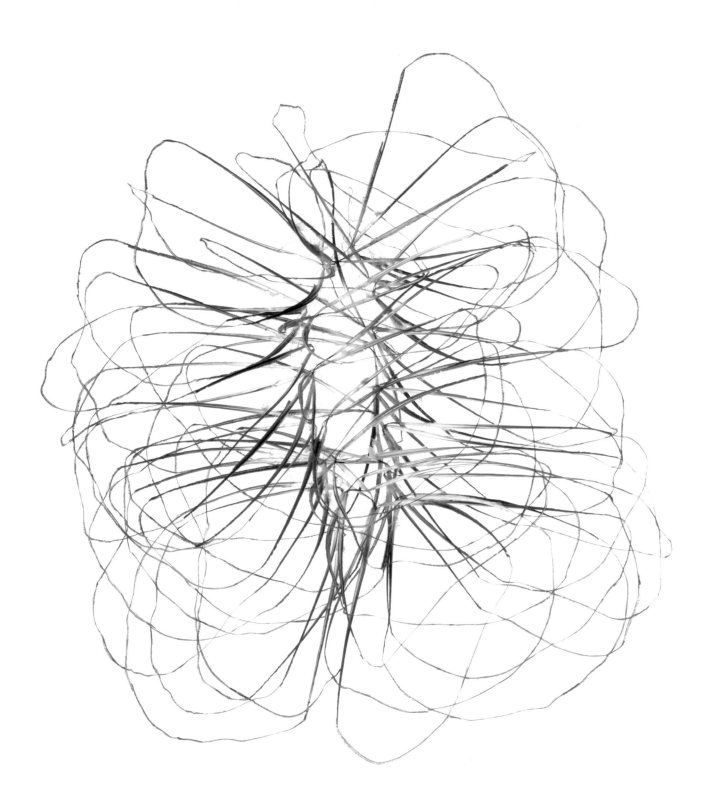

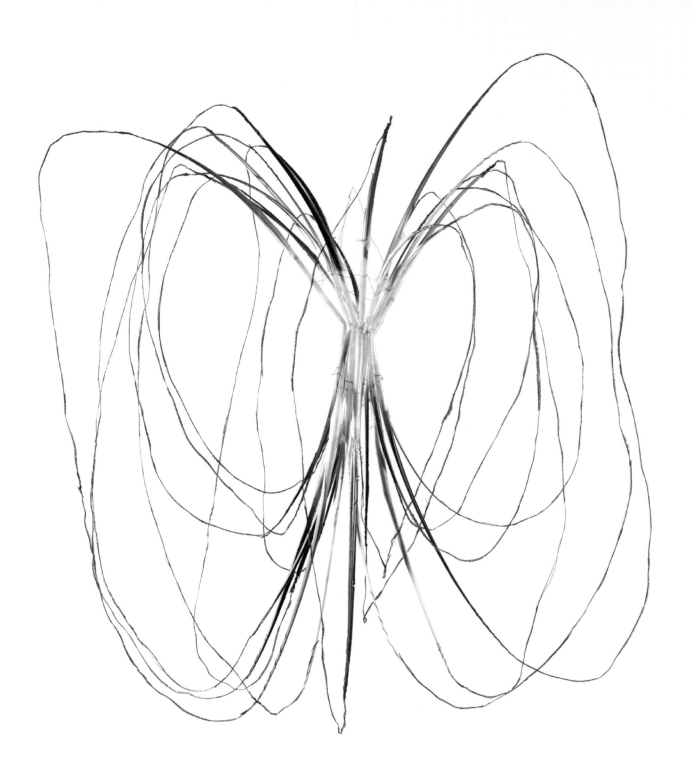

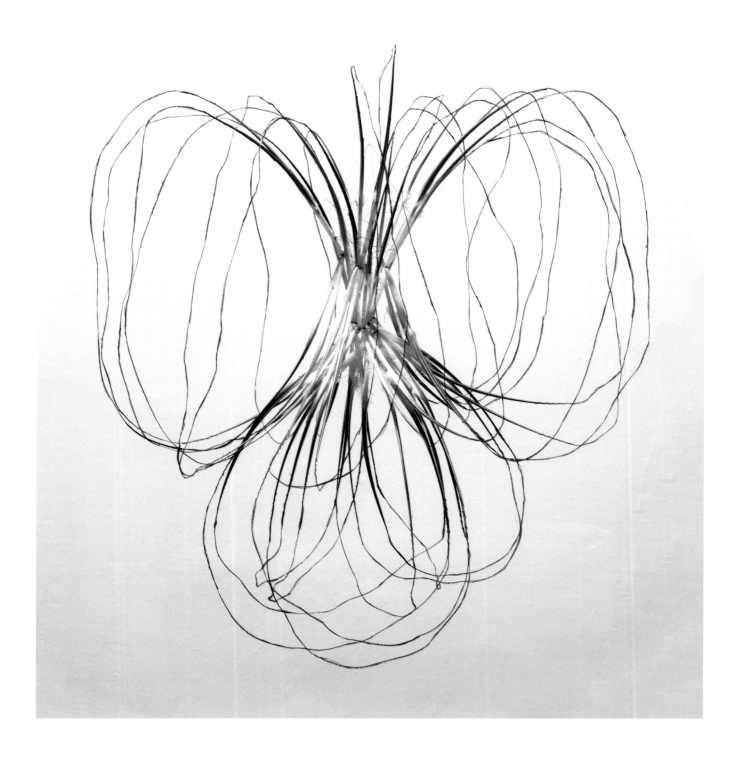

I shut my eyes and all the world drops dead;
I lift my eyes and all is born again.

Sylvia Plath

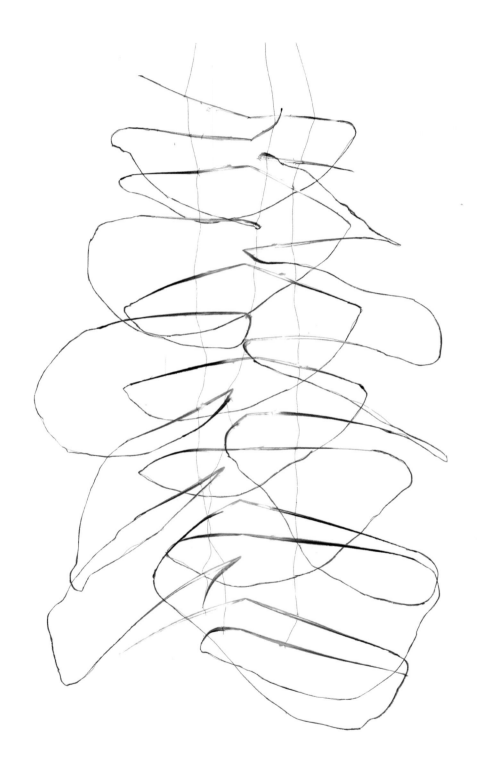

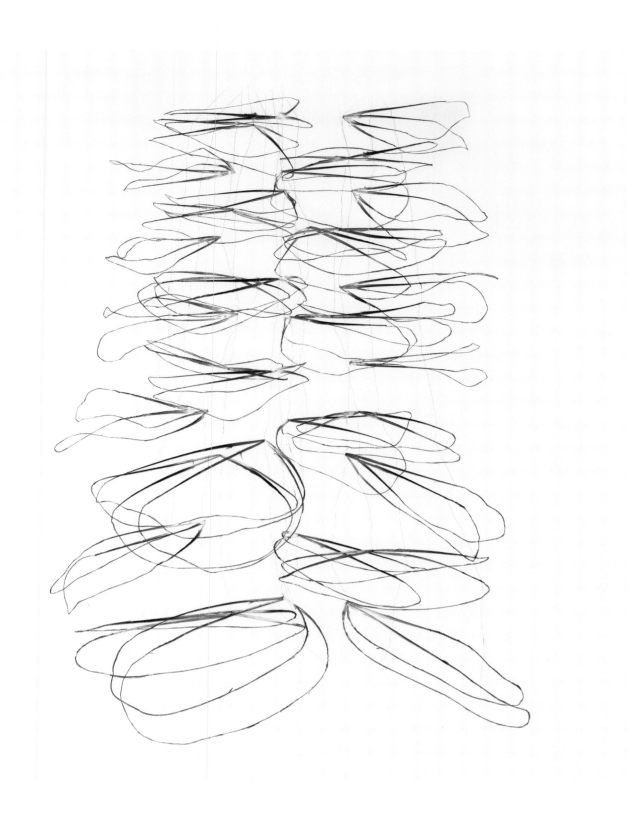

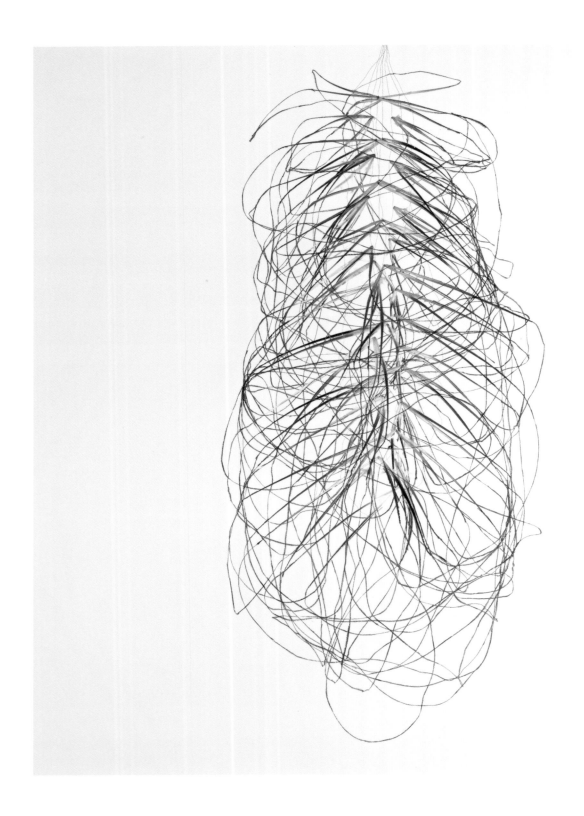

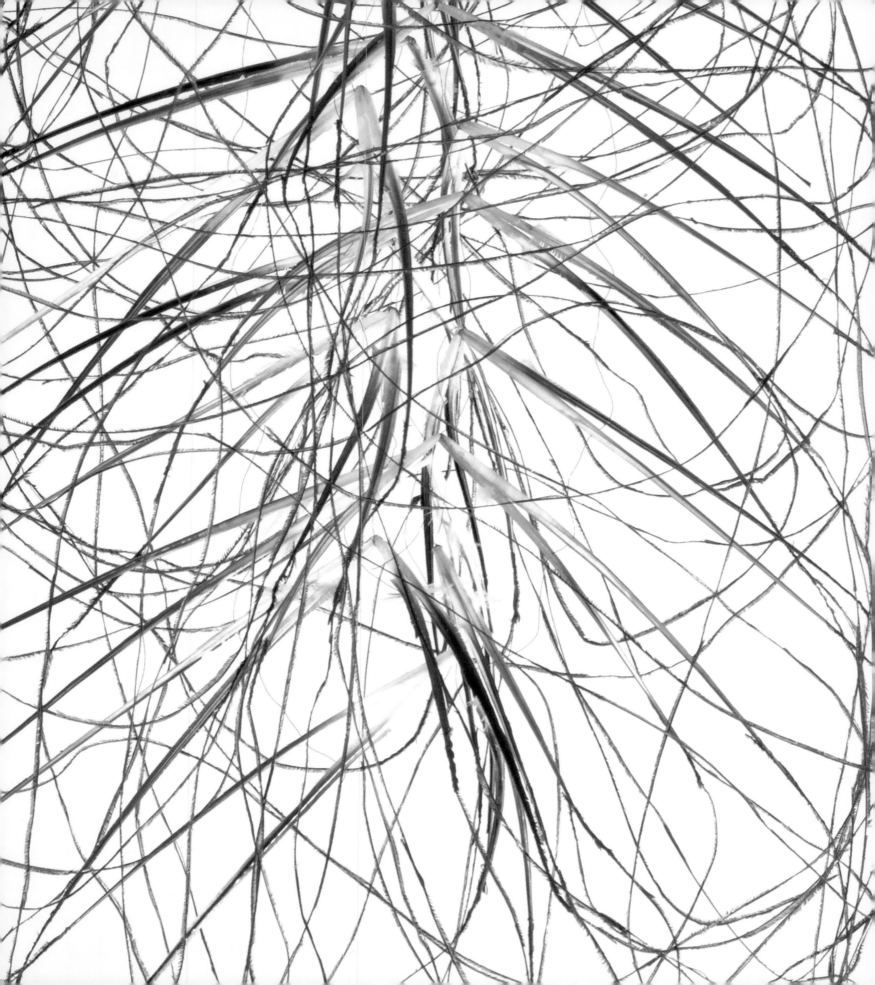

Poetry is a way of taking life by the throat.

Robert Frost

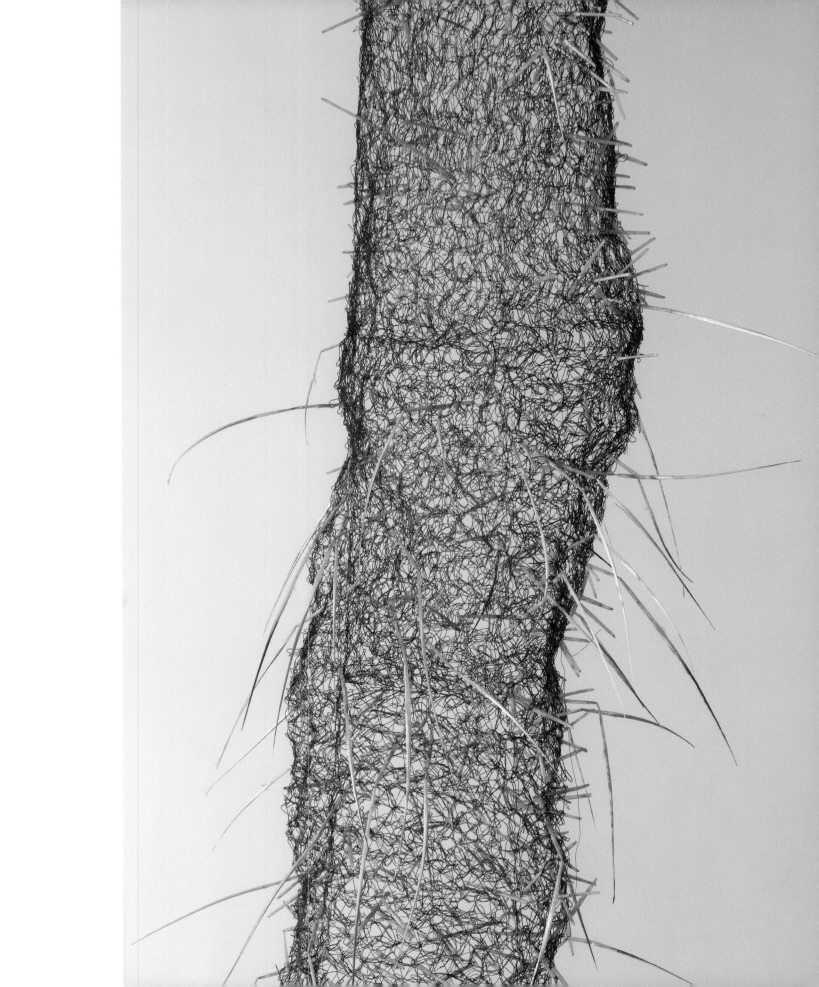

Yet we would suffer continuous estrangement from ourselves
if it weren't for our memory of the things we have done, of the
things that have happened to us. If it weren't for the memory
of ourselves.

Christa Wolf

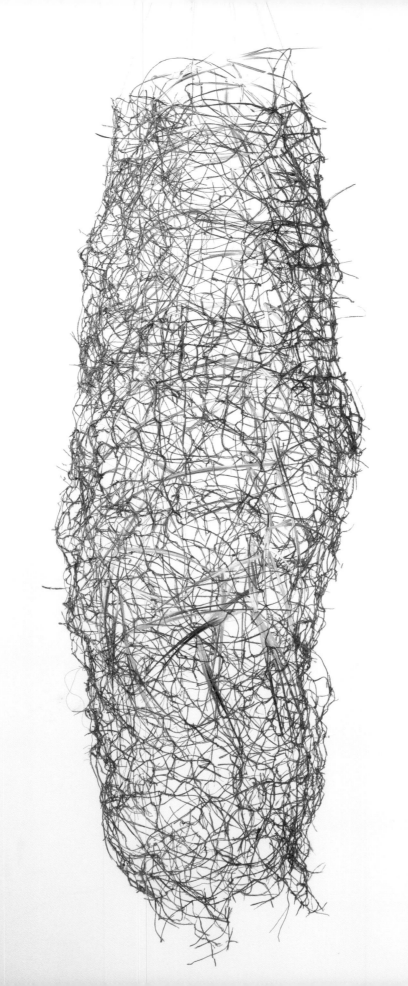

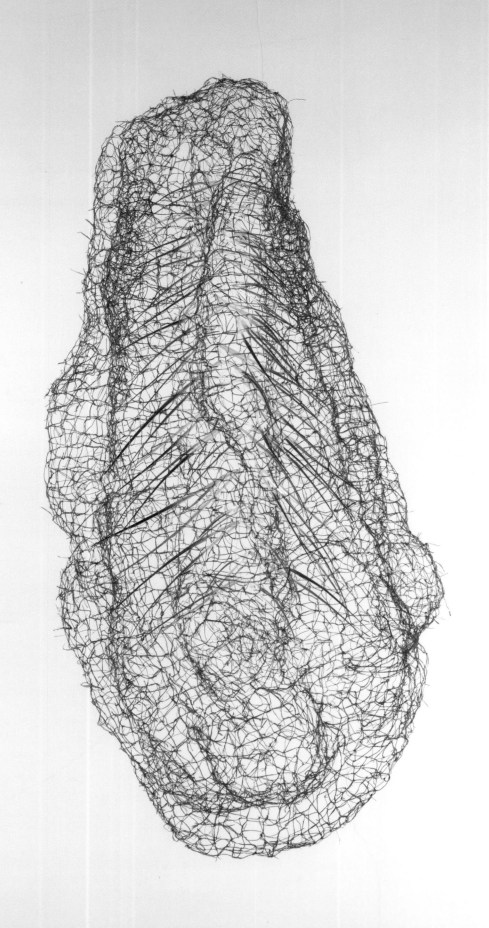

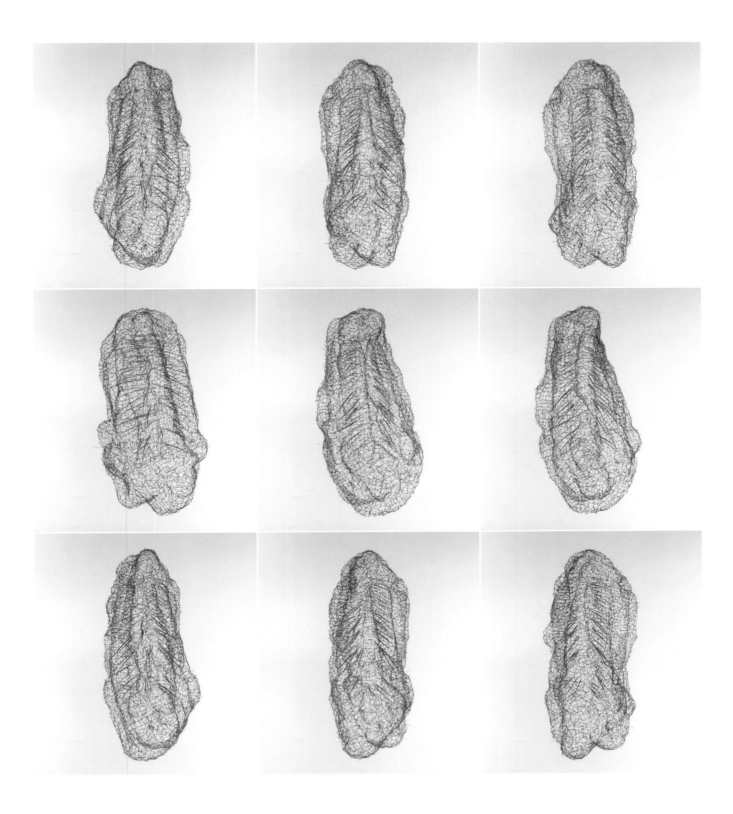

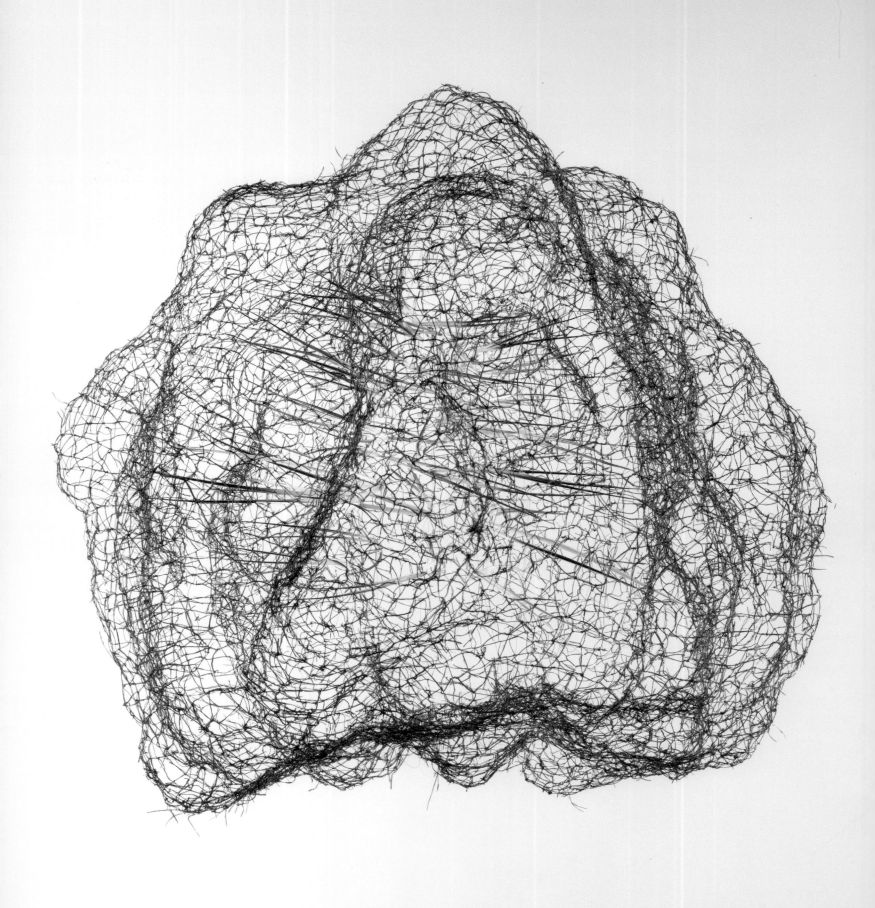

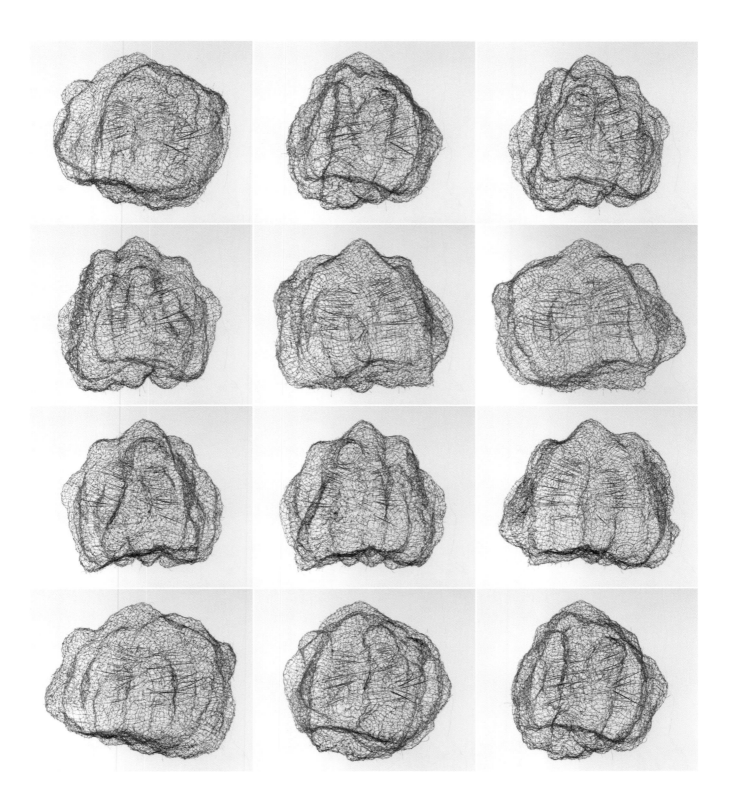

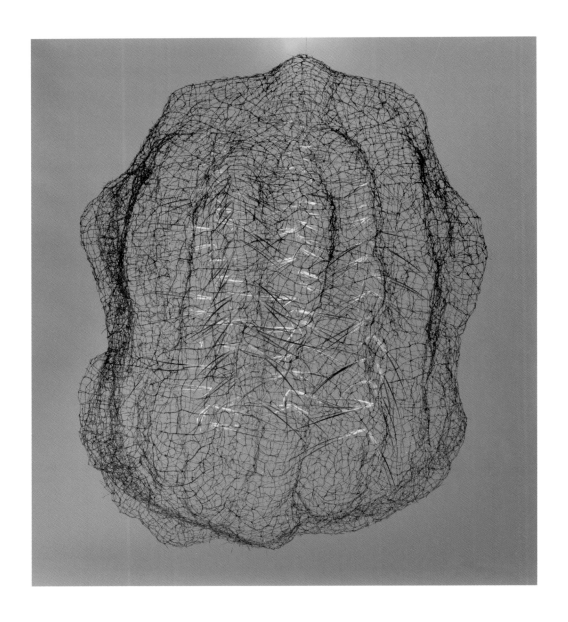

For a few months you will have nothing else to do except to go forward, where you wish, as you wish, fast or slow; nothing, no one rushes you. I have known this life, and I will forever mourn its loss.

Joseph-Arthur de Gobineau

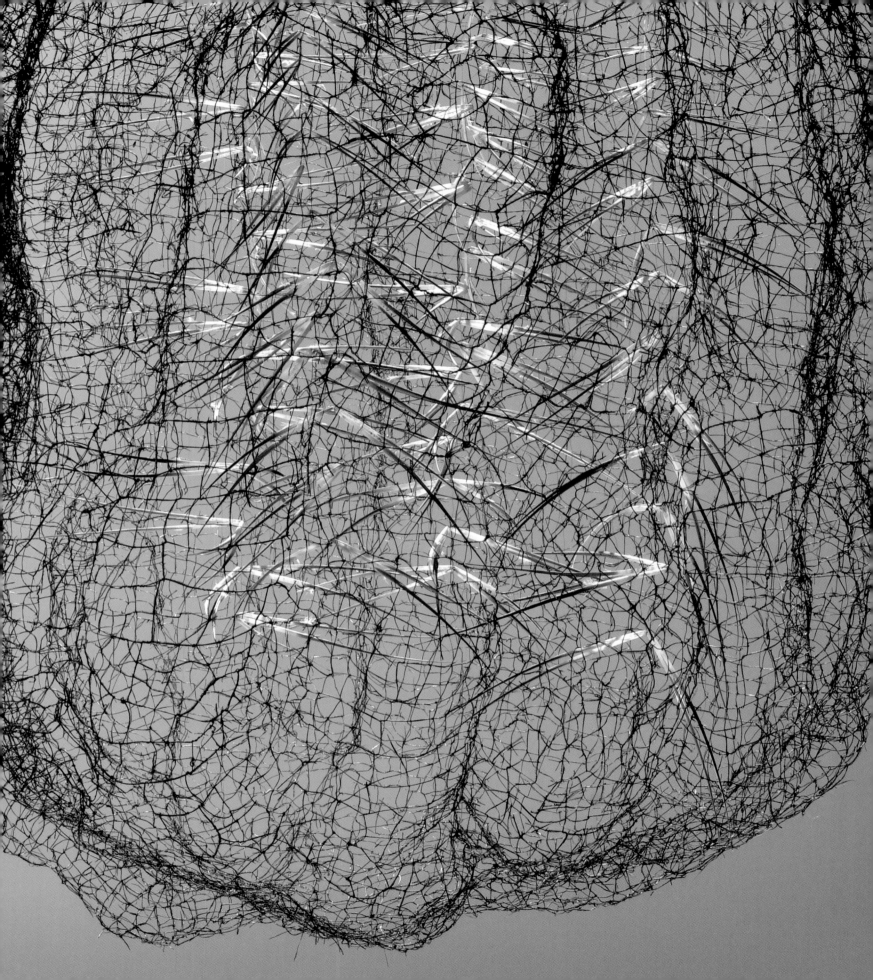

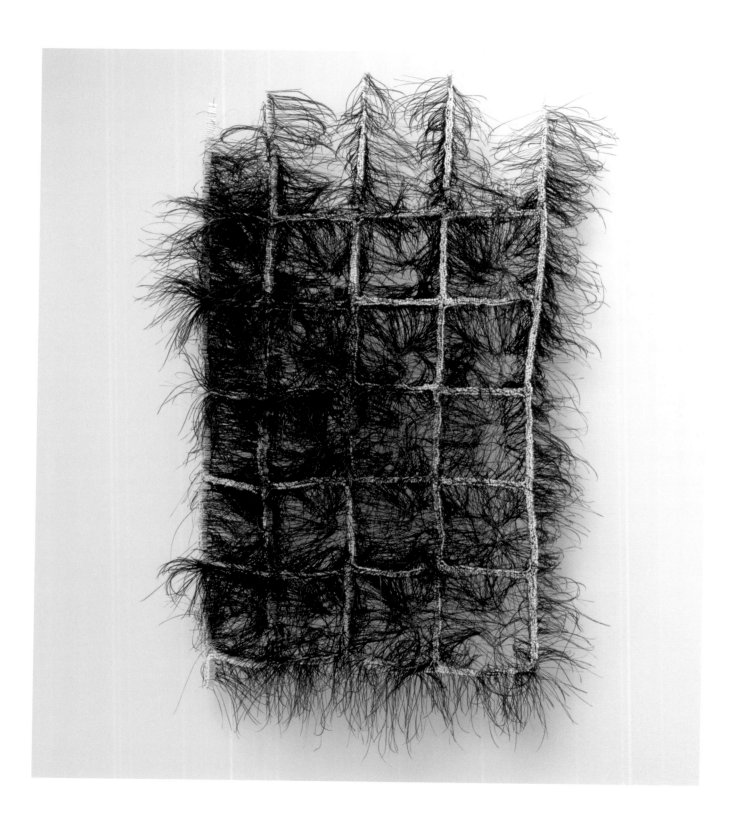

A language must be found.

This language will be of the soul for the soul, containing everything, smells, sounds, colors, thought holding on to thought and pulling.

Arthur Rimbaud

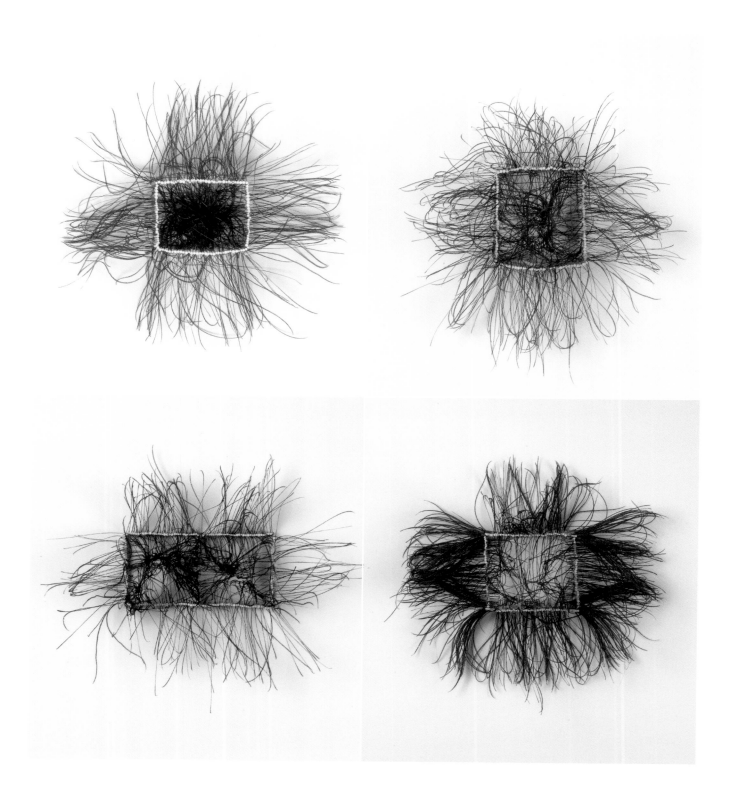

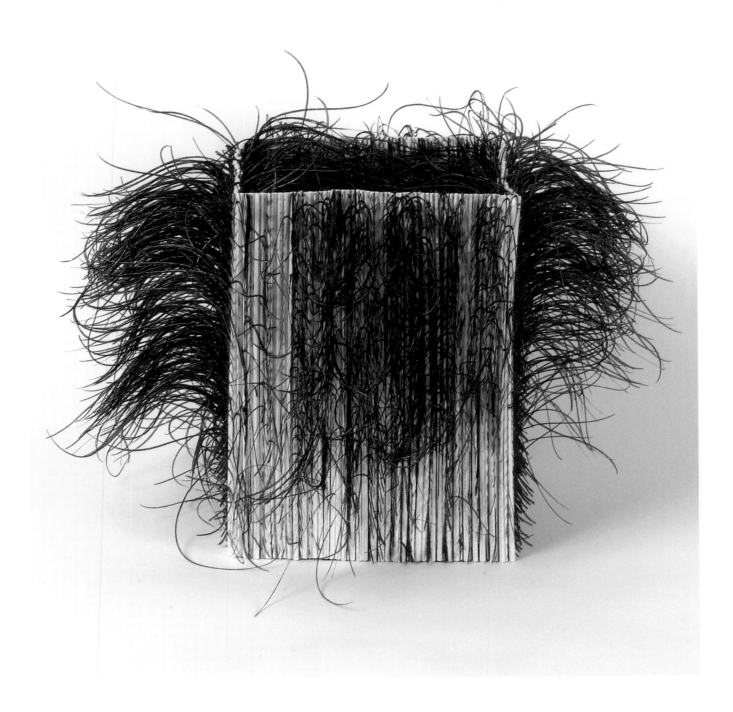

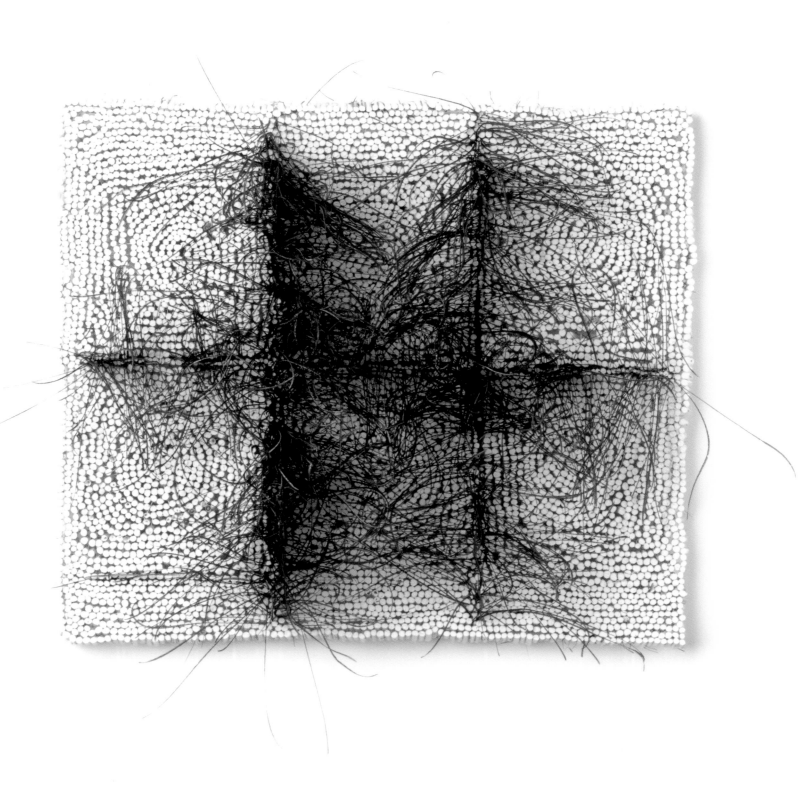

Inspiration is pervasive but not a power.
It's a peaceful thing. It is a consolation even to
plants and animals … It is an untroubled mind.

Agnes Martin

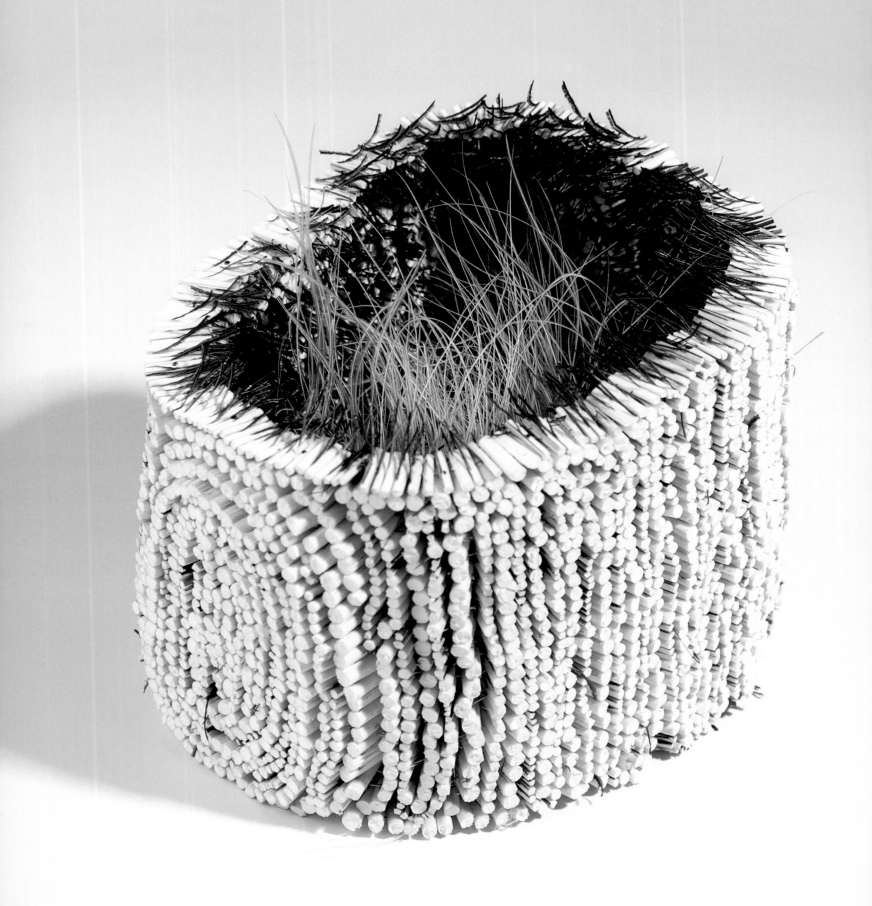

A most mediocre person can be the object of a love which is wild, extravagant, and beautiful as the poison lilies of the swamp.

Carson McCullers

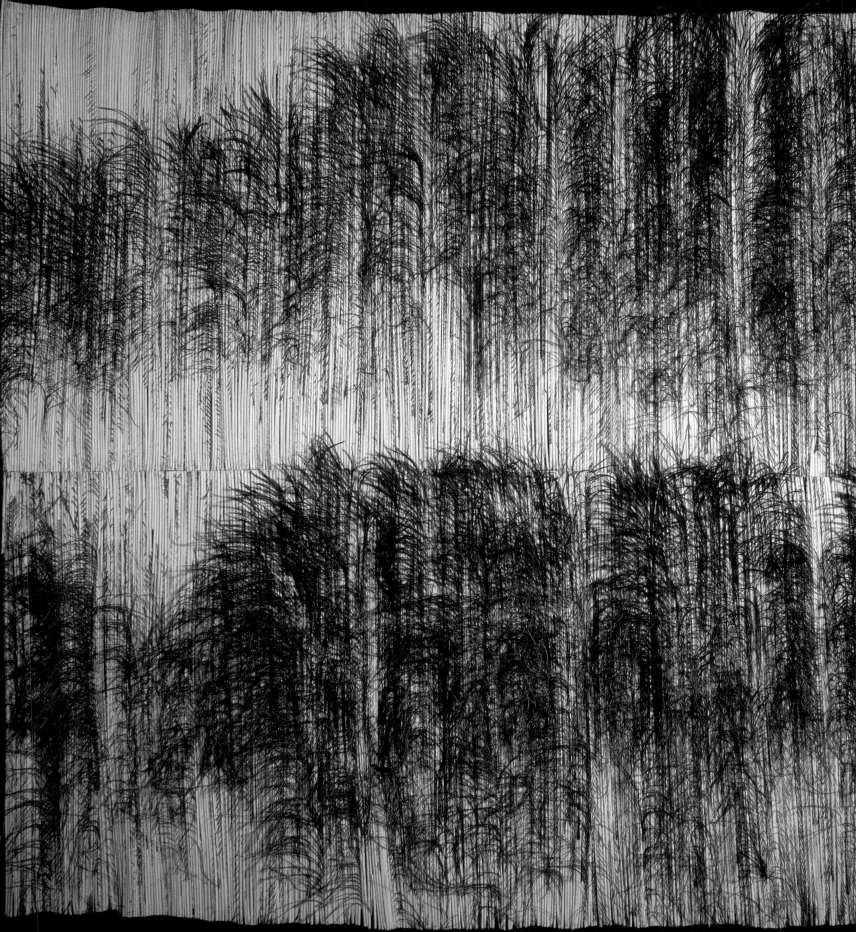

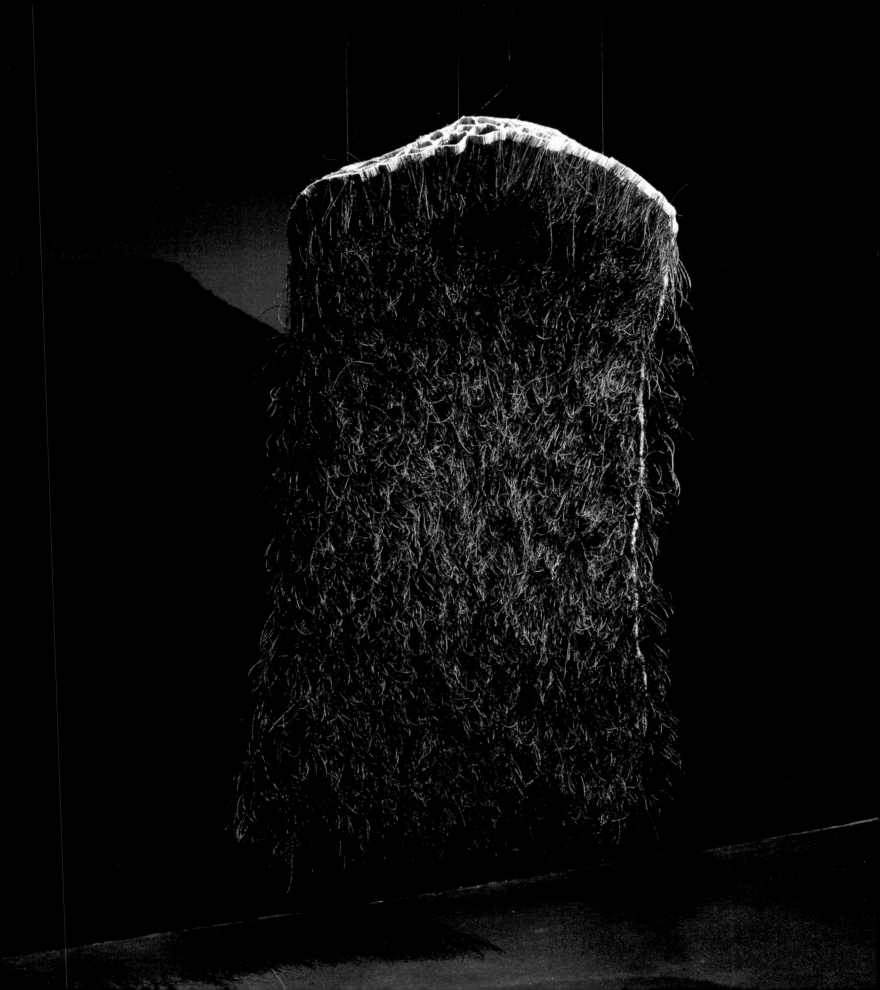

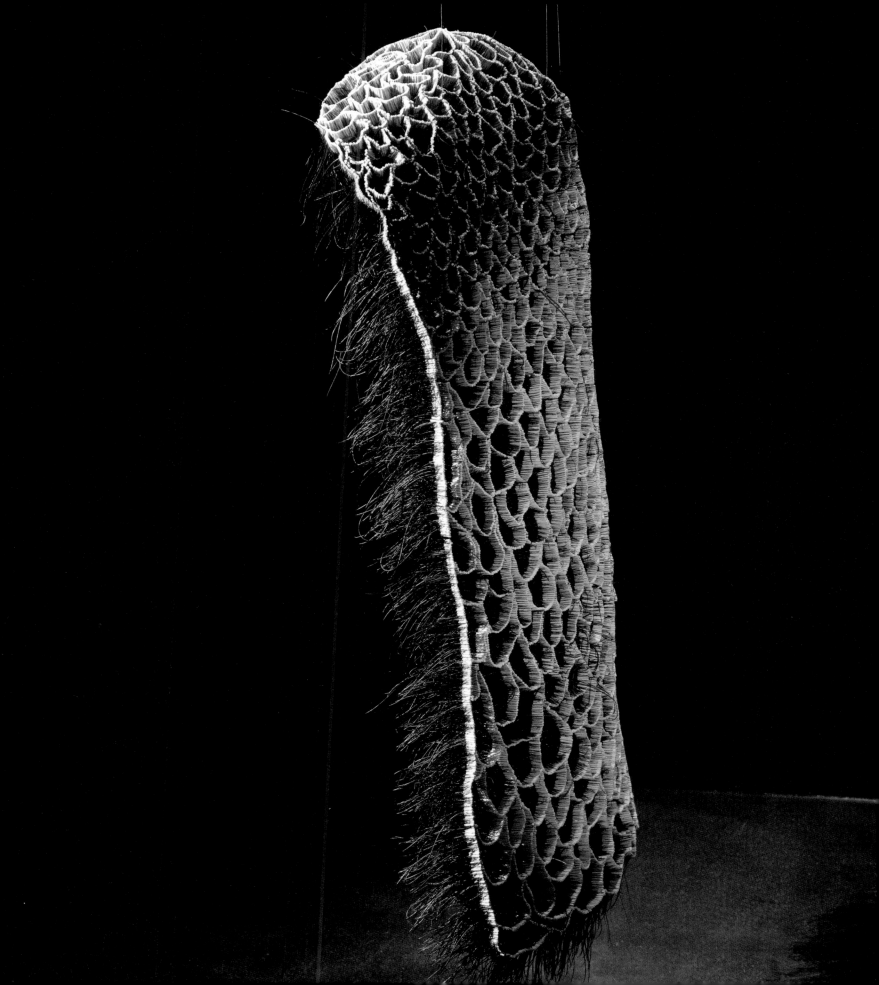

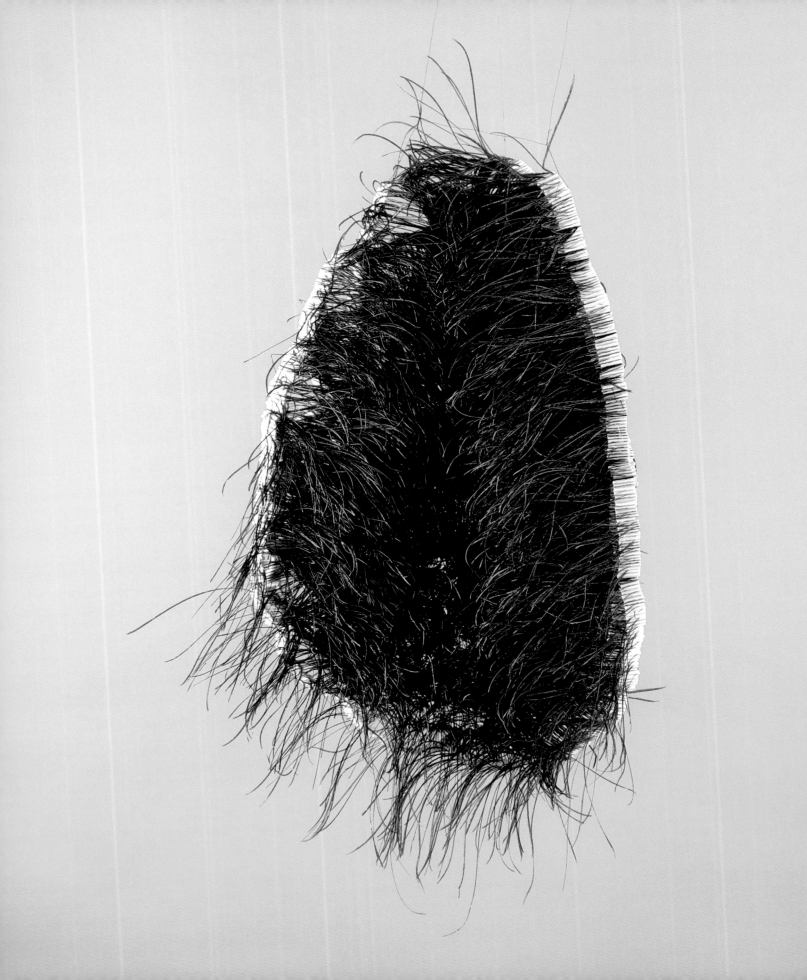

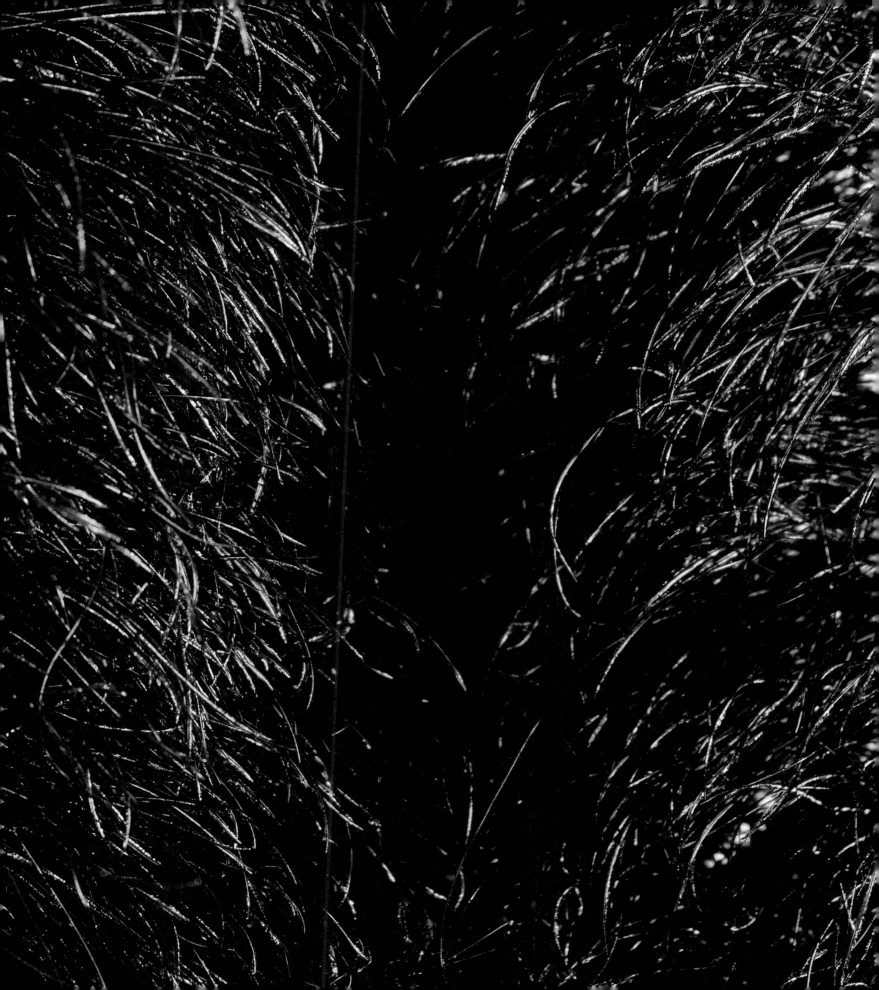

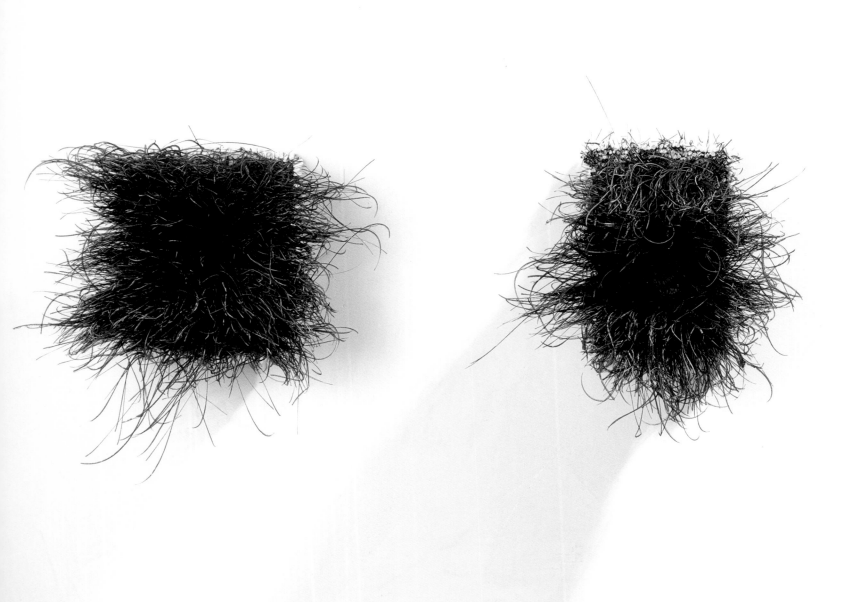

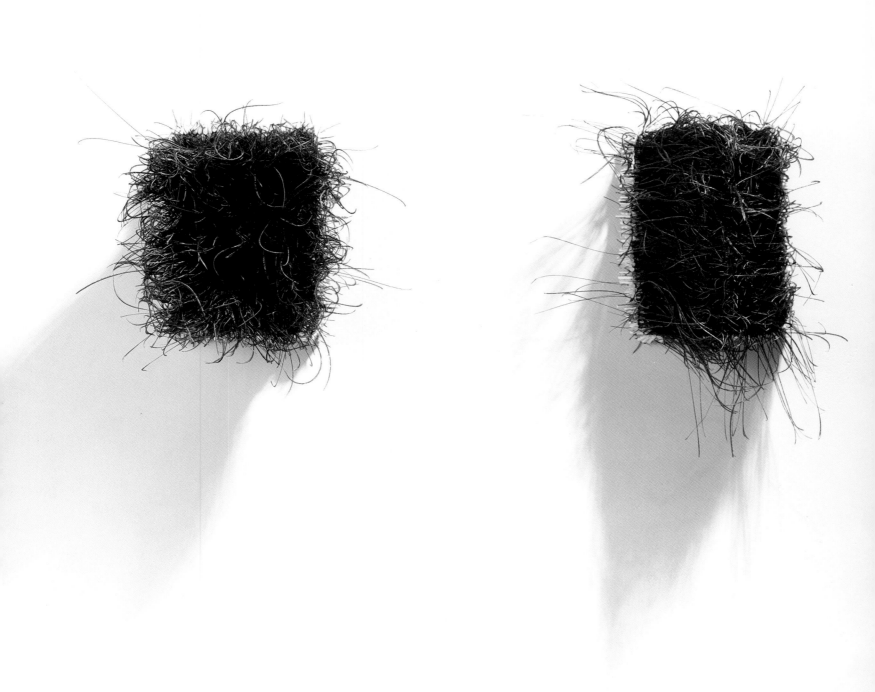

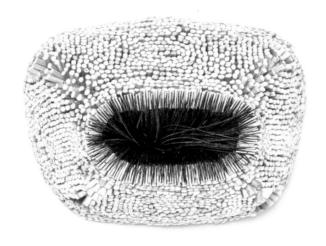
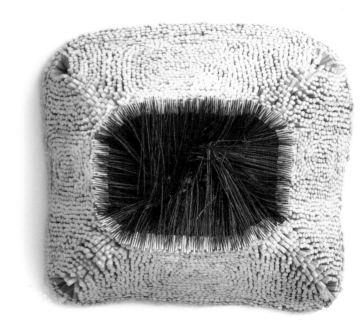
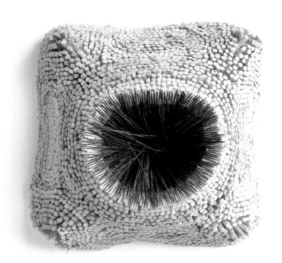
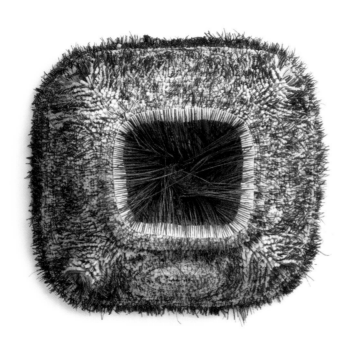
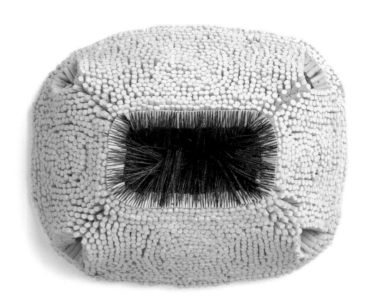

I write only because
There is a voice within me
That will not be still.

Sylvia Plath

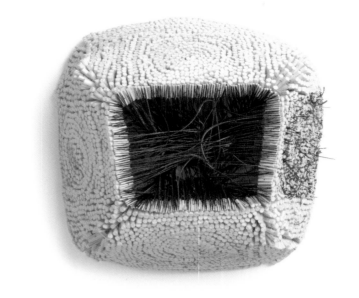

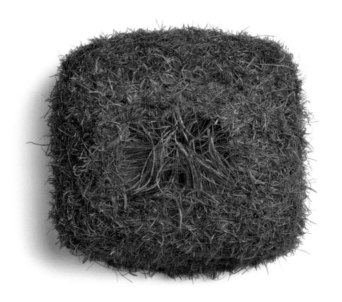

I took a deep breath and listened to the old
brag of my heart. I am. I am. I am.

Sylvia Plath

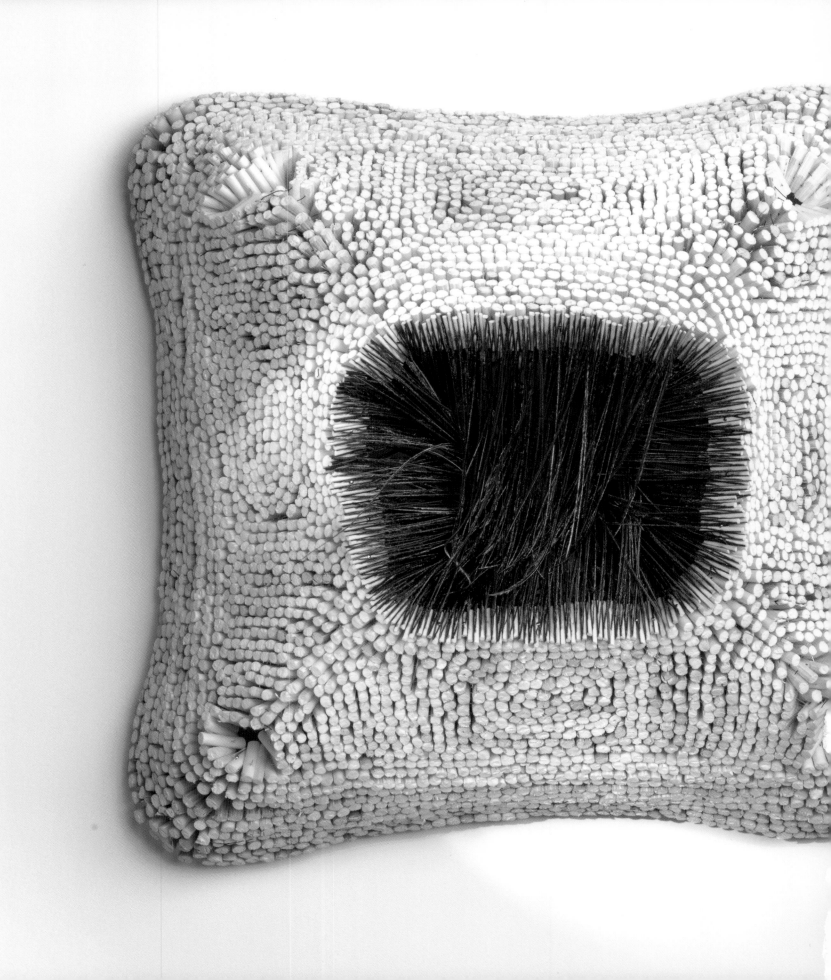

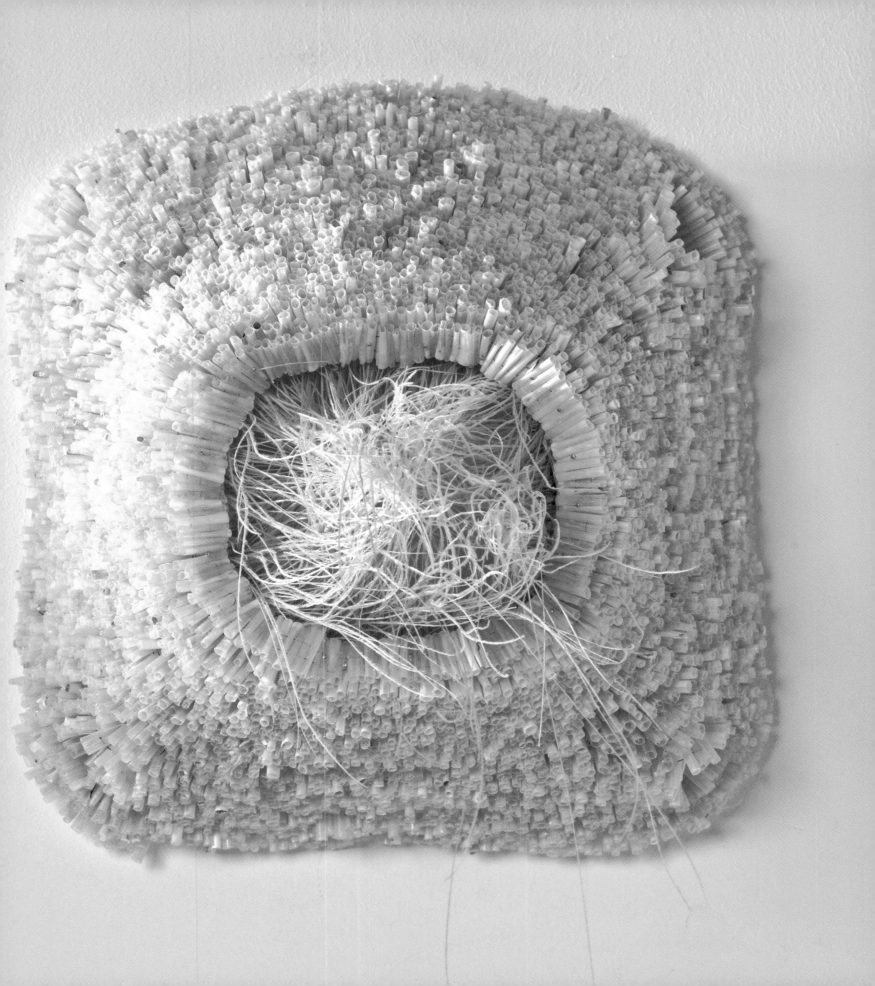

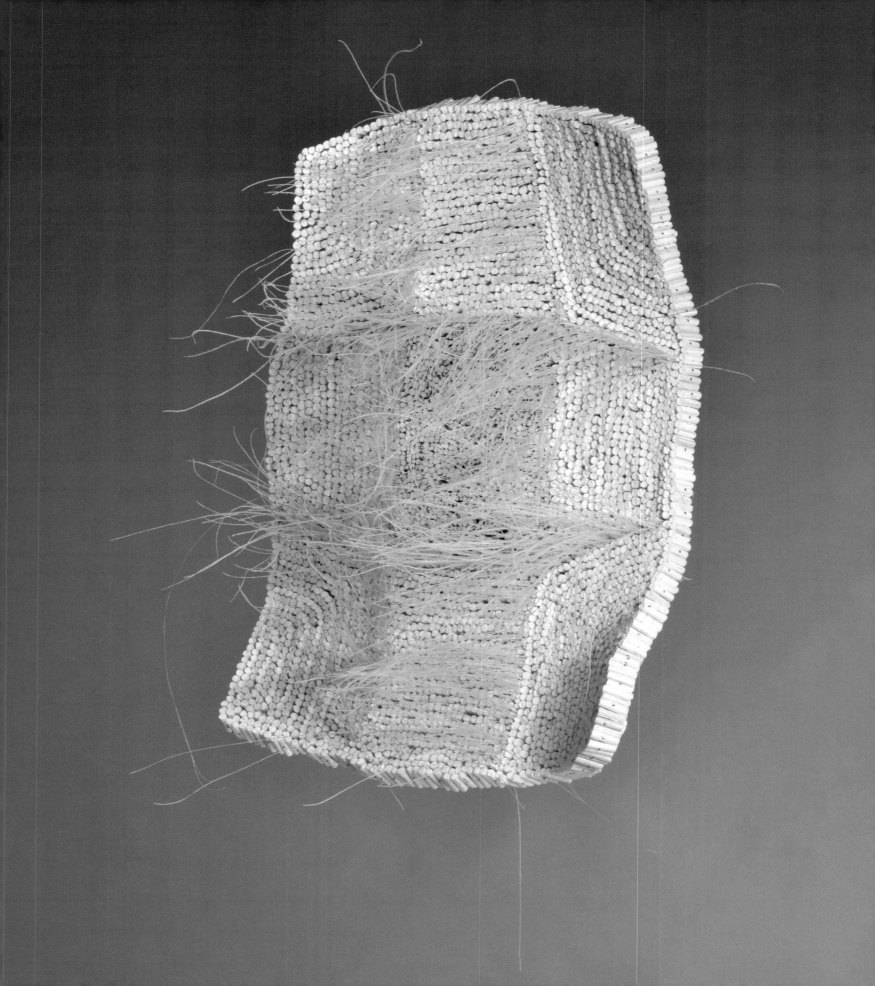

I'd rather live like a person following the flight of a bird.

Laurens van der Post

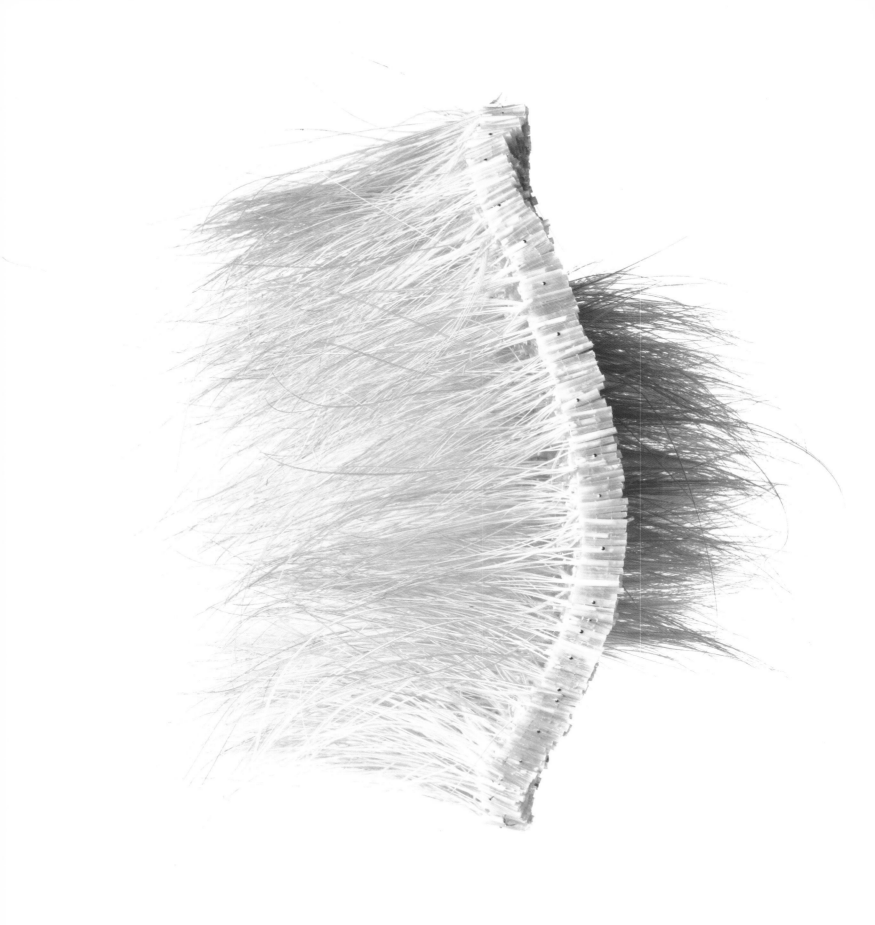

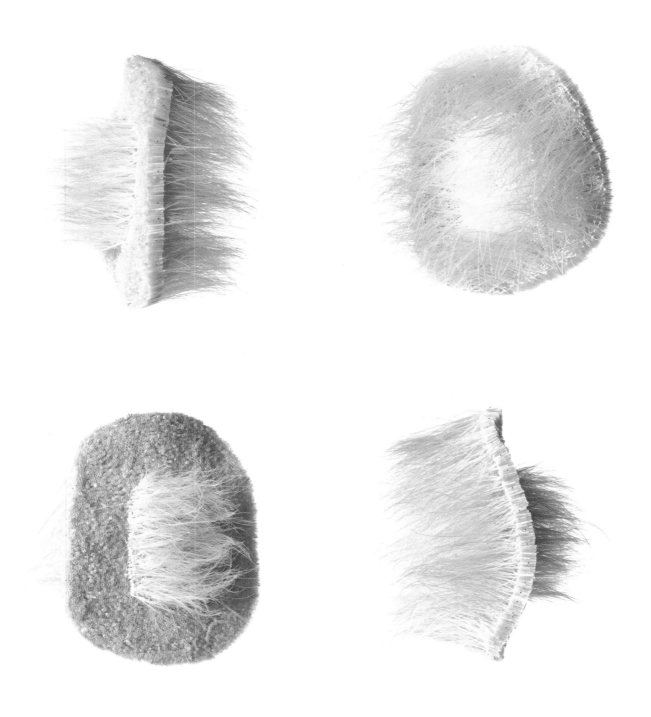

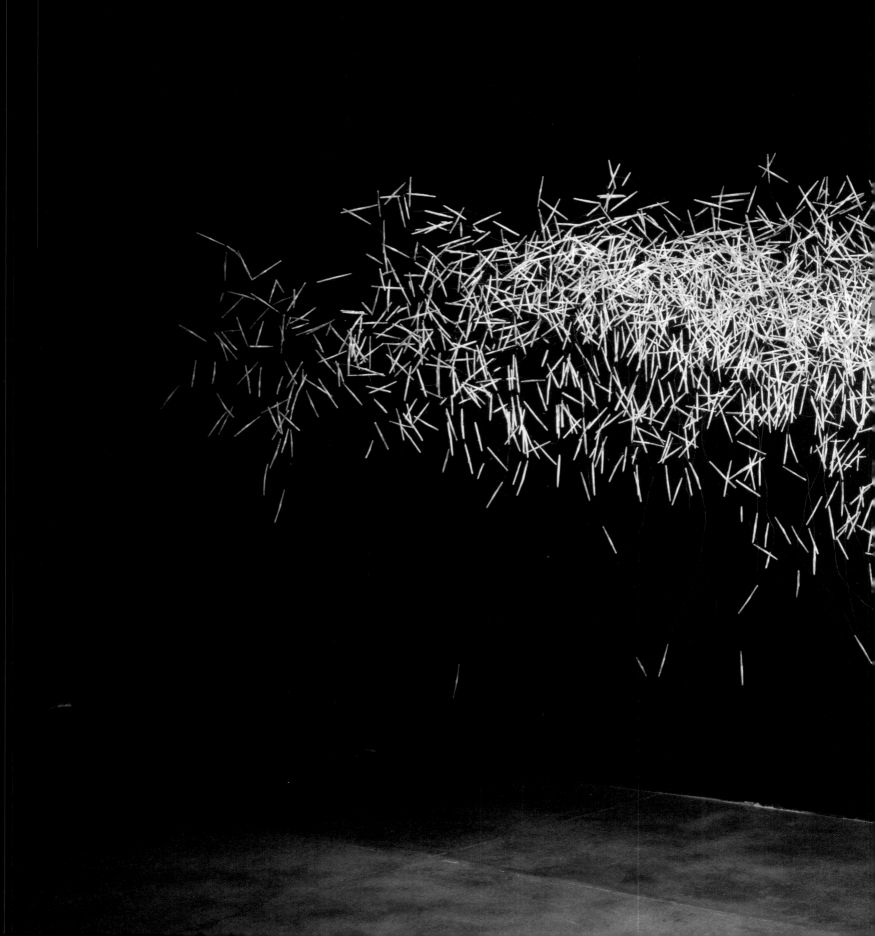

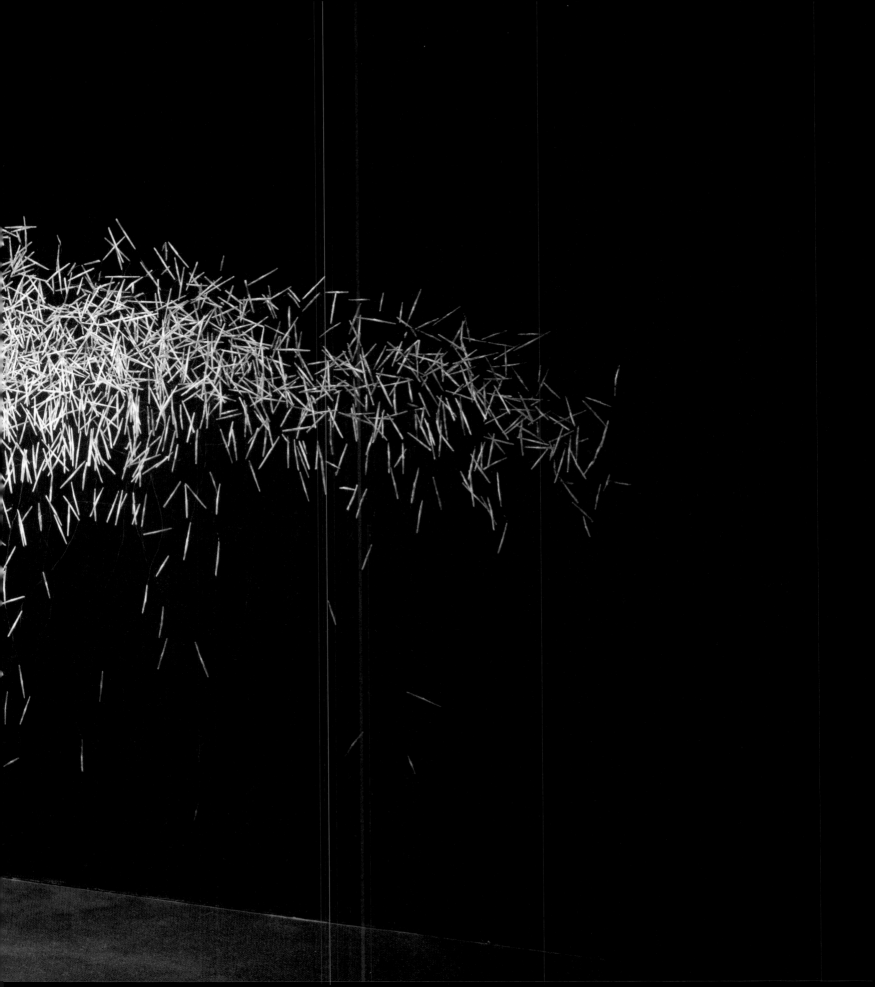

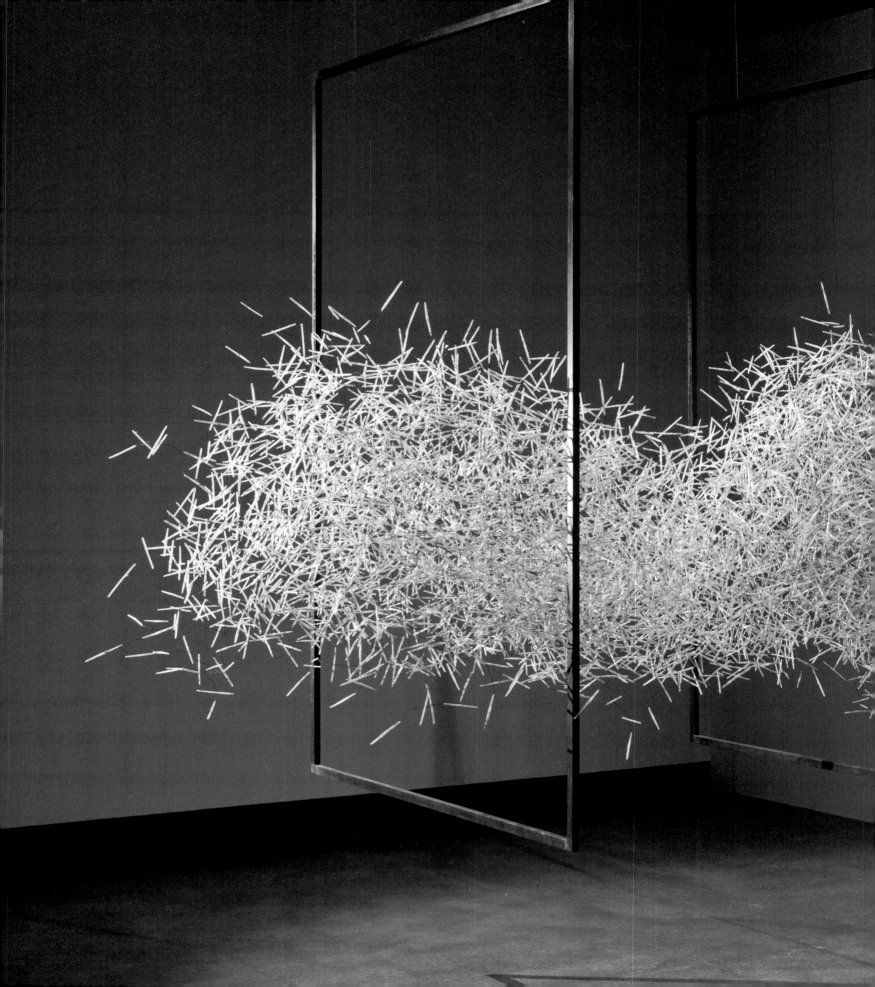

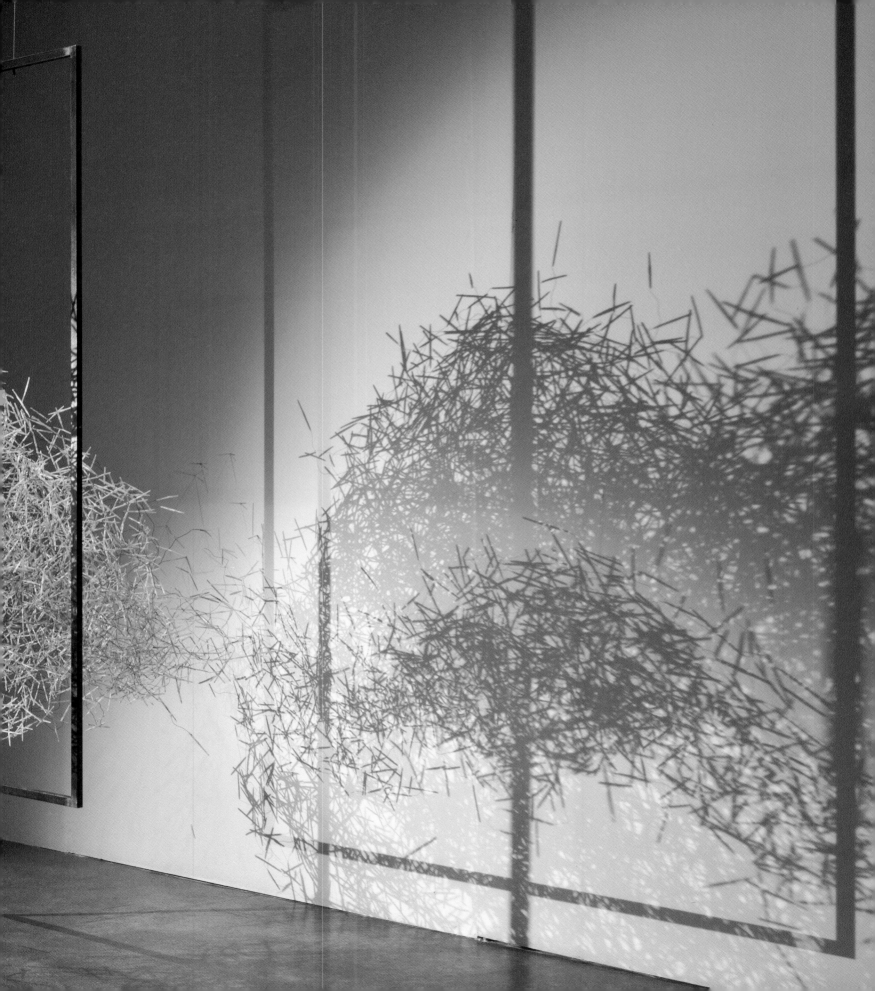

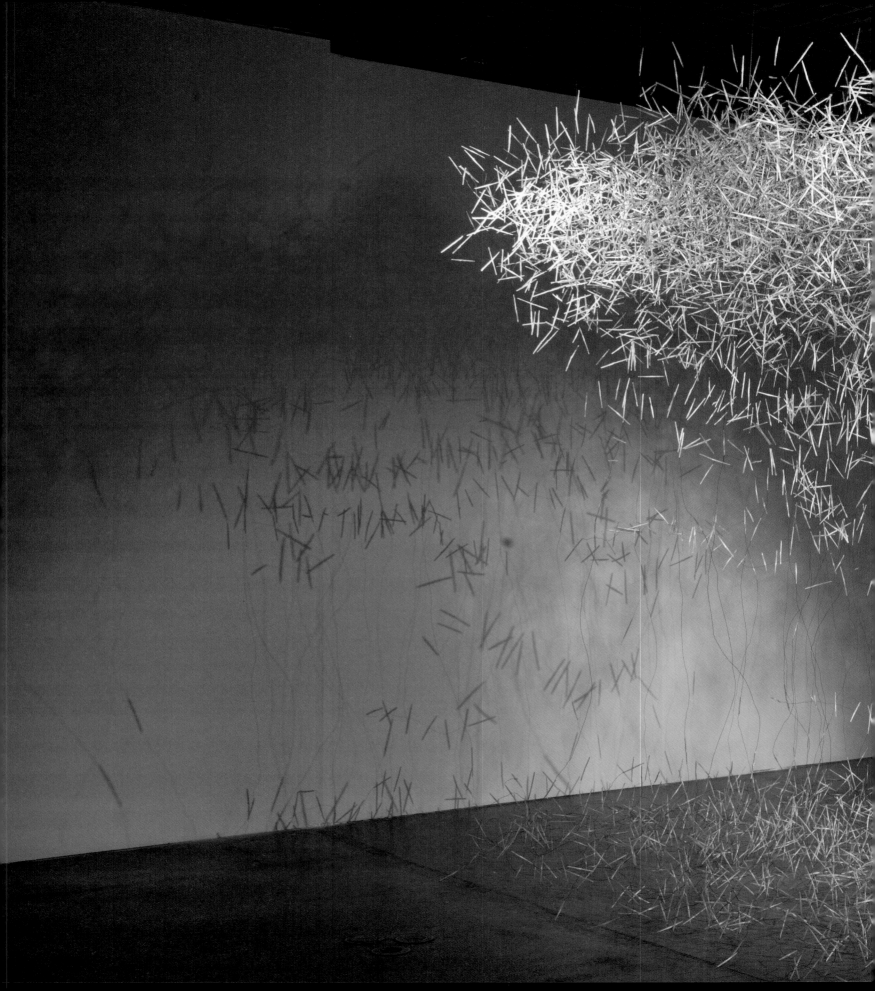

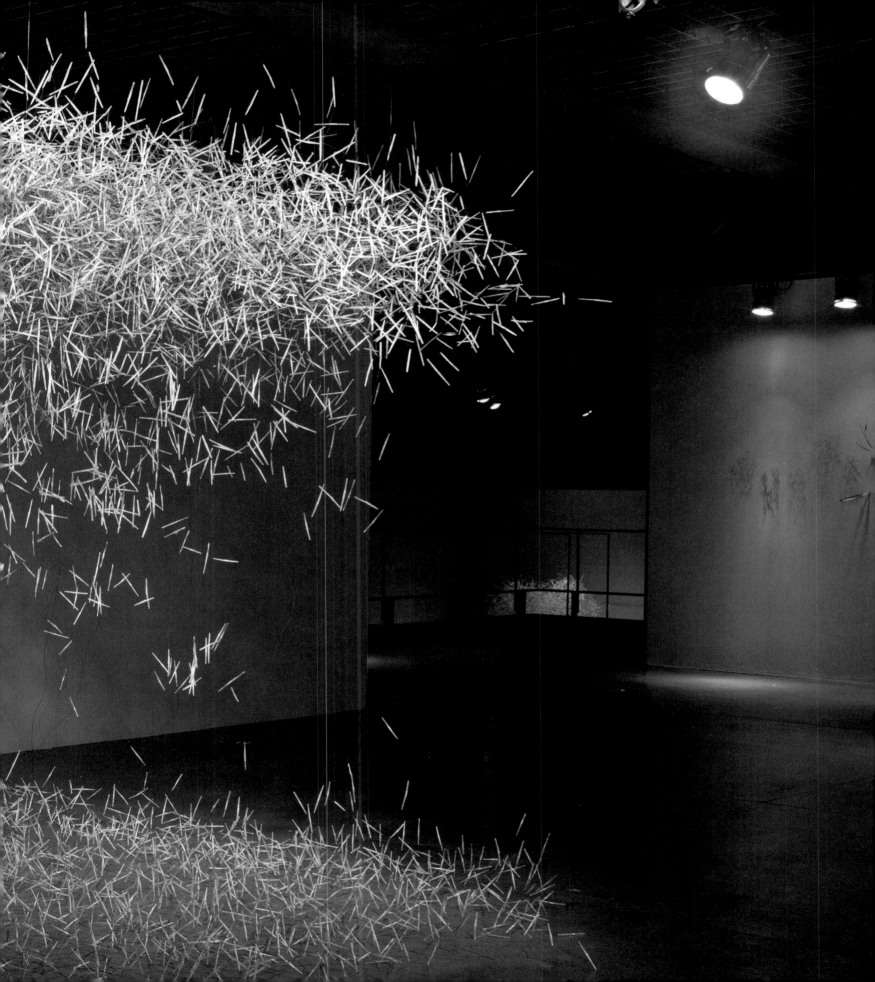

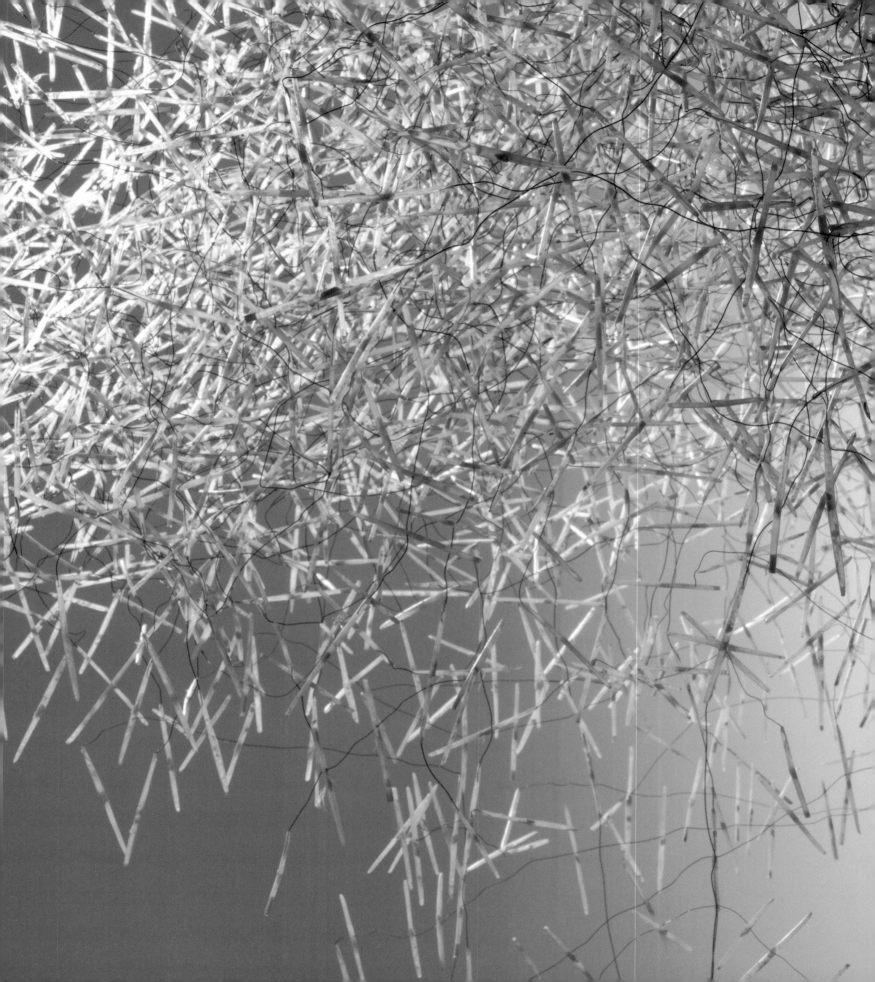

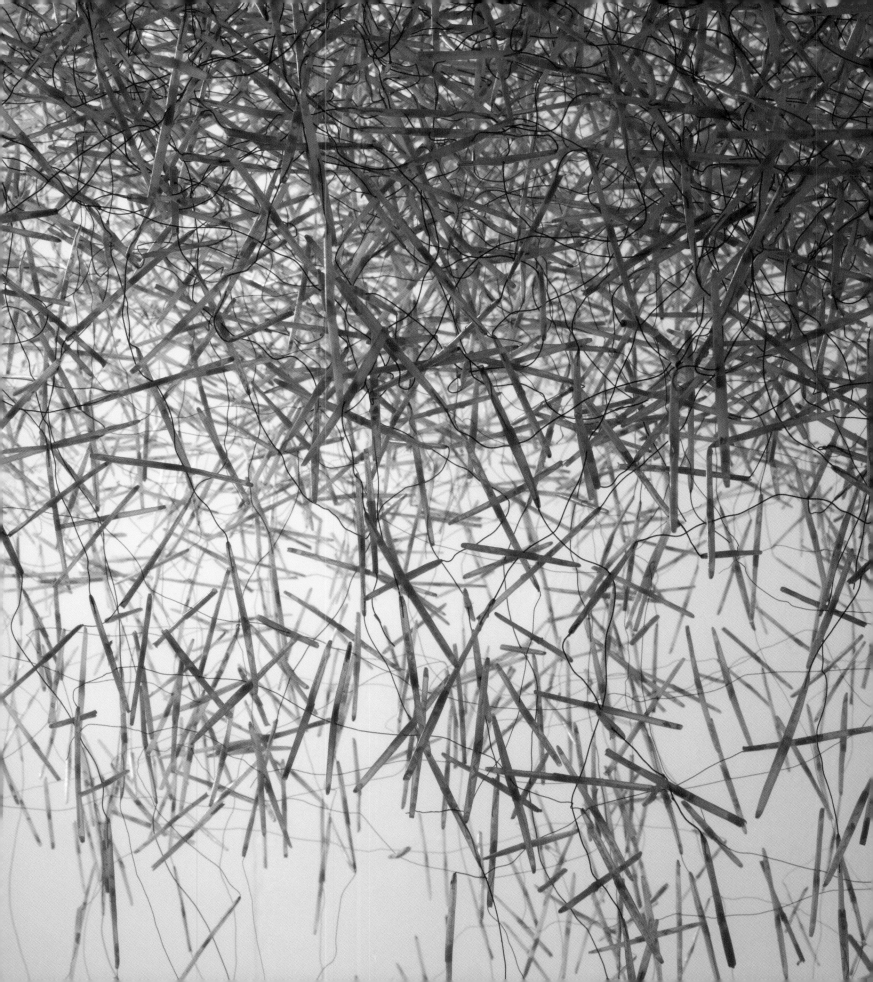

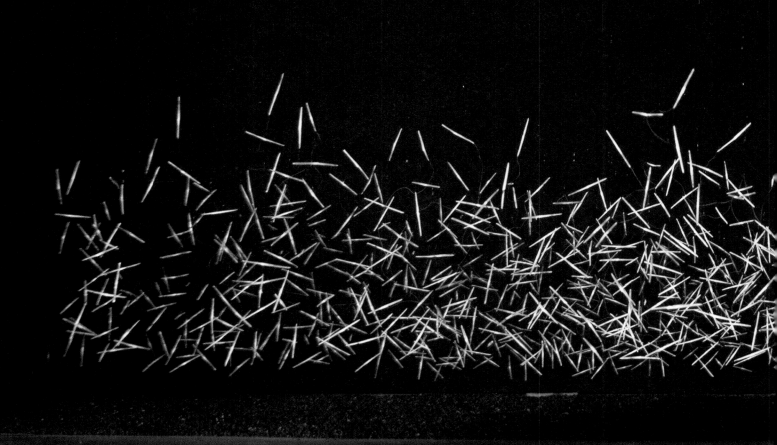

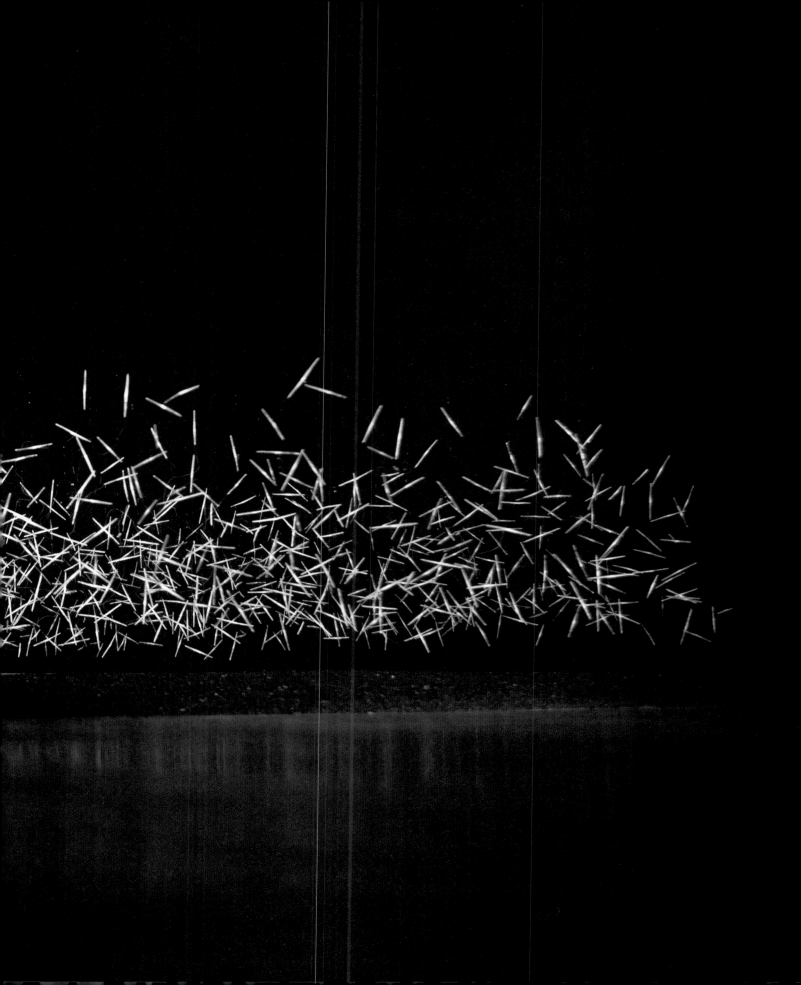

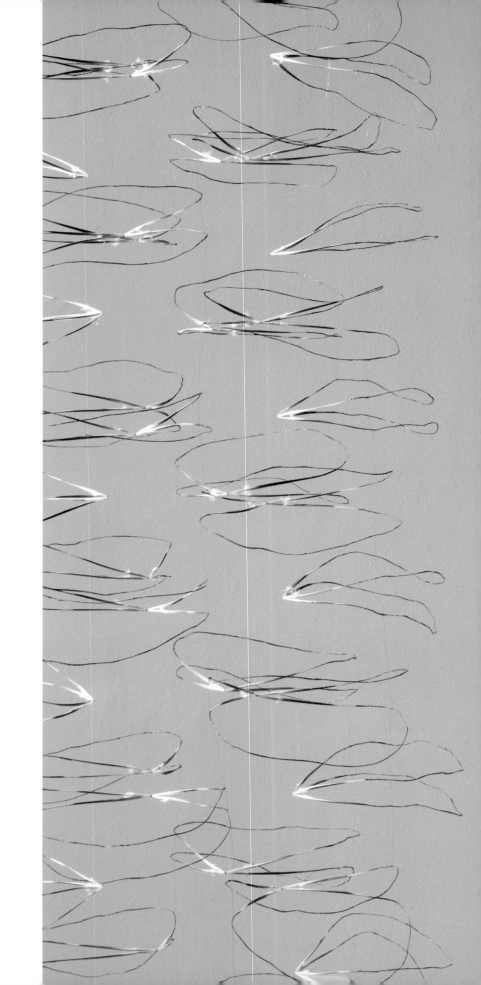

A little cold

After last night's pouring rain.

Alone I climb

A high peak and stand motionless.

Light clouds do not know

How to change into dragons or snakes,

But only to condense into pearls

That decorate my hair.

Zhang Chonghe

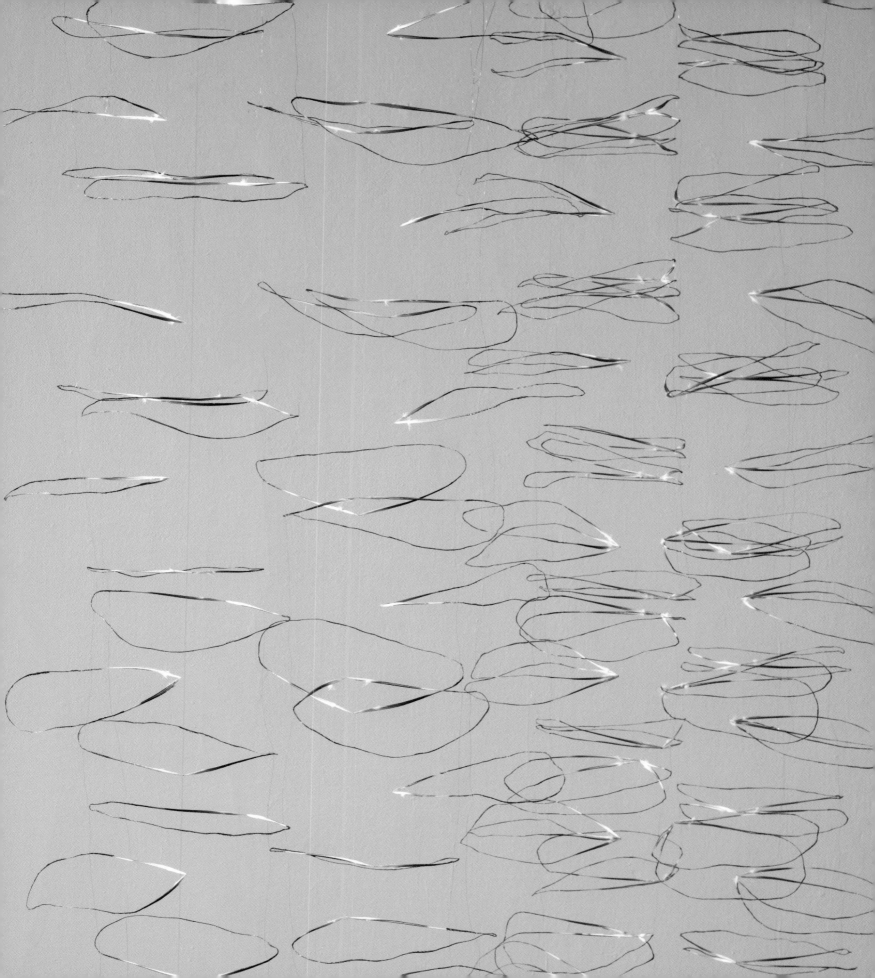

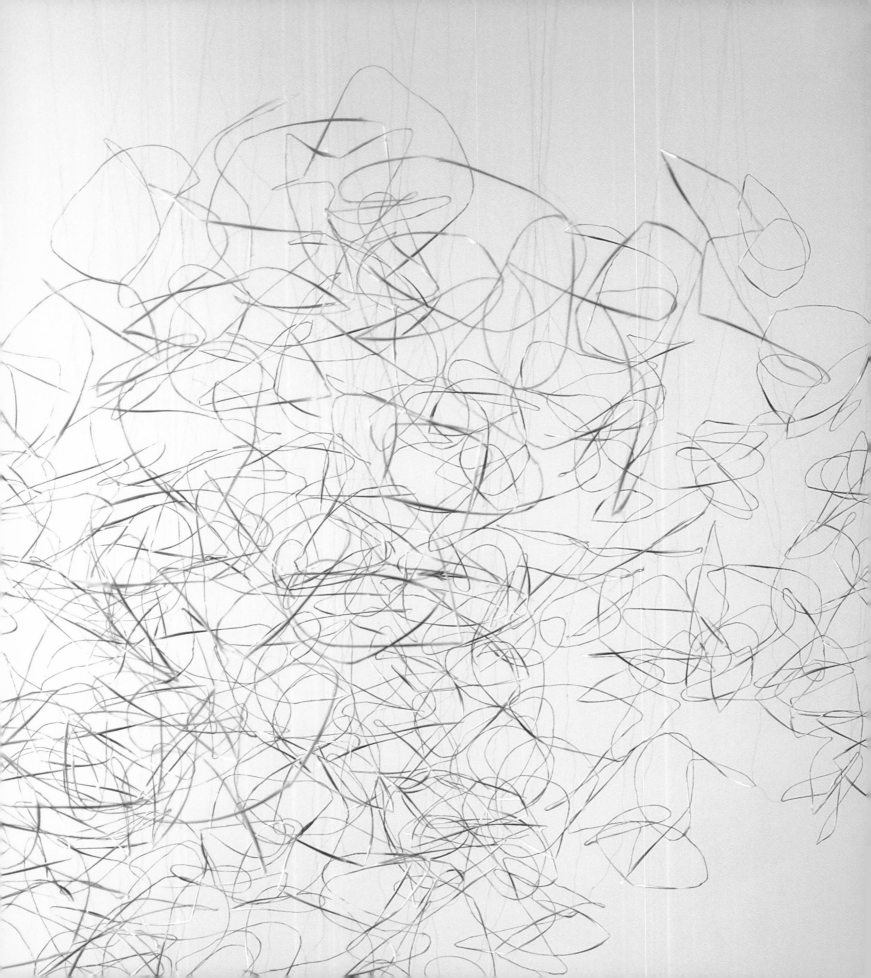

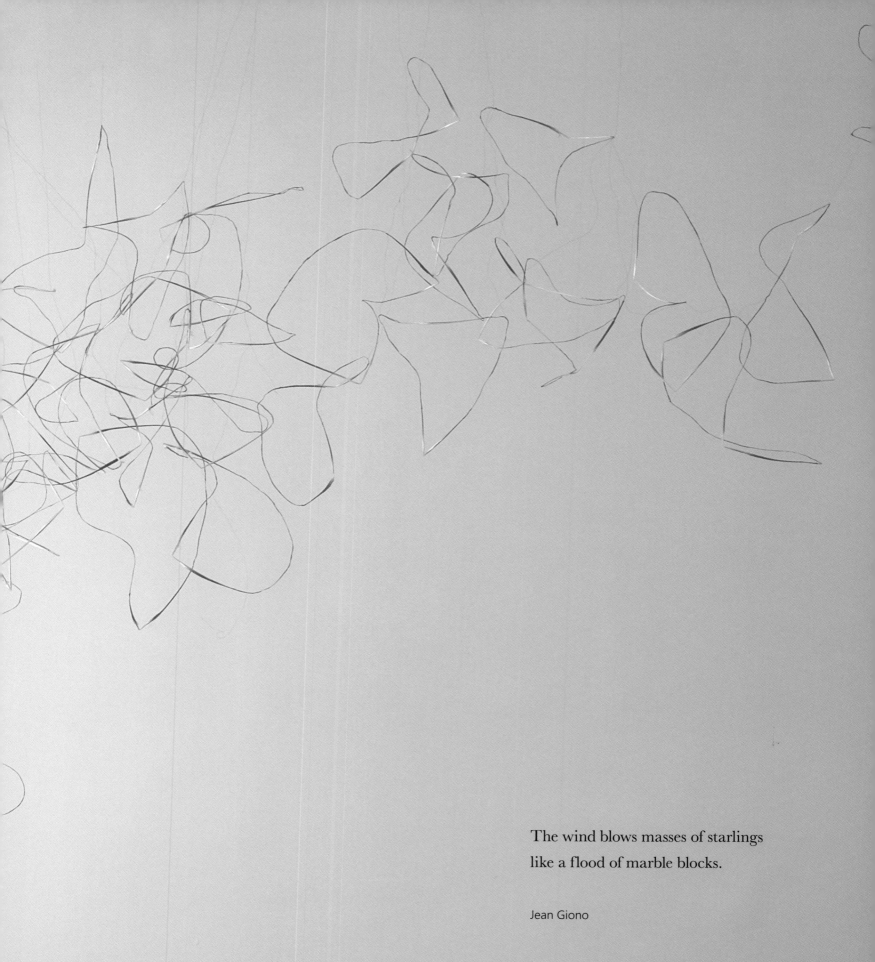

The wind blows masses of starlings
like a flood of marble blocks.

Jean Giono

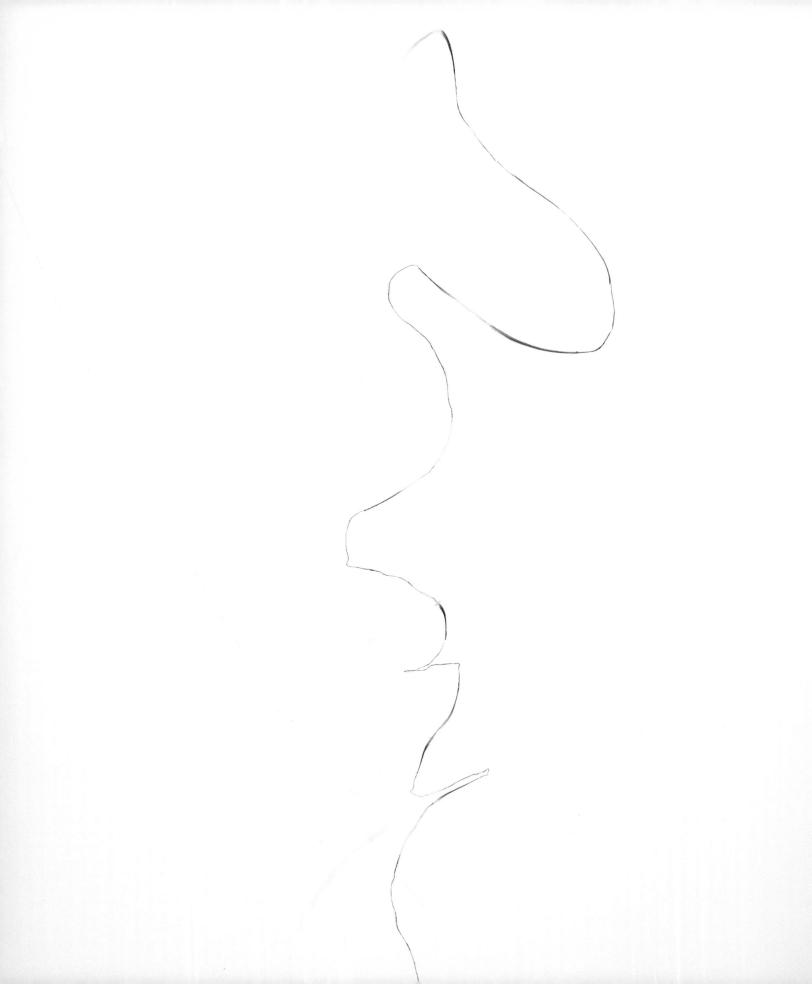

All the difficulty lies in the
dialogue with the invisible.

Hassan Massoudy

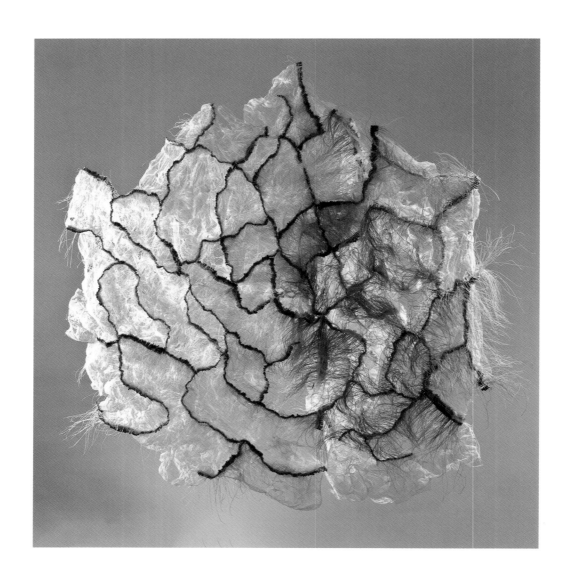

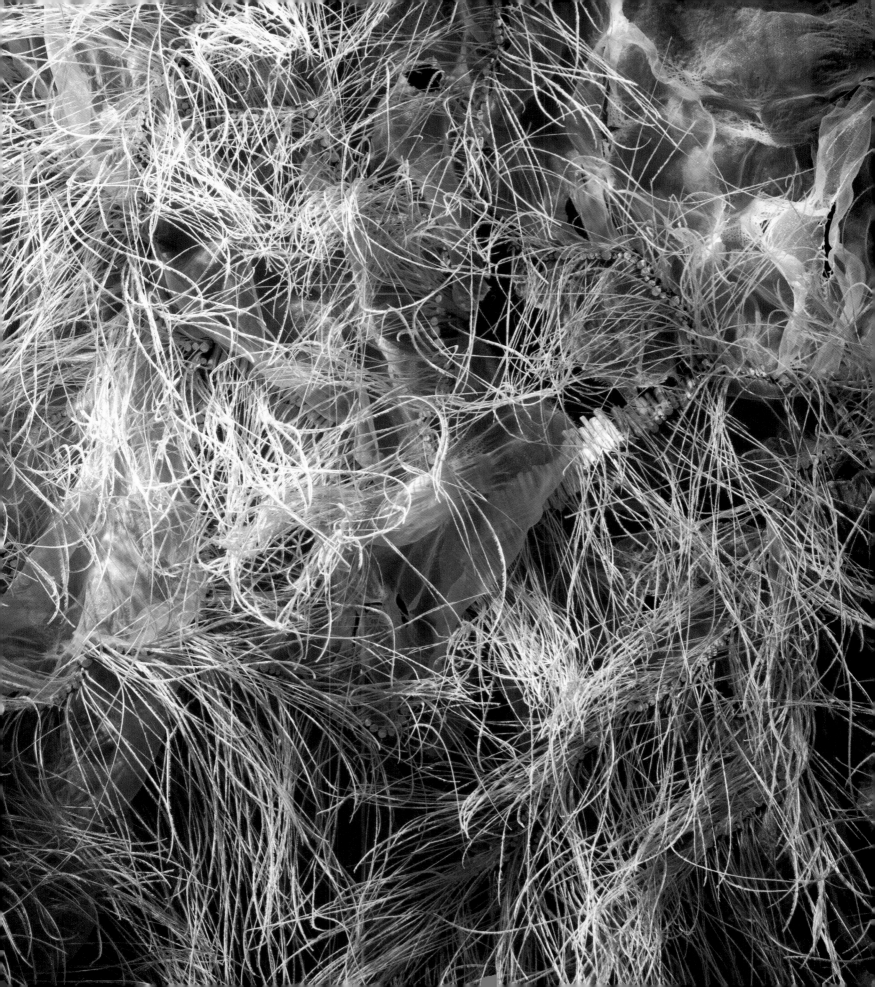

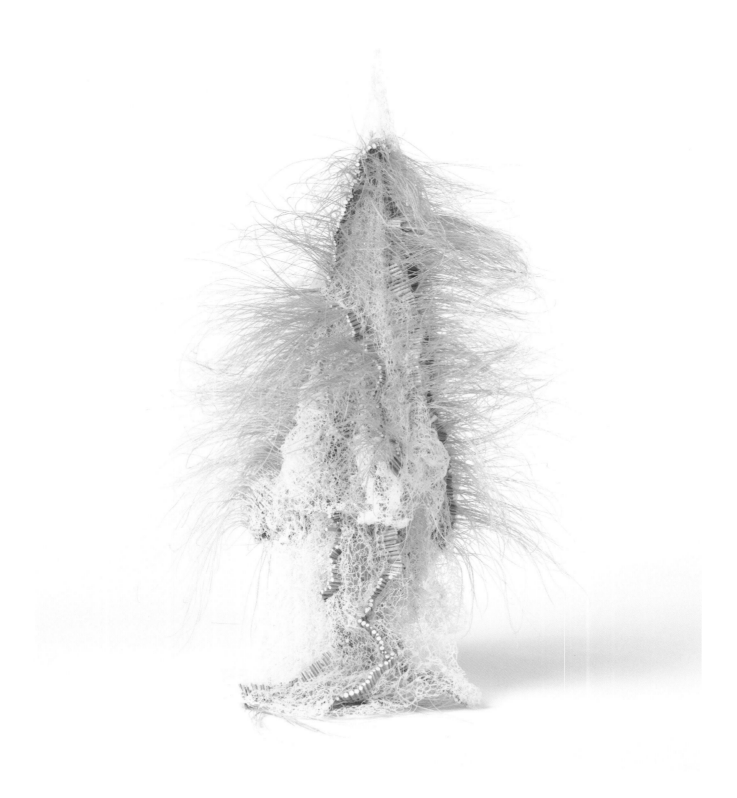

When you wake up, with the remains of a paradise
half-seen in dreams hanging down over you like
the hair on someone who's been drowned.

Julio Cortázar

The repetition of all the rain that falls

on earth, trees, and sea,

on my hands, face, and eyes,

and of the drops crushed on the glass.

Nâzım Hikmet

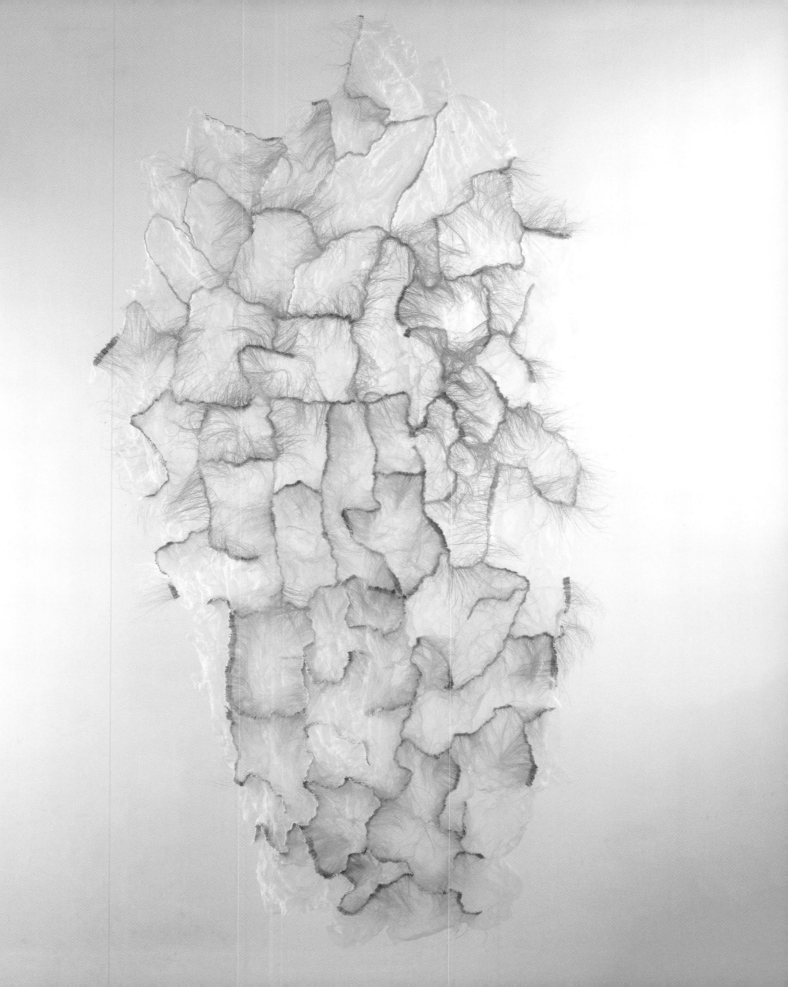

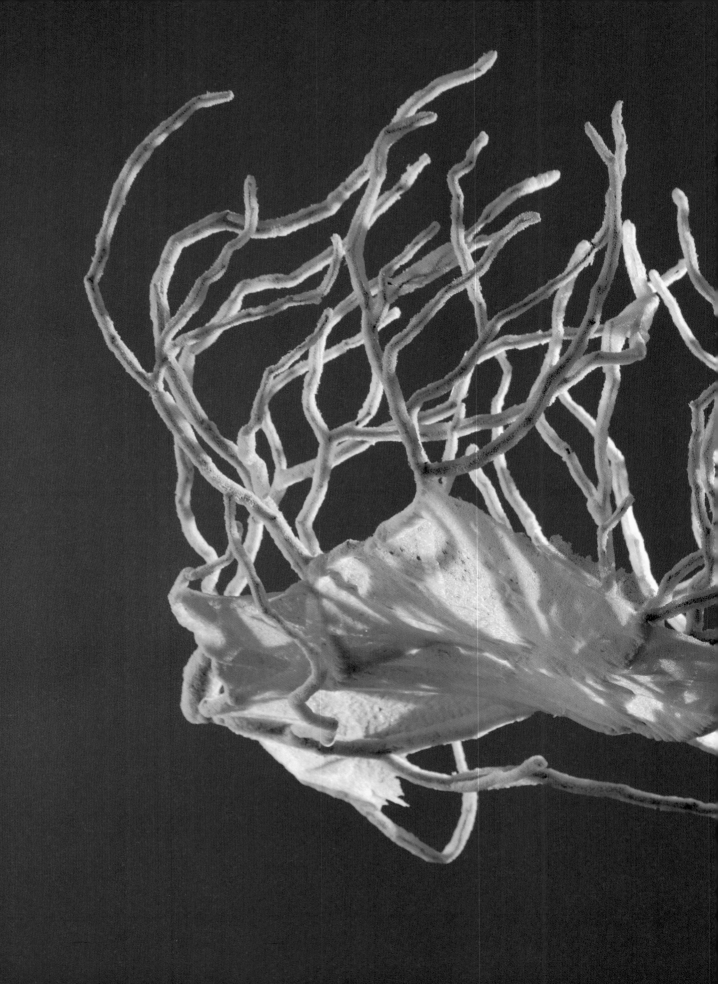

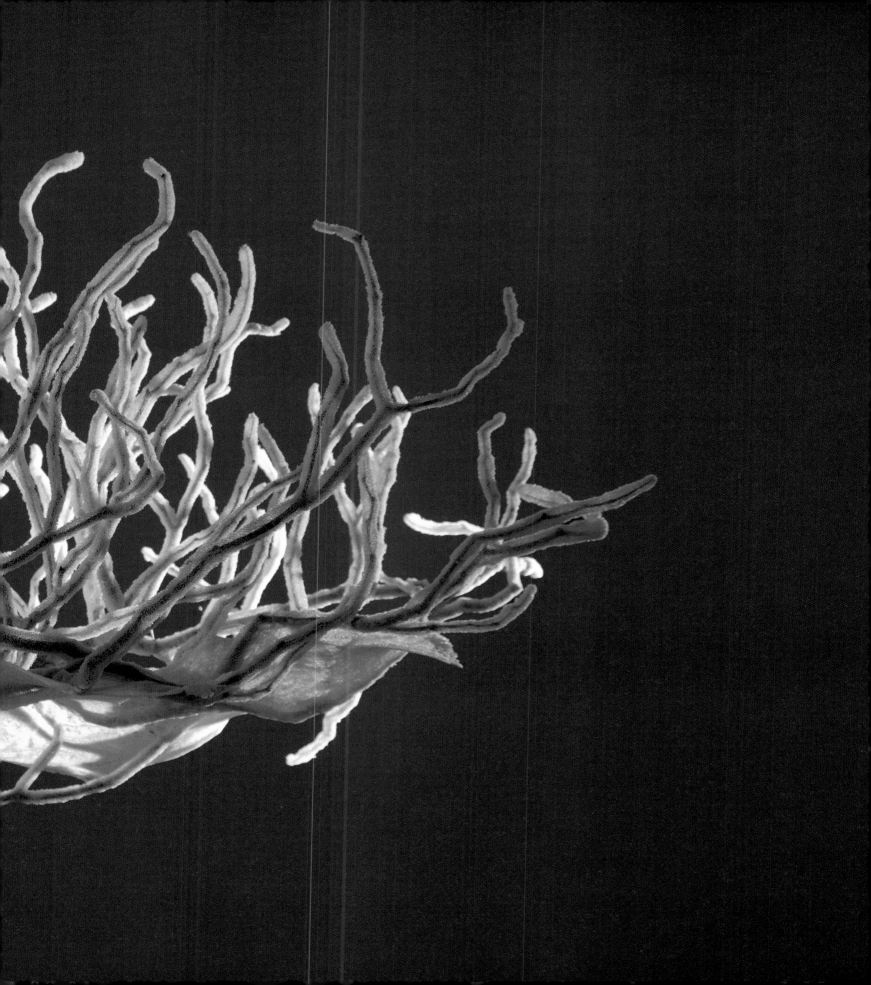

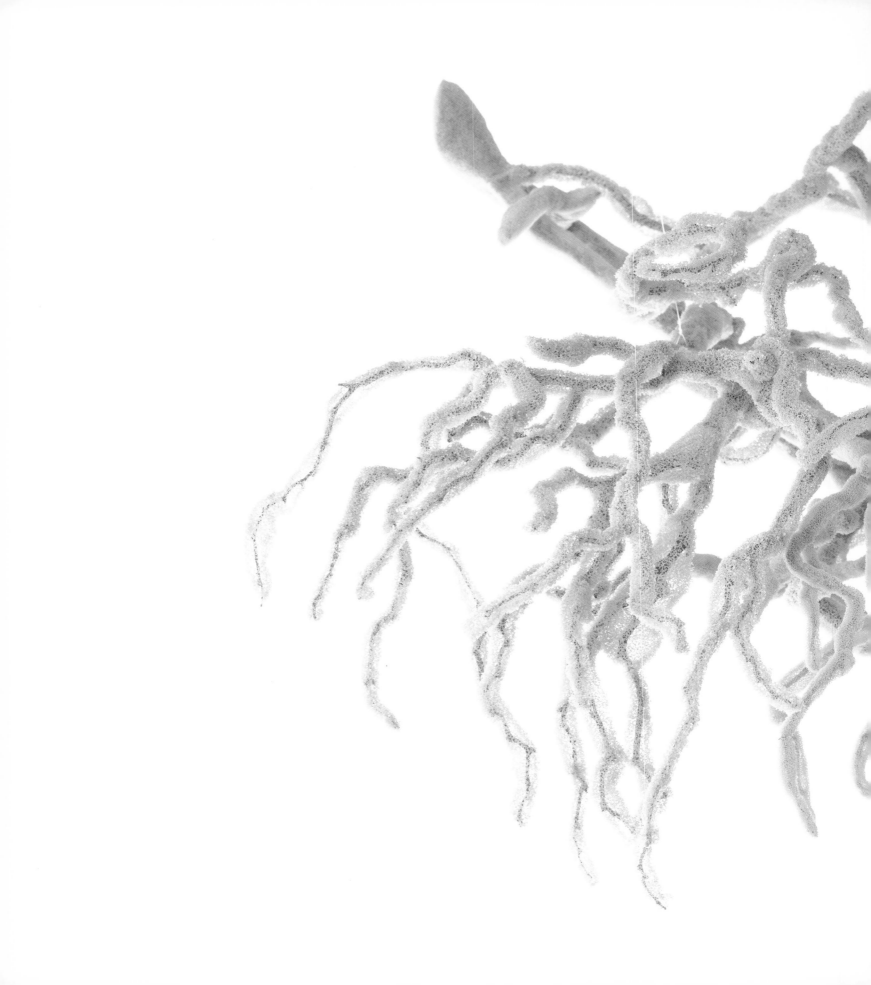

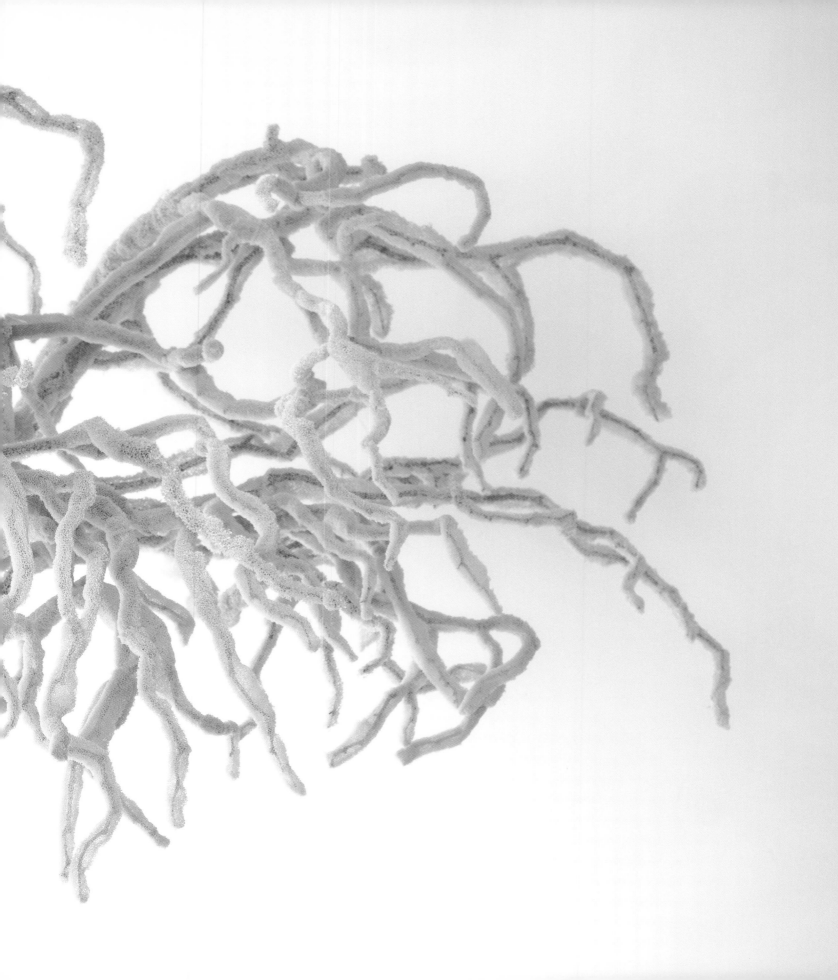

The short night –
Bubbles of crab froth
among the river reeds.

Yosa Buson

I should have been a pair of ragged claws
Scuttling across the floors of silent seas.

T. S. Eliot

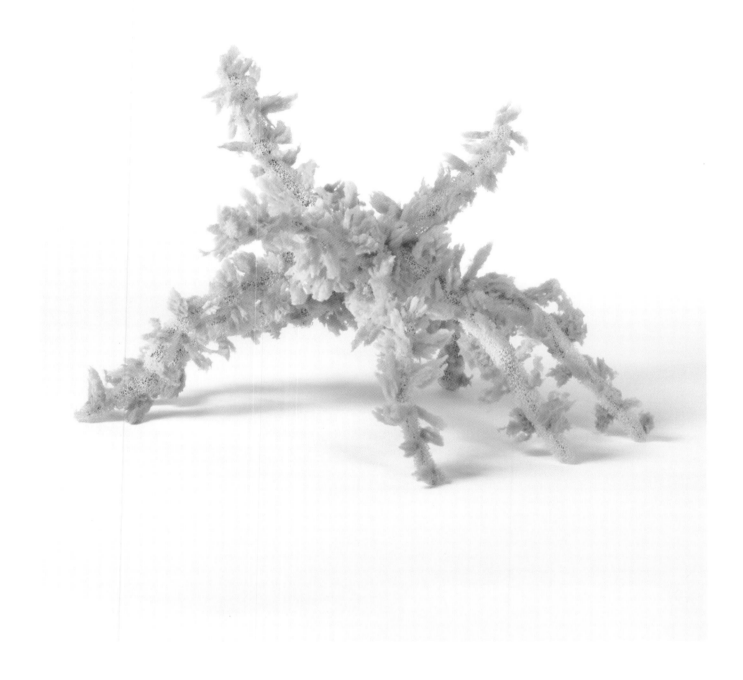

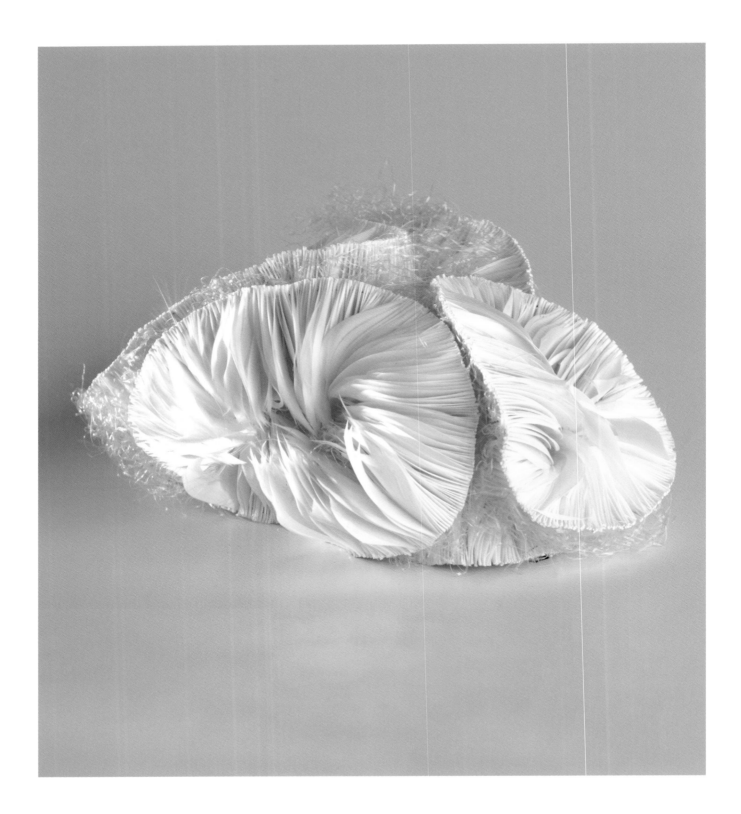

I am a skylark, often flying high and far into the blue sky, to a certain point, only to finally fall and return to the old nest.

Shen Congwen

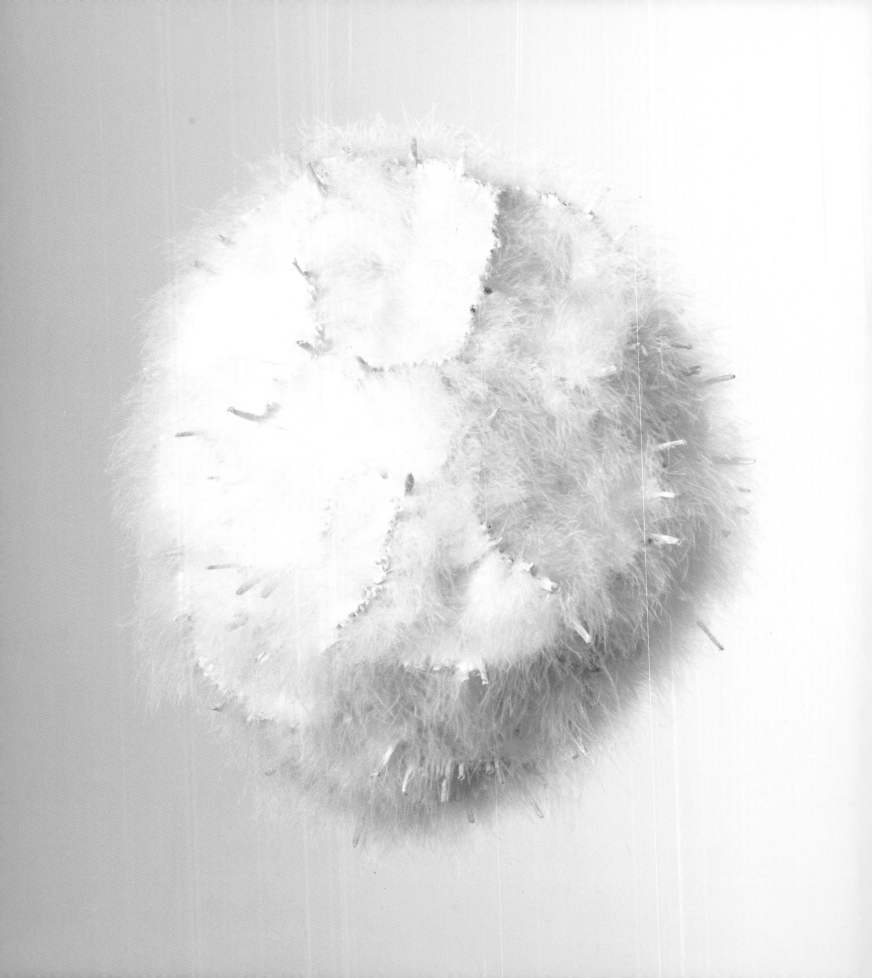

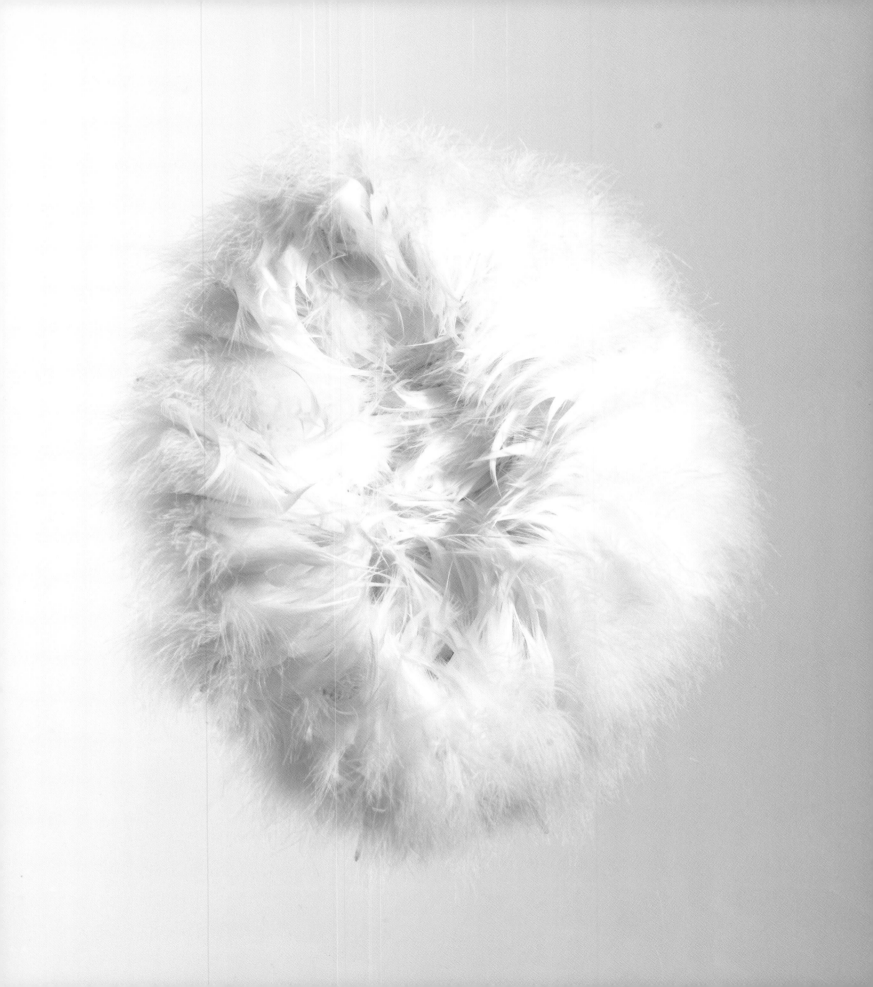

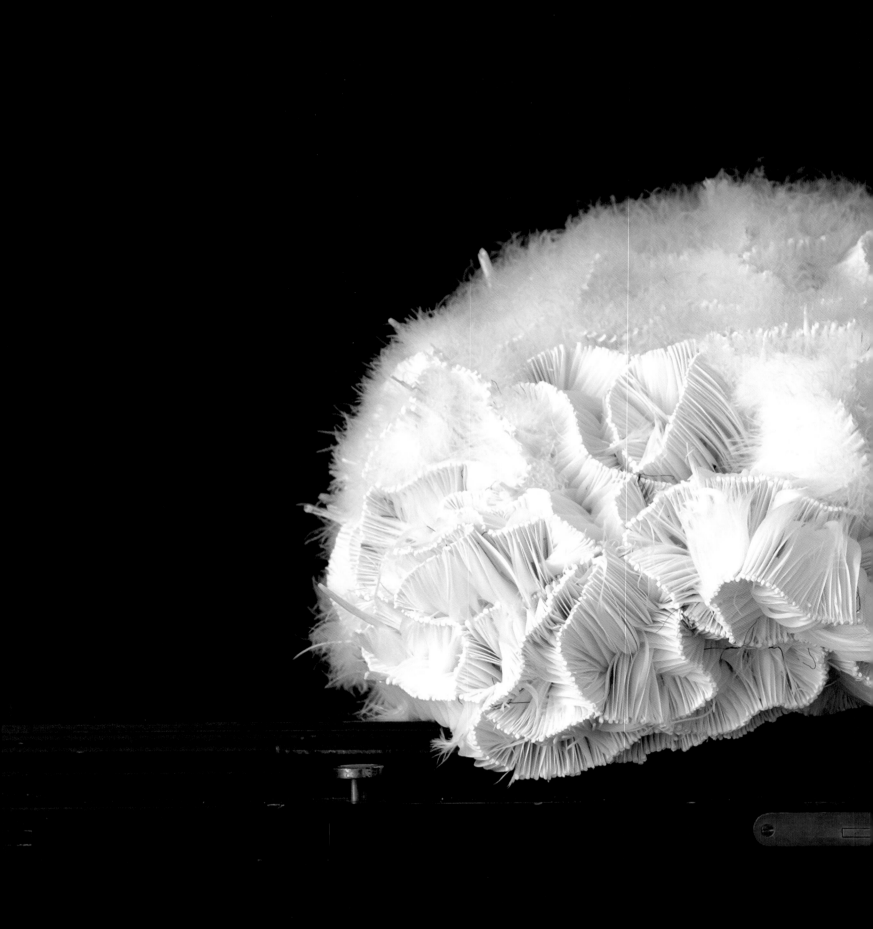

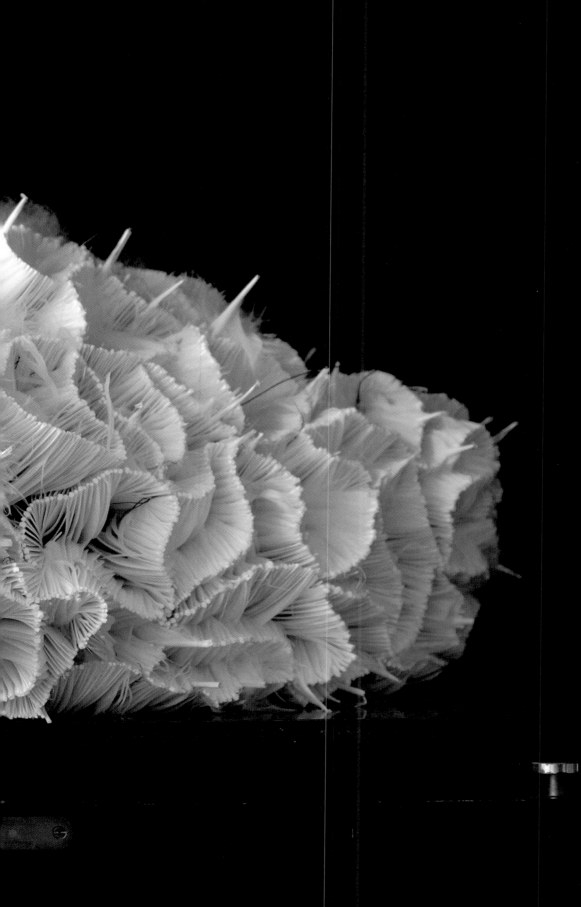

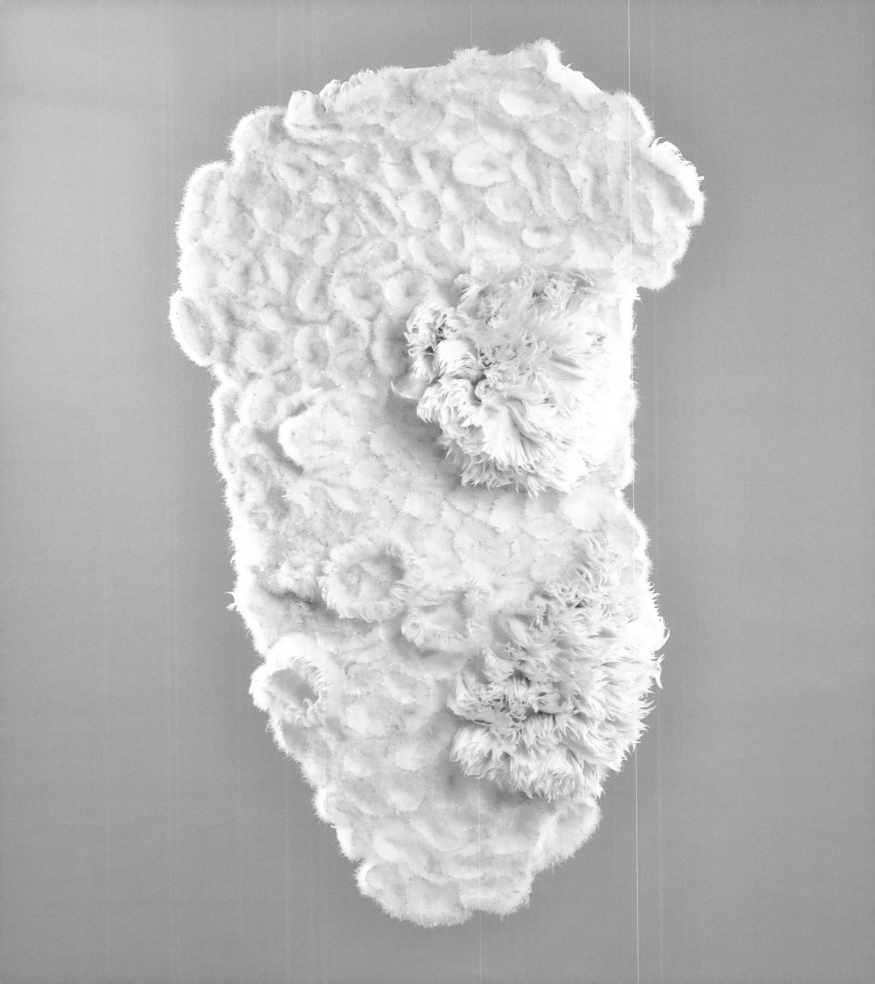

A day comes when, thanks to rigidity, nothing causes wonder any more, everything is known, and life is spent in beginning over again. These are the days of exile, of desiccated life, of dead souls. To come alive again, one needs a special grace, self-forget-fulness, or a homeland. Certain mornings, on turning a corner, a delightful dew falls on the heart and then evaporates. But its coolness remains, and this is what the heart requires always.

Albert Camus

There are rounds and half rounds; corals like little barrels and little cylinders; there are straight, crooked and even hunchbacked corals. They come as stars, spears, hooks, and blossoms. For corals are the noblest plants in the oceanic underworld; they are like roses for the capricious goddesses of the sea, as inexhaustible in their variety as the caprices of the goddesses.

Joseph Roth

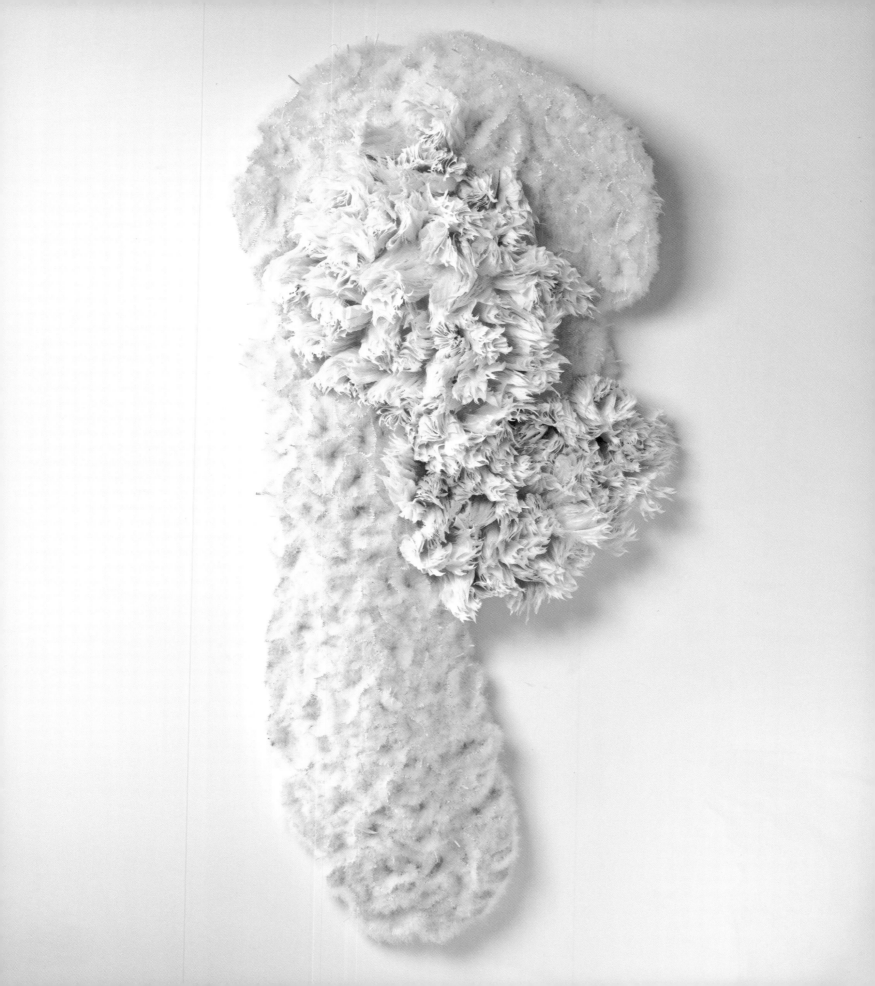

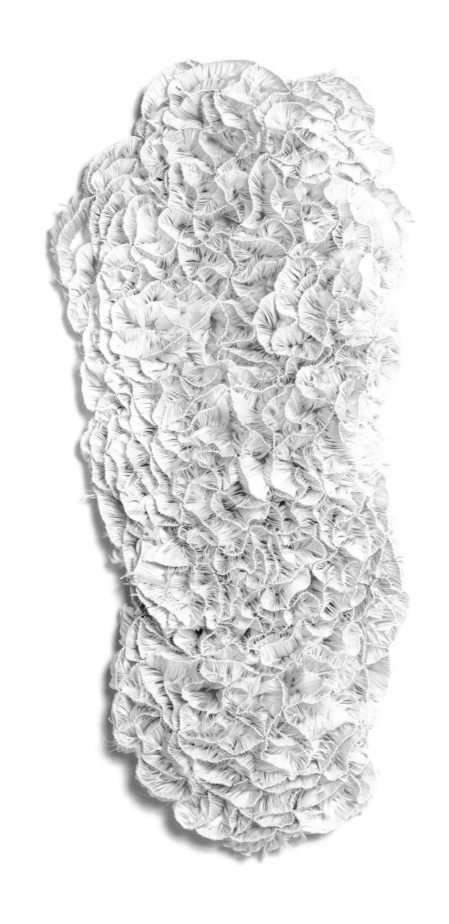

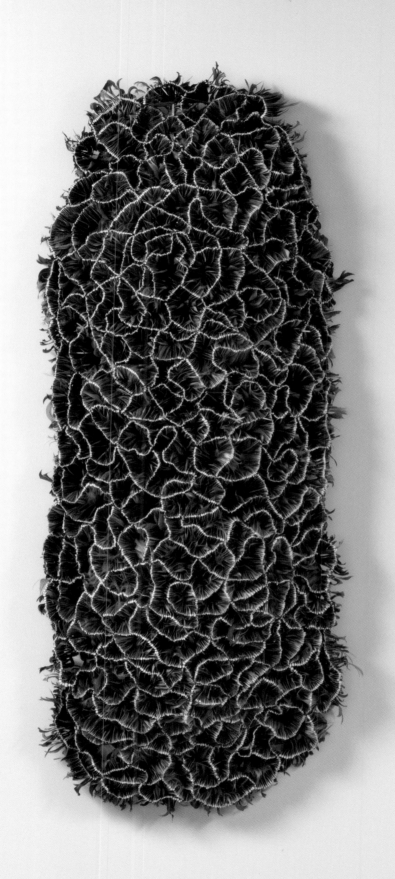

It comes, I tell you, immense with gasolined rags
and bits of wire and old bent nails, a dark arriviste,
from a dark river within.

Gregory Corso

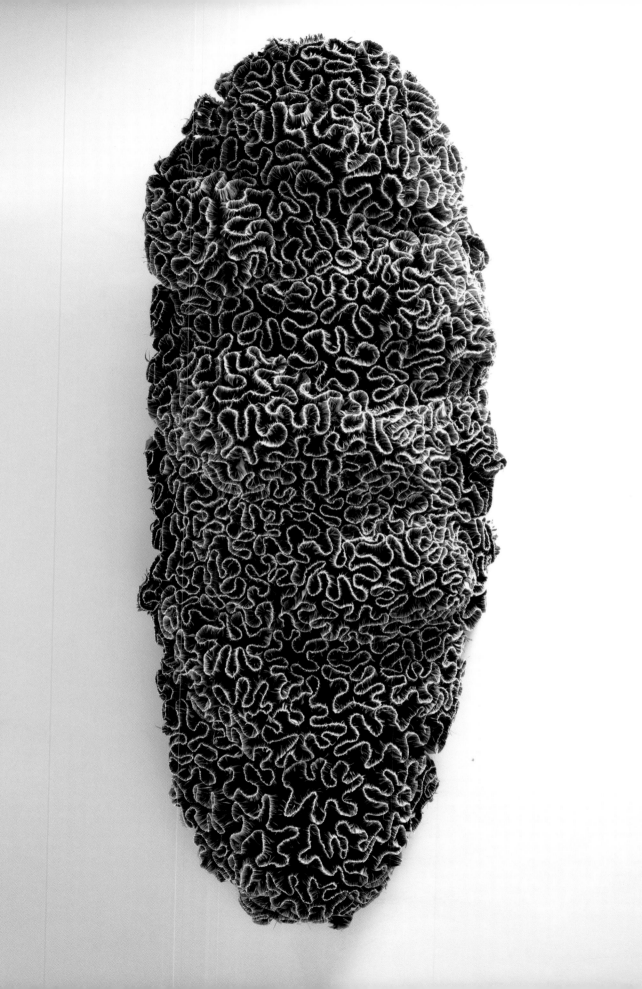

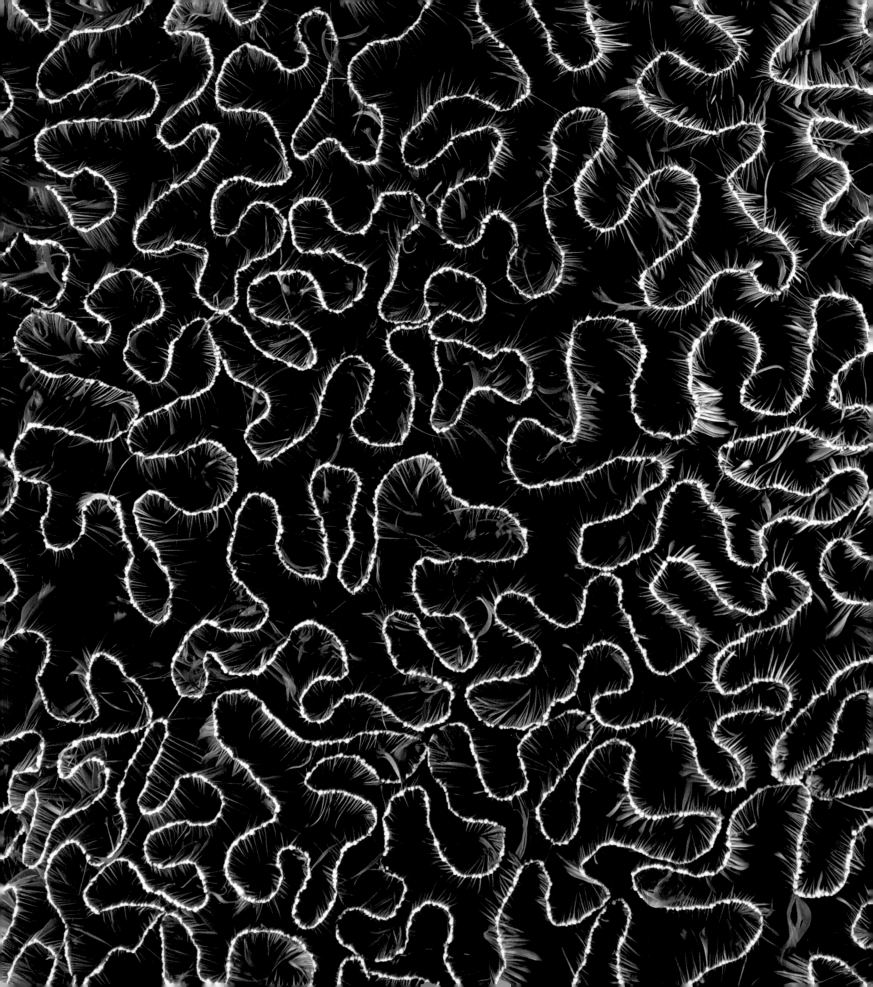

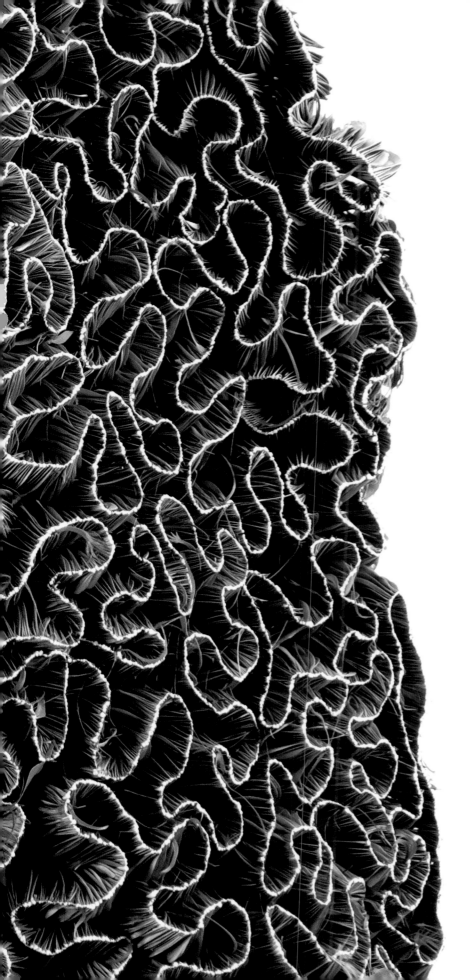

My way is in the sand flowing
between the shingle and the dune.

Samuel Beckett

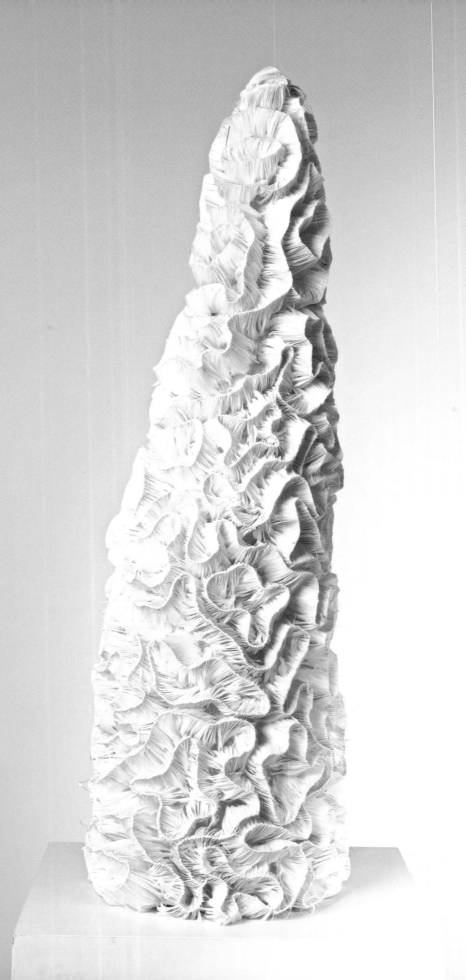

I want to tell you the ocean knows this, that life in its
jewel boxes
is endless as the sand, impossible to count, pure ...

Pablo Neruda

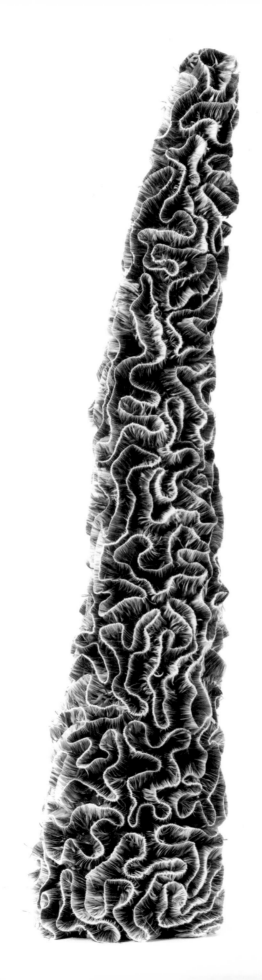

We sit and talk,

quietly, with long lapses of silence

and I am aware of the stream

that has no language, coursing

beneath the quiet heaven of

your eyes

which has no speech.

William Carlos Williams

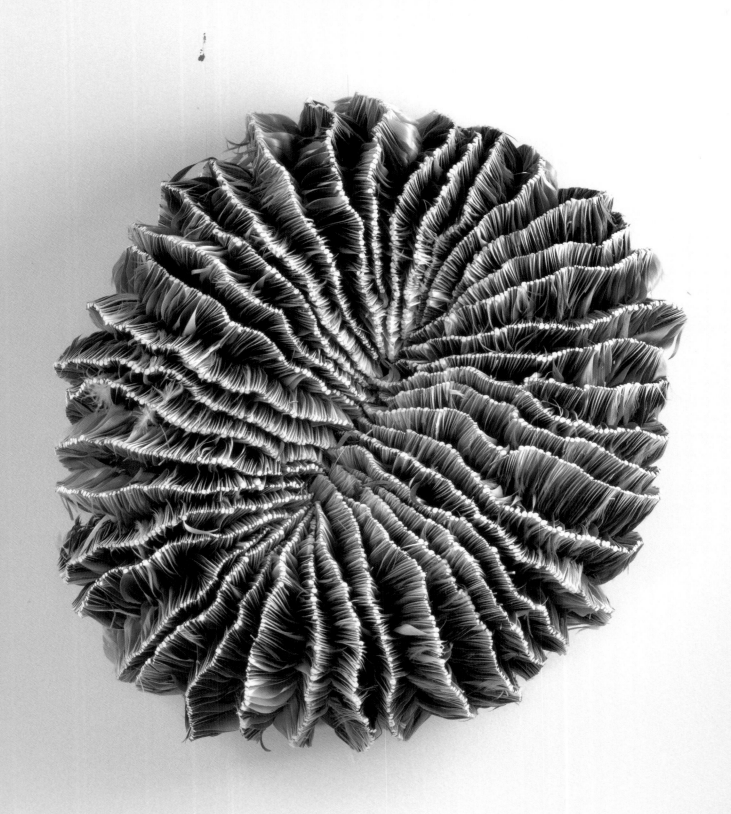

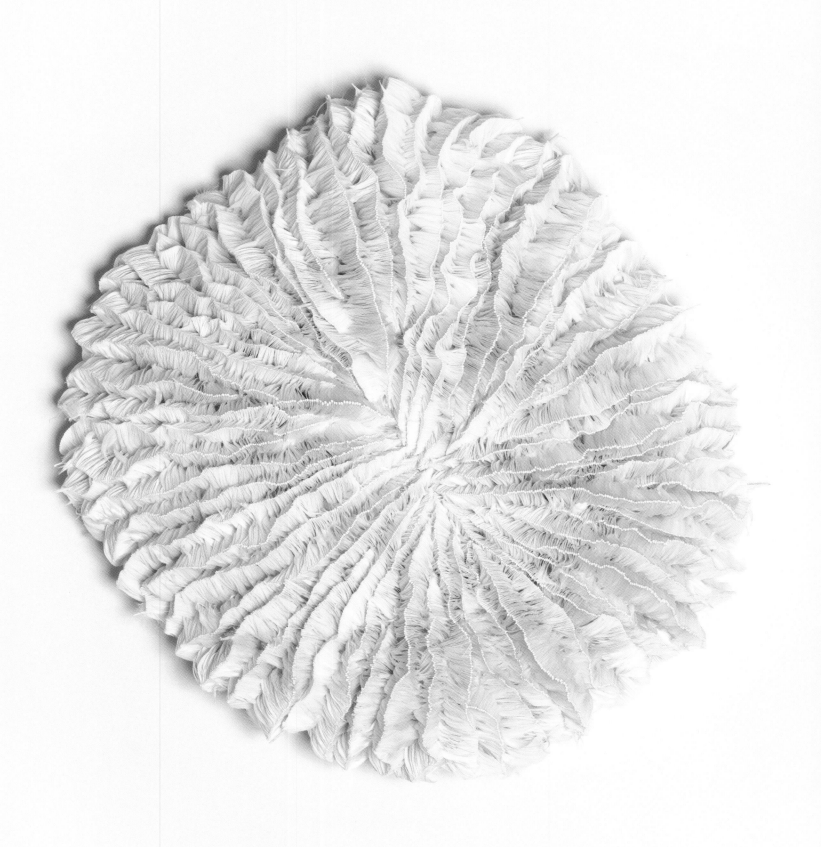

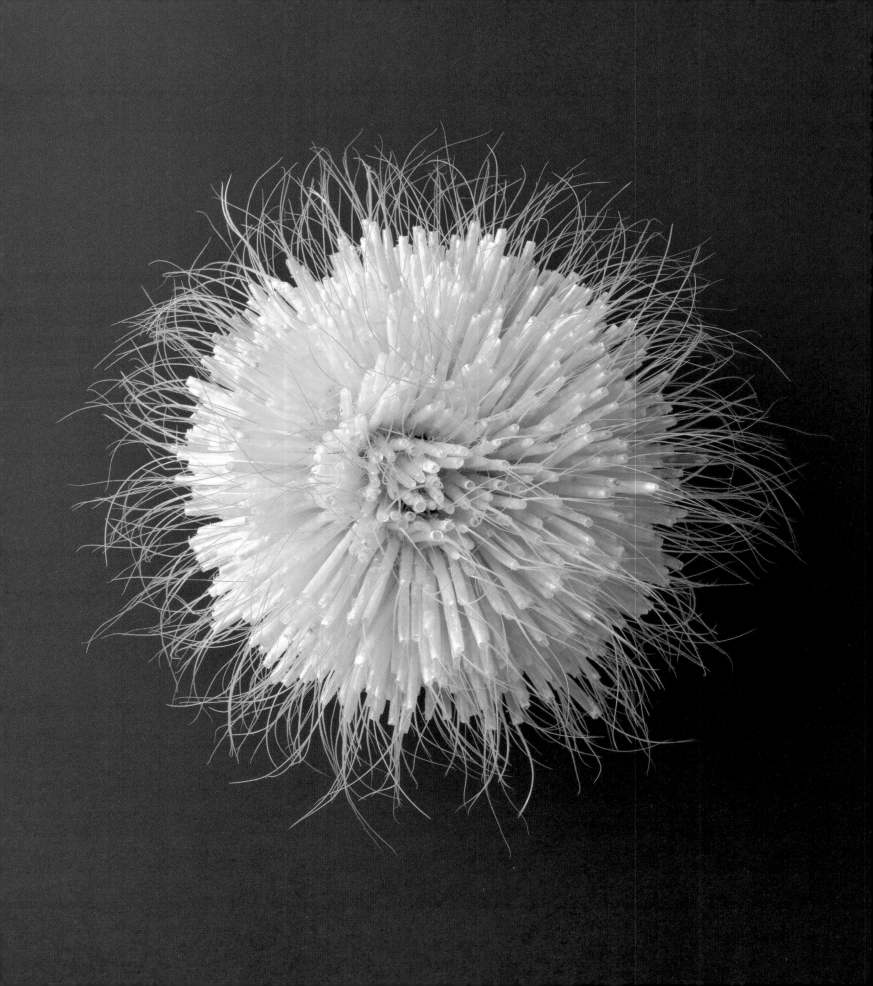

Life if u were a match I wd lite u into something beautiful.

Don L. Lee

Even now corals have the same nature, hardening
at a touch of air, and what was alive, under the water,
above water is turned to stone.

Ovid

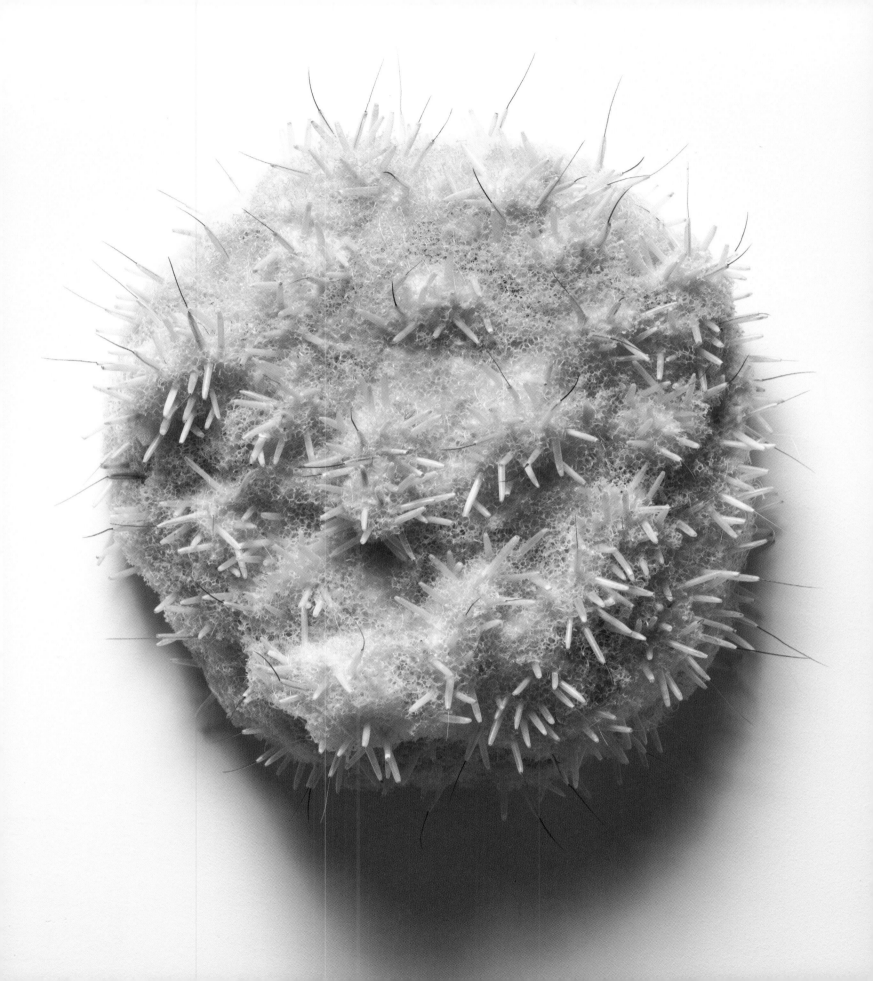

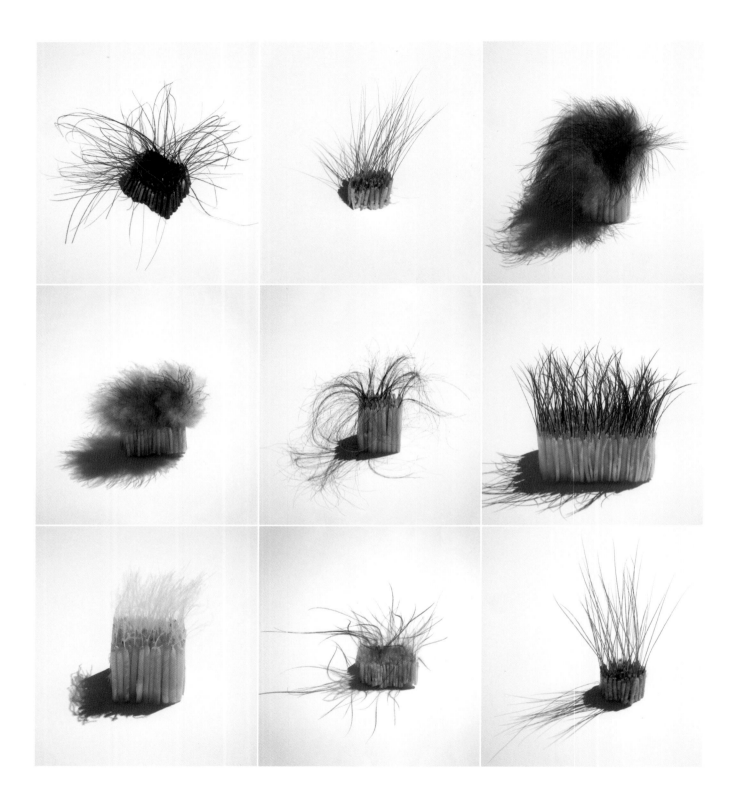

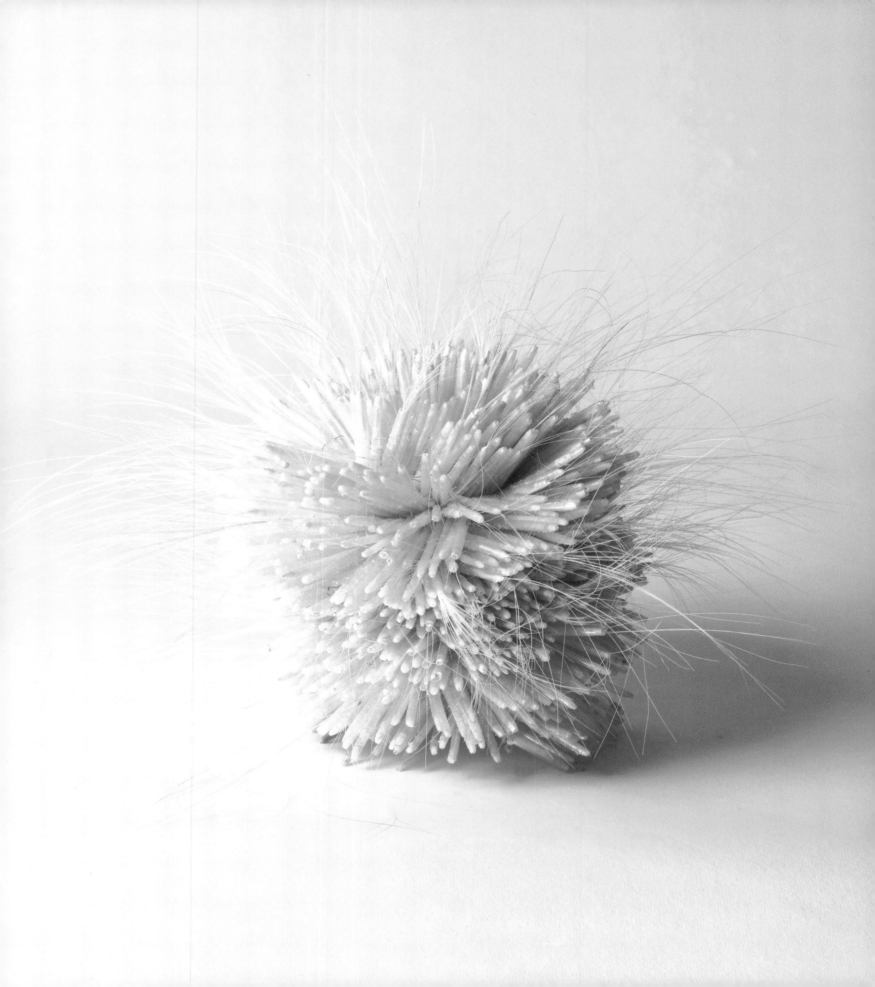

Write if you can on your last shell
the day the place the name
and fling it into the sea so that it sinks.

George Seferis

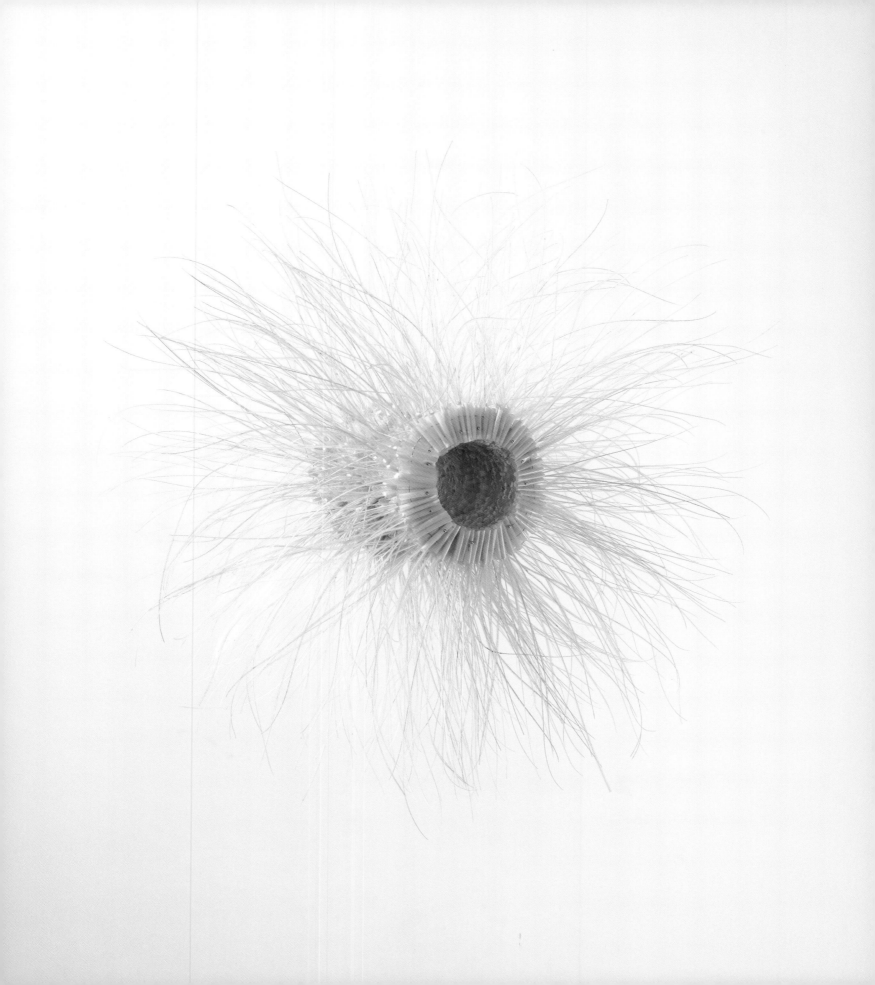

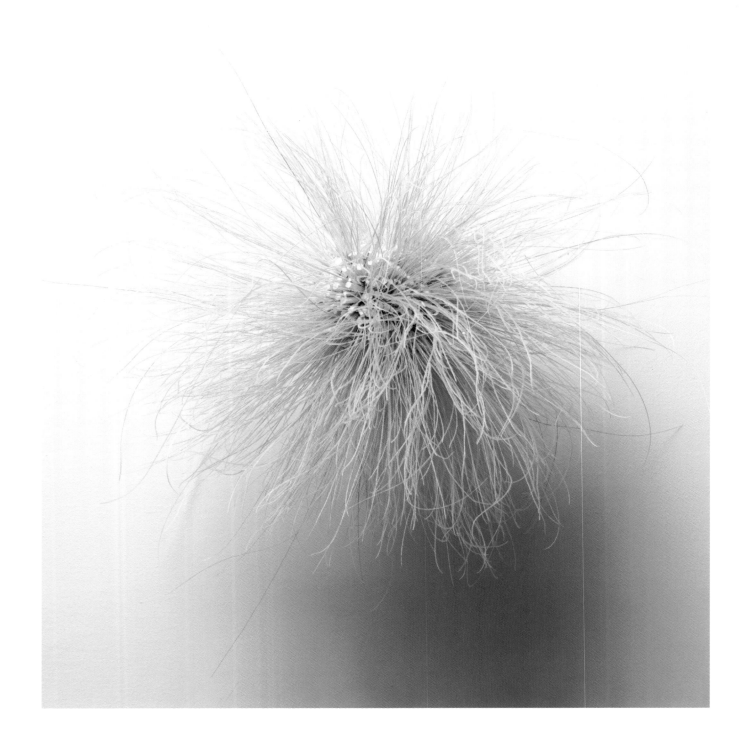

... and I float, aerial, scattered without ever having been, among the dreams of a creature who did not know how to finish me off.

Bernardo Soares

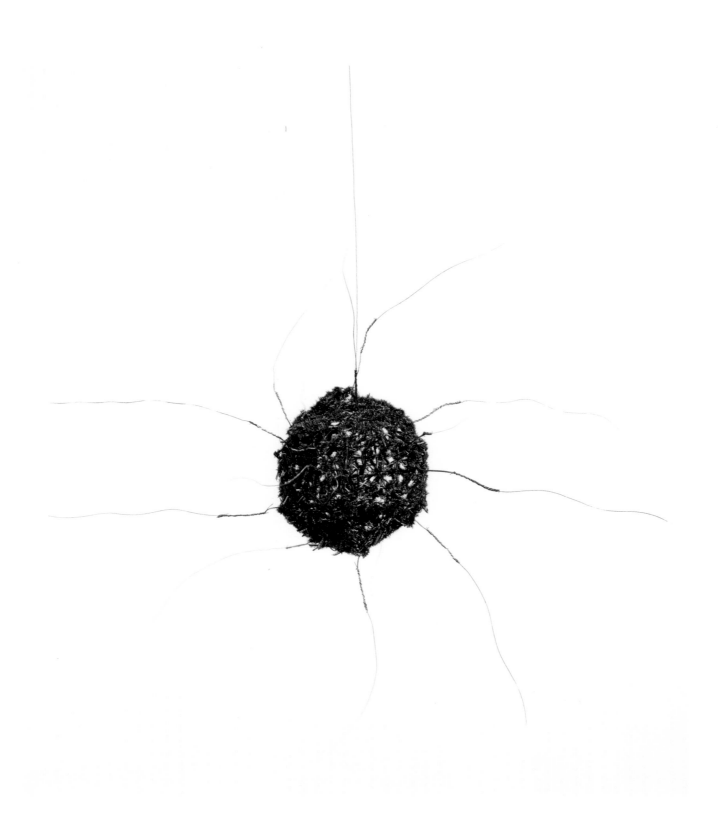

Yes, this is what my senses learned on their own:

Things have no meaning: they exist.

Things are the only hidden meaning of things.

Alberto Caeiro

Only the sinking of stars. Silence and reflection.

Ingeborg Bachmann

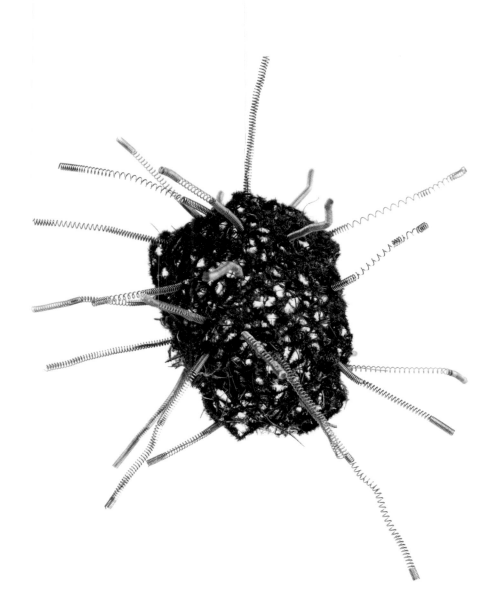

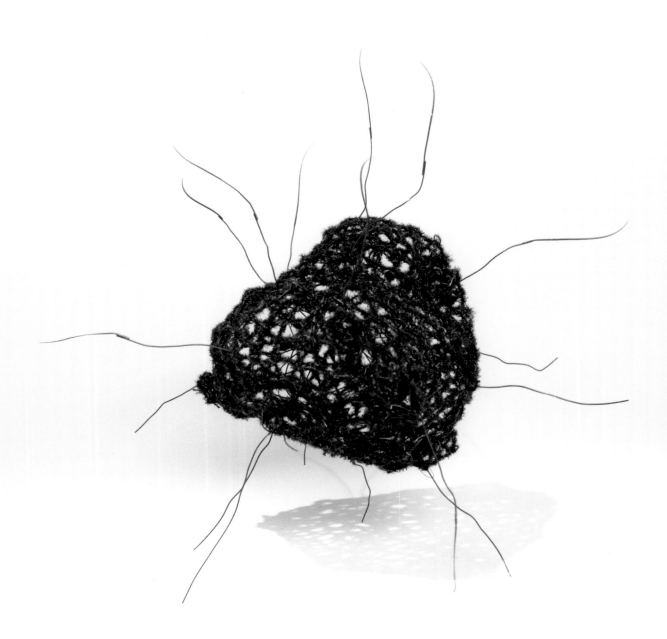

An autumn wind
passes by,
and swaying with it
a scarecrow.

Yosa Buson

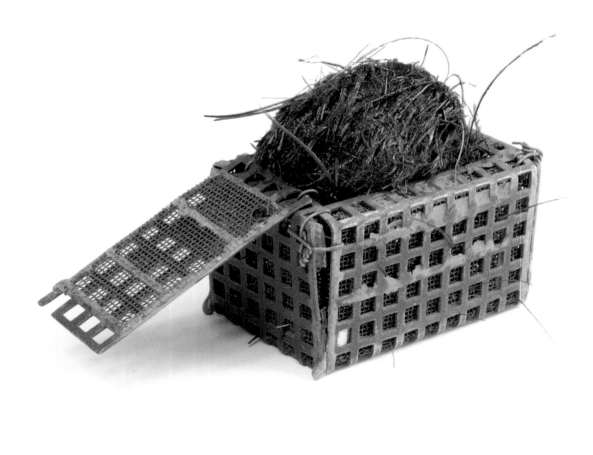

LIST OF WORKS

17

Series: Studies
Untitled, 2003
8 × 26 × 4 cm
Feathers, thread

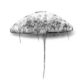

18

Series: Studies
Untitled, 2003
35 × 34 × 7 cm
Feathers, thread

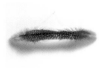

19

Series: Studies
Untitled, 2003
8 × 26 × 4 cm
Feathers, thread, thin
wire

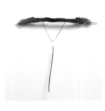

21

Series: Studies
L'aile, 2001
39 × 40 × 4 cm
Feathers

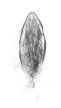

23

Series: Studies
Untitled, 2002
49 × 15 × 14 cm
Feathers, copper thread

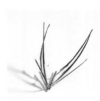

24

Series: Studies
Untitled, 2001
18 × 14 × 6 cm
Feathers, fish bones

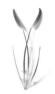

26

Series: Studies
Untitled, 2001
24 × 6 × 6 cm
Feathers

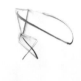

27

Series: Studies
Untitled, 2001
12 × 8 × 23 cm
Feathers

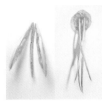

28–29

Series: Studies
Les mariés, 2001
32 × 22 × 5 cm (p. 28)
41 × 8 × 6 cm (p. 29)
Feathers, copper thread,
plastic film

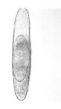

31

Series: Studies
Untitled, 2001
75 × 15 × 5 cm
Metal threads, silk
thread

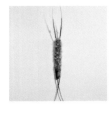

32

Series: Studies
Untitled, 2001
45 × 10 × 7 cm
Feathers, down

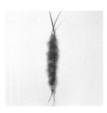

33

Series: Studies
Untitled, 2001
45 × 10 × 7 cm
Feathers, down

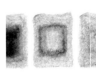

34–35

Series: Studies
Untitled, 2003–04
36 × 3 × 3 cm
Feathers, hair

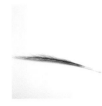

36–37

Series: Horse hair
Triptyque, 2004–05
80 × 55 × 3 cm (each)
Horse hair

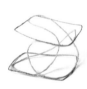

38

Series: Wires & Threads
Untitled, 2000
11 × 16 × 13 cm
Thin wire, copper thread

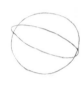

41

Series: Wires & Threads
Untitled, 2000
10 × 12 × 12 cm
Thin wire, cotton thread

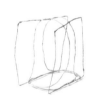

42

Series: Wires & Threads
Untitled, 2000
20 × 12 × 19 cm
Thin wire, cotton thread

44–45

Series: Wires & Threads
Untitled, 2001
31 × 10 × 9 cm
Thin wire, copper thread

46

Series: Wires & Threads
Untitled, 2002
36 × 36 × 5 cm
Thin wire, copper
thread

56–57

Series: Writings
Untitled, 2005
123 × 71 × 18 cm
Bird of paradise
feathers,* veil

66

Series: Spiderwebs
Untitled, 2006
50 × 30 × 10 cm
Feathers, veil

47

Series: Wires & Threads
Untitled, 2001
27 × 27 × 8 cm
Thin wire, copper
thread

58–59

Series: Chrysalids
Chrysalide I, 2004
36 × 90 × 15 cm
Feathers, veil

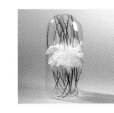

67

Series: Captures
Untitled, 2006
50 × 20 × 20 cm
Feathers, veil, glass bell

48

Series: Wires & Threads
Untitled, 2011
45 × 15 × 19 cm
Feathers, thin wire,
silicon

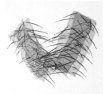

60–61

Series: Chrysalids
Untitled, 2007
75 × 50 × 14 cm
Feathers, veil

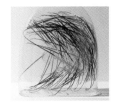

68

Series: Captures
Untitled, 2008
48 × 48 × 19 cm
Feathers, metal jersey,
glass bell

50

Series: Lines
Ligne, 2001
115 × 7 × 7 cm
Feathers, thin wire

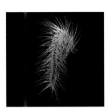

63

Series: Chrysalids
Grande chrysalide, 2007
105 × 30 × 50 cm
Feathers, metal jersey

70

Series: Skeletons
Untitled, 2002
90 × 50 × 13 cm
Feathers

52

Series: Wires & Threads
Untitled, 2004
17 × 17 × 11 cm
Thin wire, hair

64

Series: Chrysalids
Chrysalide II, 2005
55 × 40 × 10 cm
Feathers, veil

71

Series: Skeletons
Untitled, 2004
122 × 72 × 5 cm
Feathers

54

Series: Writings
Untitled, 2005
66 × 55 × 30 cm
Feathers, veil

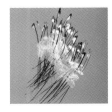

65

Series: Spiderwebs
Untitled, 2007
40 × 30 × 14 cm
Feathers, veil

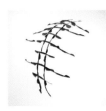

73

Series: Skeletons
Le Samouraï, 2004
125 × 80 × 30 cm
Feathers

* Feathers found in a flea market

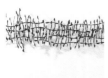

74–75

Series: Writings
Grande écriture, 2012
65 × 295 × 20 cm
Feathers

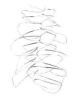

84

Series: Ripples
Untitled, 2012
60 × 36 × 36 cm
Feathers, thin wire

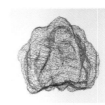

94–95

Series: Cages
Untitled, 2018
100 × 120 × 120 cm
Feathers, thin wire

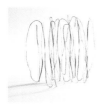

76

Series: Lines
Untitled, 2012
25 × 33 × 15 cm
Feathers, thin wire

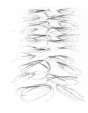

85

Series: Ripples
Untitled, 2016
150 × 75 × 75 cm
Feathers, thin wire

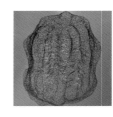

96–97

Series: Cages
Untitled, 2019
180 × 130 × 145 cm
Feathers, thin wire

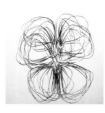

79

Series: Breaths
Untitled, 2012
76 × 63 × 58 cm
Feathers, thin wire

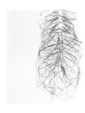

86–87

Series: Breaths
Untitled, 2011
85 × 61 × 61 cm
Feathers, thin wire

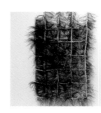

98

Series: Furs
Untitled, 2007
130 × 85 × 30 cm
Feathers

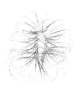

80

Series: Breaths
Untitled, 2011
50 × 45 × 45 cm
Feathers, thin wire

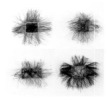

89

Series: Wires & Threads
Le fumeur noir, 2010–11
300 × 30 × 30 cm
Feathers, thin wire

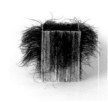

100

Series: Furs
Untitled, 2006
30 × 15 × 20 cm (4 p.)
Feathers

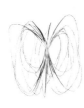

81

Series: Breaths
Untitled, 2013
60 × 50 × 50 cm
Feathers, thin wire

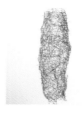

91

Series: Cages
Untitled, 2018
110 × 35 × 35 cm
Feathers, thin wire

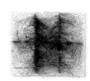

101

Series: Furs
Untitled, 2006
40 × 55 × 55 cm
Feathers

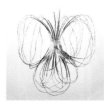

82

Series: Breaths
Untitled, 2012
80 × 67 × 62 cm
Feathers, thin wire

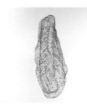

92–93

Series: Cages
Untitled, 2018
140 × 65 × 60 cm
Feathers, thin wire

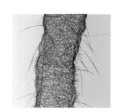

102

Series: Furs
Untitled, 2002
40 × 47 × 15 cm
Feathers

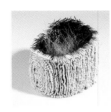

104

Series: Furs
Untitled, 2015
14 × 19 × 15 cm
Feathers

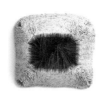

114 #2

Series: Insolubles
Untitled, 2015
30 × 31 × 14 cm
Feathers

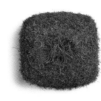

115 #3

Series: Insolubles
Untitled, 2016
31 × 29 × 15 cm
Feathers

106–107

Series: Furs
Forêt, 2007–09
192 × 220 × 30 cm
Feathers

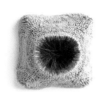

114 #3

Series: Insolubles
Untitled, 2017
24 × 24 × 14 cm
Feathers

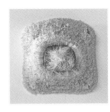

117

Series: Insolubles
Untitled, 2015–16
25 × 25 × 30 cm
Feathers

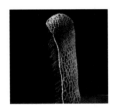

108–109

Series: Furs
Traversée, 2009
175 × 95 × 25 cm
Feathers

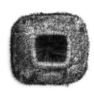

114 #4

Series: Insolubles
Untitled, 2015
31 × 31 × 18 cm
Feathers

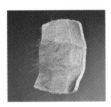

118

Series: Furs
Untitled, 2015–16
41 × 28 × 17 cm
Feathers

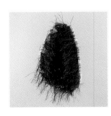

110–111

Series: Furs
Untitled, 2007
42 × 40 × 15 cm
Feathers

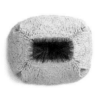

114 #5

Series: Insolubles
Untitled, 2015
24 × 29 × 11 cm
Feathers

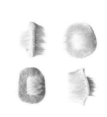

120–121

Series: Furs
Untitled, 2016
30 × 35 × 30 cm
Feathers

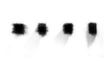

112–113

Series: Furs
Quadriptyque, 2007
22 × 15 × 20 cm (4 pieces)
Feathers

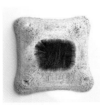

115 #1

Series: Insolubles
Untitled, 2015
28 × 30 × 15 cm
Feathers

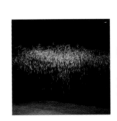

122–123

Series: Clouds
Untitled, 2010
50 × 80 × 240 cm
Feathers, thin wire

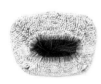

114 #1

Series: Insolubles
Untitled, 2016
25 × 28 × 13 cm
Feathers

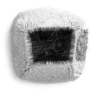

115 #2

Series: Insolubles
Untitled, 2015
28 × 30 × 15 cm
Feathers

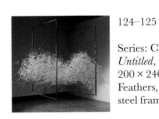

124–125

Series: Clouds
Untitled, 2008
200 × 240 × 275 cm
Feathers, thin wire,
steel frames

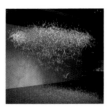

126–129

Series: Clouds
La pluie, 2009
250 × 210 × 190 cm
Feathers, thin wire

140

Series: Cnidarians
Pélagie, 2014
75 × 40 × 40 cm
Feathers, veil, elastic
yearn

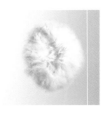

152–153

Series: Cnidarians
Untitled, 2015
25 × 25 × 10 cm
Feathers

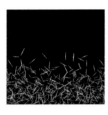

130–131

Series: Vapors, Cinetics
Whispers, 2010
(with Alain Chang)
500 × 420 × 420 cm
Feathers, wire, mechatronics

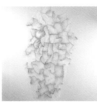

143

Series: Cnidarians
Untitled, 2011
225 × 140 × 25 cm
Feathers, veil

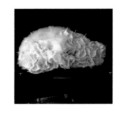

154–155

Series: Cnidarians
Untitled, 2015
32 × 50 × 20 cm
Feathers

132–133

Series: Ripples
(installation)
Untitled, 2012
270 × 45 × 45 cm (15 p.)
Feathers, thin wire

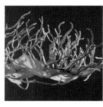

144–145

Series: Cnidarians
Untitled, 2015
120 × 180 × 160 cm
Industrial sponge,
branch

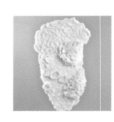

156

Series: Cnidarians
Untitled, 2015
167 × 90 × 25 cm
Feathers

134–135

Series: Lines
(installation)
Migration, 2016
200 × 450 × 450 cm
Feathers, thin wire

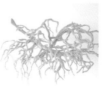

146–147

Series: Cnidarians
Untitled, 2015
110 × 160 × 130 cm
Industrial sponge,
branch

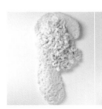

159

Series: Cnidarians
Untitled, 2016
170 × 80 × 30 cm
Feathers

136

Series: Lines
Ligne, 2011
95 × 30 × 20 cm
Feathers, thin wire

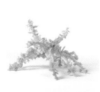

149

Series: Cnidarians
Untitled, 2017
26 × 35 × 28 cm
Natural sponge, branch

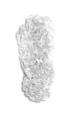

160

Series: Cnidarians
Untitled, 2015
105 × 48 × 15 cm
Feathers

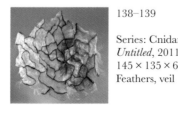

138–139

Series: Cnidarians
Untitled, 2011
145 × 135 × 60 cm
Feathers, veil

150

Series: Cnidarians
Untitled, 2015
12 × 18 × 14 cm
Feathers, synthetic net

161

Series: Cnidarians
Untitled, 2015
120 × 40 × 15 cm
Feathers

163–165

Series: Cnidarians
Untitled, 2017
200 × 80 × 30 cm
Feathers

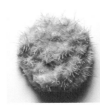

175

Series: Cnidarians
Untitled, 2016
30 × 30 × 15 cm
Feathers, industrial
sponge

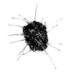

185

Series: Nets
Untitled, 2019
20 × 20 × 18 cm
Feathers, thin wire

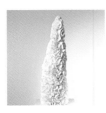

166

Series: Cnidarians
Untitled, 2016
110 × 32 × 32 cm
Feathers

176

Series: Cnidarians
Untitled, 2005
[5~12] × [5~8] × [3~5] cm
Feathers

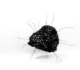

186
Series: Nets
Untitled, 2019
16 × 18 × 17 cm
Feathers, thin wire

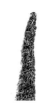

168

Series: Cnidarians
Untitled, 2016
160 × 40 × 40 cm
Feathers

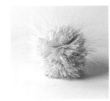

177

Series: Cnidarians
Untitled, 2017
35 × 35 × 25 cm
Feathers

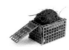

188

Series: Studies
Untitled, 2019
8 × 13 × 5 cm
Feathers, steel box

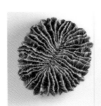

170

Series: Cnidarians
Untitled, 2017
31 × 24 × 10 cm
Feathers

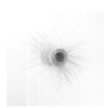

179

Series: Cnidarians
Untitled, 2016
38 × 38 × 20 cm
Feathers

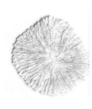

171

Series: Cnidarians
Untitled, 2017
75 × 80 × 28 cm
Feathers

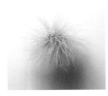

180

Series: Cnidarians
Untitled, 2015
35 × 35 × 25 cm
Feathers

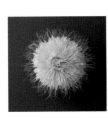

172

Series: Cnidarians
Untitled, 2017
25 × 25 × 25 cm
Feathers

182

Series: Nets
Untitled, 2019
24 × 24 × 24 cm
Feathers, thin wire

LIST OF QUOTATIONS

5 **Jean GIONO** (1895–1970)
Ennemonde: A Novel (London: Peter Owen, 1970)
Translated by David Le Vay

17 **Anonymous**, Japanese proverb
in Lafcadio Hearn, *The Buddhist Writings of
Lafcadio Hearn* (Santa Barbara: Ross-Erikson, 1977)

20 **William Butler YEATS** (1865–1939)
'Aedh Wishes for the Cloths of Heaven'
The Wind Among the Reeds
(New York/London: J. Lane, The Bodley Head, 1899)

22 **Giuseppe UNGARETTI** (1888–1970)
'Pleasure'
*A Major Selection of the Poetry of Giuseppe
Ungaretti* (Toronto: Exile Editions, 1997)
Translated by Diego Bastianutti

25 **T. S. ELIOT** (1888–1965)
'The Love Song of J. Alfred Prufrock'
Richard Ellmann and Robert O'Clair (ed.),
The Norton Anthology of Modern Poetry
(New York: Norton, 1988)

28–29 **Carson McCULLERS** (1917–1967)
The Ballad of the Sad Café
(London: Cresset Press, 1958)

30 **Paul ELUARD** (1895–1952)
'Universe-Solitude'
*Samuel Beckett, Collected Poems in English
and French* (New York: Grove Press, 1977)
Translated by Samuel Beckett

39 **Nicolas BOUVIER** (1929–1998)
The Way of the World (Edinburgh: Polygon, 1992)
Translated by Robyn Marsack

40 **LAOZI** (**LAO-TZU**) (5th century BC)
in Lin Yutang, *The Wisdom of China*
(London: New English Library, 1963)

43 **Christian BOBIN** (1951–)
The Eighth Day (London: Darton, Longman &
Todd Ltd, 2015)
Translated by Pauline Matarasso

46 **Jón Kalman STEFÁNSSON** (1963–)
Ásta (Paris: Bernard Grasset, 2018)
Translated from French

49 **Zhiqi TANG** (1579–1651)
in Pierre Ryckmans, *Les Propos sur la peinture
du Moine Citrouille-Amère* (Paris: Plon, 2007)
Translated from French

51 **Hassan MASSOUDY** (1944–)
Calligraphies d'amour (Paris: Albin Michel, 2002)
Translated from French

53 **Italo CALVINO** (1923–1985)
Six Memos for the Next Millennium (Cambridge,
MA: Harvard University Press, 1988)

55 **Mahmoud DARWISH** (1941–2008)
'Not as a Foreign Tourist Does'
The Butterfly's Burden (Port Townsend,
WA: Copper Canyon Press, 2007)
Translated by Fady Joudah

58 **Rupert BROOKE** (1887–1915)
'Clouds'
Poetical Works (London: Faber & Faber, 1970)

PHOTO CREDITS

Philippe De Gobert: 17, 24, 28, 29, 31, 32, 33, 36–37, 46, 54, 65, 66, 67, 70, 100, 101.

Serge Verheylewegen: 18, 19, 23, 26, 27, 34–35, 38, 41, 42, 44–45, 50, 52, 56, 58–59, 60–61, 64, 73, 79, 80, 86–87, 91, 92, 93, 94, 95, 96–97, 98, 102, 114 #1–5, 115 #1–3, 117, 118, 120, 121, 140, 143, 146–147, 149, 150, 152, 153, 156, 159, 160, 161, 163, 166, 168, 170, 171, 172, 177, 179.

Alain Chang: 14, 21, 47, 48, 71, 76, 57, 104, 110, 111, 112–113, 134–135, 136, 138–139, 144–145, 154–155, 164–165, 182, 185, 186, 188.

Pierre Yves Refalo: 63, 108–109, 122–123, 124–125, 126–127, 130-131.

Luc Schrobiltgen: 68, 74–75, 79, 81, 82, 84, 85, 89, 106–107, 128–129, 132–133, 133, 175, 180.

Laure du Petit-Thouars: 176.

COLOPHON

Executive publisher: **Mercatorfonds** (director: Bernard Steyaert)

Editor: **Alain Chang**

Layout: **Alain Chang**

Coordination: **Alain Chang**; **Geneviève Defrance** and **Marianne Thys** (Mercatorfonds)

Editing: **Faye Robson**; **David Price, First Edition Translations Ltd, Cambridge**

Translation: **Mark Carlson** (Roger Pierre Turine, Adrien Grimmeau, Alain Chang)

Colour separation, printing and binding: **Graphius**

Paper : **Symbol Tatami 150g**

Copyright © for the texts: the authors

Copyright © for the images: the photographers

© 2019 Carole Solvay

www.carolesolvay.com

Distributed for Mercatorfonds in Belgium, the Netherlands and Luxembourg by Exhibitions International, Leuven.
ISBN 978-94-6230-106-1
D/2019/703/21
www.mercatorfonds.be

Distributed for Mercatorfonds outside Belgium, the Netherlands and Luxembourg by Yale University Press, New Haven and London.
ISBN YALE 978-0-300-24655-1
Library of Congress Control Number: 2019952804
yalebooks.com/art – yalebooks.co.uk

Cover image:
Untitled, 2017 (Series: Cnidarians, pp. 163–165)